D0470583

CURATORIAL CARE OF WORKS OF ART ON PAPER

ANNE F. CLAPP

Curatorial Care of Works of Art on Paper

BASIC PROCEDURES FOR PAPER PRESERVATION

LYONS & BURFORD, PUBLISHERS

Copyright © 1987 by Intermuseum Conservation Association

ALL RIGHTS RESERVED. No part of this book may be reproduced in any manner without the express written consent of the publisher, except in the case of brief excerpts in critical reviews and articles. All inquiries should be addressed to: Lyons & Burford, Publishers, 31 West 21 Street, New York, NY 10010.

Printed in the United States of America

10 9 8 7 6 5 4

(Third Revised Edition, May 1978)
(Second Revised Edition, May 1974)
(First Revised Edition, March 1973)

Library of Congress Cataloging-in-Publication Data

Clapp, Anne F.
 Curatorial care of works of art on paper.

 Bibliography: p.
 Includes index.
 Figure 1. Paper—Preservation. Figure 2. Art—Conservation and
restoration. I. Title.
TS 1109.C55 1987 760 87–4011
ISBN 0–941130–31–2

Illustrations by S. B. Watkins.

In grateful memory
to
Richard Buck and Delbert Spurlock, a distinguished, innovative team—
my teachers and companions in conservation

Contents

Part II: Procedures 55

Acknowledgments

My thanks are extended to all the conservators and scientists who favored me with helpful comments and suggestions, especially to Mr. Paul N. Banks of the Columbia University School of Library Service; Dr. George B. Kelly, Jr. and John C. Williams, formerly of the Research and Testing Office of the Library of Congress; Dr. George J. Reilly, Head of Scientific Research, and Mr. Richard C. Wolbers, Paintings Conservator, both of the Henry Francis du Pont Winterthur Museum.

There can be no greater comfort to a writer than the intelligent skill of Patricia R. Lisk of the Publications Office of Winterthur. Her knowledge of the English language and her logical application of the required manuscript conventions have been of great help.

CURATORIAL CARE OF
WORKS OF ART ON PAPER

Introduction

This book is designed to aid the conservation technician, private or institutional, in caring for works of art on paper. Only basic problems and procedures are discussed; techniques of advanced restoration are omitted because all major treatment should be submitted to a trained, qualified conservator working in a well-equipped laboratory. "Major treatment" means any procedure, more than elementary in character, that involves the direct manipulation of a paper support or its design for the purposes of restoration.

The person this book especially addresses is he whose business it is to care for paper objects, yet who has not had the advantage of years of training under a conservator or of education in a conservation program: a person fearful of causing harm and wanting to know how to avoid it; a person who has an established association with a conservator to whom he can appeal in all cases of doubt; a conscientious person who knows his limits and knows when to submit a problem to the conservator; a person who, because of his skills and dedication, can be called a conservation technician or a paraconservator or an assistant in conservation. Whatever he is called, his ranks are legion. He works in museums, historical societies, private collections, libraries, and dealer's and framer's establishments. Because of the vast amount of papers that need care and because of the still hard to find and overburdened trained conservator, he is very much needed.

The book is divided into three parts. Part I consolidates published information about factors that can be injurious to paper, and about suggested safeguards. The substance has been drawn largely from the books and articles listed in the bibliography. Because of the broad scope of the subject and because technical knowledge about paper is constantly expanding, this section should be considered simply an indication of the principal areas about which to be informed.

1

Part II outlines procedures for treatment: initial care, matting, framing, storage, and so forth. It is based on techniques generally advocated by paper conservators, sometimes modified by my own experience and personal preferences.

All parts of Part III and the following Appendices—formulas, materials, and equipment, together with their suppliers—could be expanded to fill many more pages. The few formulas are for substances that the technician will need but that he may prefer to make himself rather than buy. For the start of his workroom, the list of materials and equipment will be sufficient, at least until he has developed his own modifications of techniques and preferences for tools. The list of actual suppliers for purchase is only cursory and subject to change.

Specific products mentioned in the notes, as well as in Part III, are given not because they are necessarily the best of their kind but because they have been found satisfactory by me or have been recommended by others, and also because they could make good starting points in the purchaser's search for the particular articles most suitable to his needs.

No attempt has been made in this book to cover the complex fields of security and procedures to combat disasters caused by injury, theft, fire, storm, and flood. Fortunately, these subjects are so successfully covered by several publications that no custodian's reference library should be without them. *Museum Security* by Robert Tillotson, published by International Council of Museums, is a book in English and French, the product of a committee of people from fourteen countries. It discusses the subjects from every aspect, offering directives for protection against calamities and the establishment of personal security. It is addressed to all kinds of institutions, from small collections to large museums. For action to be taken after any kind of damage by water, there are *Procedures for Salvage of Water Damaged Library Materials* by Peter Waters, published by the Library of Congress; and ''After the Water Comes'' by Willman Spawn, in the *Pennsylvania Library Bulletin*, volume 36. Both give careful, reliable instructions based on the personal experiences of each author. It would be well to keep these instructions clearly in mind so that emergency action can be taken without last-minute review. Many institutions have very wisely established disaster planning committees that meet periodically to plan exact steps to be taken, to instruct and drill the staff in their participation, and to assemble the materials needed to combat every kind of major disturbance. See *Disasters: Prevention and Coping*, edited by James N. Myers and Denise D. Bedford, and published by Stanford University Libraries.

PART I

Factors Potentially Harmful to Paper

A conservation technician's awareness of harmful factors, together with his determination to do all in his power to avoid or control them, is of prime importance. He must apply his knowledge to the actual situations in his particular building and specifically, in the present concern, to the care of paper within it. Often this requires imagination and a lot of bullheadedness. On the one hand, he should know by his own use of monitoring instruments or by consultation with professional engineers what are the conditions of atmosphere throughout the year in rooms where paper is kept, how these conditions compare to the optimum, and how to use and modify them; on the other hand, he should have some knowledge of paper as a material, its structure and principal components, its characteristic responses to environment, how modern papers differ from old, and so on. His constant vigilance, rather than unquestioning reliance upon equipment and past assurances, is a definite advantage that should guard against harmful changes, such as a malfunctioning air conditioner, a new factory in the neighborhood, or a product whose manufacture has been altered.

Many of the agents damaging to paper, whether latent in the paper's structures or in the conditions under which it is kept, have been known for some time. But increasingly in the last several decades the widely published findings of scientists and others concerned with paper have substantiated this knowledge with such emphasis as to make disregard of the teachings a serious mistake.

Environment[1]

Exterior Climate, General and Local

Every kind of climate offers difficulties for the preservation of man-made objects, and that of the northern United States certainly is no exception. It has a continental climate: humid, with hot summers and cold winters. In non-air-conditioned buildings, such a climate can mean an almost continuous struggle with humidity levels that are high except during the period of central heating, when dryness becomes excessive. Often in spring and autumn there are marked fluctuations of temperature and humidity that can cause thin hygroscopic materials like paper, when left unprotected, to swell and contract in harmful alternation.

Assessing the climatic conditions of a particular location requires more detailed information than that available from the nearest airport or media weather reports. Local variations also come into play: prevailing winds, nearby bodies of water, the conformation of the land, and the presence of surrounding vegetation. Cities have special problems. Urban conditions—congestion of buildings, industry, traffic, and so forth—affect the climate. Paul Coremans said of the microclimate of a large city, "In comparison with the general climatic characteristics of its surrounding area, a city like Paris receives less direct solar radiation but more artificial heat from domestic and industrial fires, precipitation is heavier but the relative humidity is lower and atmospheric pollution is much more pronounced."[2] Since 1968, when this statement was made, widespread gaseous pollution, together with increasing atmospheric acidity, has become of universal concern. Carried in rain and snow by prevailing winds, the destructive influences are felt in the countryside, the forests and lakes, as well as in the cities.

Another serious concern is the effects of toxic vapors from synthetic organic chemicals—compositions of carbon, hydrogen, and chlorine—widely used in

industry, manufacturing, chemical research, pesticides, and household cleansers. Because they can both evaporate and dissolve in liquids, they can move from land to water, from water to air. They persist for a long while in these elements and can reach unhealthy levels in animals and man. However, the growing insistence that pollution be controlled before we irretrievably injured the earth could result in reducing these threats. In the United States, the passage of the Clean Air Act of 1970, backed by the federal Environmental Protection Agency and by the state departments for environmental control, gives hope for the future.

Meanwhile, cities have to endure the corrosive effects of gases and particulated matter from such sources as industrial and power plants, domestic heating fuels, and car exhausts. The airborne products are all-pervasive—carried in precipitation, in smoke particles, themselves sooty and scarring, and in acid aerosols so small they follow currents of air to coat buildings, to enter doors and windows, and to cling to the garments of people. These conditions are worsened during the winter months or whenever there are temperature inversions that reduce the dispersion of pollutants into the upper air. Some cities, expecially in sunny localities, are termed "automobile cities" because present in their climate is ozone, a strong oxidizing agent that the ultraviolet rays of the sun liberate from car exhausts and industrial emissions by initiating reactions between hydrocarbons and nitrogen oxides. The Los Angeles smog, where concentrations of ozone can be very high, is usually the example cited, but the dangerous gas exists in every urban area. More common are "smoke cities," so called because of the high percentage in the air of sulfur oxides emitted by heating and industrial fuels. Sulfur dioxide can be changed into the destructive, nonvolatile substance sulfuric acid in the presence of moisture, and catalyzed by metallic particles that are always found in polluted air and very often found as impurities in paper itself. We now realize that oxidizing pollutants—ozone with its precursors nitrogen oxides and peroxides, and reducing agents derived from sulfur oxides—coexist in urban air, and that both must be considered in the protection of sensitive objects.

Certainly it is not within a technician's scope to be meterologist or building superintendent, yet he should be aware of the condition of the surrounding climate and of what kinds of control are needed by his particular building in order to reduce harmful intake and exposure. Knowledge of the weather history of the area, its extremes of temperature and humidity, and of the way the building in all its parts functions as a shelter—even, indeed, how it withstands nature's worst manifestations—is important for many reasons, not the least of which is the

selection of exhibit and storage locations for holdings of different kinds of materials. Reactive substances like paper should occupy places most protected against sudden changes or adverse climatic effects.

Monitoring Atmospheric Pollution

Under the Environmental Protection Agency and administered by state departments for environmental control, stations have been established throughout the country, with concentrations near urban centers, whose function it is to monitor the neighboring air for harmful pollutants. The state departments dispense the information they accumulate. In many localities, it is published or broadcast as the Air Quality Index, in which is registered the daily amounts of particulates and polluting gases and in which it is noted whether the levels are within the limits of safety.[3] This service can be of value to a building's superintendent in determining the general character of the surrounding air.

In order to know with greater surety if local variations of pollution exist, however, the information can be augmented by the use of portable gas detectors. A number of instruments are available that can detect gases such as the oxides of sulfur, nitrogen and carbon, and hydrogen sulfide. The instruments range from very sensitive but costly ones[4] to relatively inexpensive kits. The latter are composed of small air pumps and sets of calibrated tubes, each tube containing a material impregnated with a chemical that reacts by color changes to one gas or another, the degree of concentration being measured by the length of the stain. The amount of ozone in the air is more difficult to determine reliably. The National Draeger Company makes a kit that indicates the presence of this gas,[5] together with calibrated tubes for many different pollutants.

A better way to determine exterior ozone is to rely on information from the local department for environmental control. The sensitive instruments involved are used by professionals who calibrate them frequently. The levels of low-atmosphere ozone can spread more or less evenly over quite wide areas, exhibiting only very local pockets of change. In many cases, the formation of ozone has been traced to the tall stacks of industrial and electric-power plants whose smoky plumes can be many miles long. It is in these plumes that the ozone-forming chemical reactions can take place between oxygen in the air and sulfur dioxide from the stacks. Based on the speed of the wind and the rate of the reactions, the formation may occur miles downwind from the plant source.

Interior Climate, Monitoring and Control

Air-Conditioned Buildings

The problems imposed by the climate and by the quality of modern air can best be counteracted by closed buildings equipped with efficient air-conditioning systems tailored for the requirements of the building and its uses. A museum, for example, should have very clean air and a system that can be adjusted to give locally modified temperatures and humidities for the climate needs of different materials. The air in such buildings can be filtered at the intakes, washed (preferably with alkaline water), and humidified or dehumidified as the situation demands. It can be circulated and then recirculated after being mixed with a proportion of freshly admitted and treated air. In the construction of a new museum, the air-conditioning plant should be given prime consideration; the most advisable equipment should be installed without skimping on cost. A building whose structure can isolate the interior from the influences of outside conditions and that is furnished with a properly maintained system can offer the best possible housing for the preservation of priceless objects and for the well-being of its occupants.

Unfortunately, however, the ideal museum building is rarely if ever found, and the technician should be aware of the factors inherent in the structure of his building that can modify the interior environment in spite of the automatic equipment. What is the temperature of the inside surfaces of the outer walls during very high or very low outside temperatures? If the walls fulfill the function of providing thermal insulation, the temperature should come reasonably close to that of the room. What kinds of windows and window framing are installed and how much area do the windows cover? Windows are poor thermal barriers, although double and triple glazing increase their insulating efficiency. The glass walls in some contemporary buildings make climate control of the interior ex-

tremely difficult. Do the walls contain adequate vapor barriers? In cold climates, if moisture seeps into the structure either from the inside or the outside, it can freeze there, causing cracks that could damage thermal insulation. What about interior air circulation? Some forced-air systems have been known to create air currents of such high velocity as to make framed objects vibrate against the walls. If an electronic precipitator is used at the intake to remove soot and dirt particles from the air, has the ozone this device can create been completely absorbed before the air is circulated through the building?[6]

Even if the structure and the equipment are close to the ideal, there remains the human factor. Many museum personnel do not really understand how an air-conditioning system functions. One of the most persistent mistakes is the notion that all difficulties associated with control of interior atmosphere can be dismissed from mind because the costly machinery will take care of things. Actually, a malfunctioning system whose misbehavior is not detected because it is incorrectly monitored can be more harmful than no control at all. The operation of the complex equipment must be supervised, preferably by a knowing member of the building staff. If there is no staff member thoroughly trained in the field, it would be wise to arrange for an experienced engineer to make periodic visits for inspection and advice. Additionally, the conservation technician, as well as everyone responsible for the well-being of objects, always should be alert to detect possible trouble by the use of monitoring devices and by observing physical indications: accumulations of dust or soot, condensation, water stains, soil or salt patterns on walls, cracks in wall surfaces, insects, unexplained odors, places of blocked circulation, and so on. It is important to know the limitations of the system and to avoid overtaxing it. There have been instances, for example, of popular museum exhibitions so heavily attended that the air-conditioning was completely overburdened, allowing temperatures and humidities to rise without control during visiting hours.

Monitoring Devices

Monitoring the interior environment is essential. The following devices are advisable and, especially in the case of those that measure relative humidity, should be used regularly by the maintenance staff. The technician also should be familiar with them and consider it part of his job to use them himself whenever necessary. They are required to check on the continuing efficiency of the air-conditioning and to watch places that are suspected of not receiving the full benefits of the

system. For buildings without air-conditioning, monitoring permits a surer knowledge of interior conditions than could otherwise be obtained: where weather and pollution penetrate and to what extent, where should be the closest surveillance during storm, where interior conditions are the least stable and why; by extension, to know which areas are suitable for the housing of objects according to their degrees of sensitivity to atmospheric changes. The knowledge and accumulated records would constitute the basic information needed should any form of air-conditioning be planned.

1. Gas Detectors. The instruments and indicator kits described in the foregoing section on monitoring exterior air pollution can determine the presence of polluting gases within a building. The Draeger Tube (CH 31301, see note 5) is useful to assess the presence of ozone. Concentrations of ozone can be very destructive, especially to organic materials. If found, its source should be determined and an engineer consulted to advise how best to control it. Beside seepage from the outside air as during an Ozone Alert, electronic precipitators at air-intake systems can create ozone inside a building. There are other pieces of equipment that should be checked, such as germicidal appliances sometimes used in cafeterias, laundries, and bathrooms.

2. Air Velocity Meter, or Velometer. This instrument serves a number of purposes: it measures air flow at the doors of rooms and along corridors in order to find the rate at which the air changes; measures air flow discharged at registers; detects hazardous velocities and wind-tunnel effects; determines whether there are air leaks at the fittings of windows, doors, and skylights. It should be self-contained, portable, and equipped with an extension probe in order to register air movement in confined spaces. It is important that its sensitivity be suitable for the intended uses.[7]

3. Devices for Measuring Relative Humidity and Temperature. Control of these factors is vital to the preservation of any hygroscopic material because its moisture content is directly dependent on the relative humidity and indirectly dependent on the temperature of the air surrounding it. Relative humidity (RH) is the amount of actual water vapor in a volume of air, expressed as a percentage of the total amount of vapor that the air could contain at the same temperature. If the RH should reach one hundred percent, the air would be saturated; it would be at the dew point. The warmer the air, the more moisture it is capable of holding; that is, if the temperature in a room were raised but moisture not added, the RH would be lowered.[8]

For one purpose or another, it is advisable to have on hand the instruments described below:

a. *The Sling Psychrometer* has two matching thermometers on one mount and a handle attachment that allows it to be manually rotated in the air.[9] The bulb of one of the thermometers is covered with a clean absorbent cloth sock. For RH measurement, the sock is uniformly wet with distilled or deionized water and the psychrometer swung at a fairly vigorous and constant rate until the reading of the wet-bulb thermometer remains steady as ascertained after about a minute by checking once or twice between swingings. The temperature on this thermometer must be read as quickly as possible after the final swinging. The RH is indicated by the amount of depression of temperature caused by the cooling effect of the evaporation of the moisture on the sock, an amount that is related to the moisture content of the air. For easy interpretation, the instrument is accompanied by hygrometric tables or a slide rule that gives the RH for the degrees of depression from the room temperature read on the dry-bulb thermometer. Provided the thermometers are well matched and the instrument correctly operated, accurate measurements can be obtained and can be used to check the readings of recording and dial devices that frequently need adjustment.

b. *The Battery-Operated Psychrometer* works on the same principle as the manual one except that a small fan draws the air into the housing and blows it over the thermometer bulbs.[10] It is easy to use and makes possible the taking of many RH measurements in one session without tedium. The operator should be sure to place the instrument a short distance away from him, lest his body heat affect the readings. However, because the batteries run down and the motor sometimes needs repair, the sling psychrometer is a necessary back-up instrument.

c. *Recording Hygrographs and Hygrothermographs* are complex, precision machines that record the fluctuations of temperature and/or humidity by means of various kinds of sensing elements (such as strands of hair or man-made fibers, or diaphragms for humidities and bimetallic coils for temperatures) and rotating disks or drums that are faced with calibrated charts. The sensing elements activate pens to make traces on the charts as they revolve. A complete revolution is timed to take either seven days or twenty-four hours.[11] Unfortunately, the reliable instruments are expensive. Yet there should be records for several principal locations. The

machines should be checked regularly because they require fairly frequent recalibration.

d. *Dial Hygrometers* can be used in closed areas such as display cases. They are small enough to be placed inconspicuously (the sizes vary from two inches to six inches) and are attractive in design. Some of them indicate both temperature and RH, others simply RH. Judging from experience with one or two makes, they do not remain accurate for long. Therefore, they should be checked with a psychrometer each time they are put into use. To be of real value, they should be equipped with adjustment screws. Very few of them have this means of adjustment because of possible damage to the two-paper coil mechanism that activates the RH indicator arm. For those that do not have screws, records must be kept of their drift in order to obtain the correct temperatures and humidities.[12]

e. *Humidity Indicators* made of paper or cardboard impregnated with inorganic salts containing cobalt chloride are very useful.[13] In response to variations in humidity, they change in color from blue in dry air to pink in moist air. These colors, together with intermediate shades, permit a close approximation of the RH. They seem to be fairly long lasting, and when their responses become too far off they can easily be replaced. Their great advantage is that they can give information from positions where more bulky devices cannot be placed—on an outside wall in the shadow of a picture frame, in the corners of book shelves, within cases, and so forth. A recent study of cards of this type has found them to have the accuracy of hygrographs and to be reliable over long periods.[14]

Non-Air-Conditioned Buildings

The technician in a non-air-conditioned building must solve many problems in addition to those already described for his more fortunate counterpart. Yet his task need not be hopeless. The very construction of the building may be somewhat in his favor. The thick walls, limited window spaces, and high ceilings often found in the older museums of the northern states are factors that could contribute to the stability of the atmosphere. In some cases, the quality of the air is at least partially controlled by being drawn into the building at a single intake and passed through a cleansing water curtain. If the structure is old, the conservation technician must suspect that weaknesses have developed, making it far from weather-

tight. He may find that some areas are unusable unless they are renovated: drafty corridors, the attic with its heat and dryness, the damp basement with dark and musty corners, the monumental stairway washed with high light levels from the skylighted roof. Repeated alterations over the years to partitions and utility lines may have created a tangle that should be thoroughly resolved for safety's sake. There are instances of buildings whose wiring and piping have become so confused that no record remains by which their courses can be traced. The fight for cleanliness and insulation from outside conditions will be of continual concern. In fact, if a museum in an industrial city has not some system for filtering and washing the air that is circulated through the rooms, and if its windows must be opened in warm weather, its suitability as a shelter for hygroscopic materials like paper could be justifiably questioned.

Air-Conditioning of Local Areas

Fortunately, modifications can be made. The technician should try to have as large an area conditioned as can be afforded, and should be firmly determined not to expose paper in uncontrolled surroundings. The happiest solution could occur during a period of reconstruction when it would be possible to achieve central air-conditioning for a wing or for a section of the building. Failing that, one or two rooms could be conditioned and closed off by swinging doors on either side of a small vestibule that would serve as an air trap.

However, before moisture of quantity unusual to any part of a building is evaporated into the air, its effects upon the structural elements must be carefully studied by an engineer who is fully informed on the behavior of the building, especially during times of climatic extremes. Irremediable damage could be done by condensation and freezing of moisture within the walls. Vapor barriers may have to be erected below the ceiling and close to the outside walls, thus forming a room within a room; in other words, forming the ''isolated area'' so graphically described and advocated by E. J. Amdur in his article ''Humidity Control— Isolated Area Plan.'' The ideas expressed in this article should serve as valuable guides to planners of renovations or, indeed, of new construction.

Treatment of Windows

One of the most disturbing effects that occurs when the interior humidity is kept at desirable levels in cold weather is condensation on windows. This result can be considerably lessened by the installation of double-paned windows and, during the winter, of tightly fitting and sealed storm windows. Single-paned

windows are really not functional in cold climates because they frequently frost over in winter even when the RH of the interior is twenty percent or lower, far below the level required for most museum objects. In the parts of the United States with the coldest winters, triple-paned windows[15] (or double-paned with storm windows) are a requirement if forty percent, the lowest desirable museum limit for the interior RH, is to be maintained. Moisture would not condense on the windows at that level unless the outside temperature fell below $-20°$ F ($-33°$ C); double-paned windows would frost over at $2°$ F ($-17°$ C); and single-paned windows at $28°$ F ($-2°$ C). It has been suggested for the more extreme Canadian winters that thirty-five percent RH be the lower acceptable limit for a museum climate.[16] In that case, the outside temperature could fall to $-45°$ F ($-43°$ C) if triple panes were used, or $-10°$ F ($-23°$ C) if double. But this level, held over a period of time, is questionable because it is below that considered safe for museum materials such as wood and parchment.[17]

If storm windows cannot be used and the locality is one where temperatures seldom go much below $0°$ F ($-18°$ C), and then only for short durations, envelopes of warm air can be formed over the windows as by channeling heat from floor radiators between the glass and drawn translucent curtains made of a heat-resistant material like glass cloth. Forced convection and the enclosing curtains should hold in sufficient warmth to reduce condensation.

Humidifiers, Dehumidifiers, Window Air-Conditioners

When conditioning on a still smaller scale—in a room or gallery where air currents are not strong, that is to say, where the air changes at a relatively slow rate (the usual rate of a fairly closed room is one change of air per hour)—the use of humidifying or dehumidifying units might be considered.[18]

As many units should be installed as would keep the humidity of the specific area near the proper amount. Provided the interior can be protected against the intrusion of excessive dampness during long periods of wet weather, the effectiveness of the units could be improved if the room were furnished with hygroscopic materials—draperies, carpets, and so on—which could take on or give off moisture as the humidity rose or fell. The machines must be controlled by humidistats that are routinely checked and, for ease of handling, piped to water supplies and drains. When selecting humidifiers, the evaporative type should be chosen, such as that in which a large porous wick or pad, kept continuously damp, is in the path of air from a rotating fan aimed to send moisture out into the room. Because of its method of operation, this kind of machine can use

untreated tap water without depositing films of the salts contained in the water upon room surfaces. Cooling of the area could be supplied during the summer months by window units.[19]

Exhibition Cases

If the technician has no way whatever of controlling the climate in the gallery except by winter heating, or if he finds that control is sometimes inadequate, he can resort to the display case. Cases can be engineered to hold a fixed climate over extended periods as described in basic articles by Nathan Stolow. However, if such constructions seem too elaborate for the routine exhibit of paper, well-made museum cases can be adjusted to be effective for shorter lengths of time.[20] Enclosure alone will stabilize the interior climate of a case to some extent by subduing the short-lived variations of the levels of humidity experienced by the room. If the case is made as tight as possible and if it contains a quantity of hygroscopic materials (paper, paperboard, decorative covering cloths, silica gel) that have been conditioned before enclosure to the desired RH at an average temperature, the stability will be improved. Since the case is not constructed to be hermetically sealed, the enclosed air will exchange slowly with the air of the room, probably at the rate of one change per day.

The temperature within the enclosure will be approximately that of the room (which therefore should be kept as even as possible night and day), provided there is no local heating or cooling of the enclosure as by lights within the case or by placing either case or frame too near a source of heat or against a cold outside wall. Strong display lighting outside the case must be avoided because it causes serious fluctuations: high temperatures and lowered RHs during the day and the reverse conditions at night. The thermal expansion and contraction thus created would speed up the interchange of air, the interior air moving out when heated by the lights and the room air moving in when the lights are off.

If, then, the temperatures are kept fairly steady, the RH of the enclosure will not reflect the short-lived changes of gallery humidity, yet will, over a period of time, drift toward the gallery's average RH. The "dunnage" effect of the contents of the enclosure—that is, their ability to take on or give off moisture in response to moderate changes in temperature—will play a large part in stabilizing the inner climate and will prolong the drift of the RH. During the warm part of the year, when central heating is not in use and room temperatures are not easy to control, reliance for stability will shift even more to the moisture-absorbing ability of the contents. Secondary materials can be deliberately chosen for their hygroscopic

characteristics, of which one of the most effective is silica gel. A humidity gauge or indicator should be placed within the enclosure to warn when its climate is becoming undesirable. Because paper should not be exposed to long periods of display, there are beneficial aspects to methods of exhibit that require periodic dismounting. In Part II, suggestions will be given for exhibition frames and cases in which the RH can be kept reasonably stable over a number of months—a span of time more consistent with conservation of paper than would be a longer period.

Whatever the conditions in the rest of the building, the paper technician must insist that there be at his disposal at least one room, if not several, for work and storage areas whose climate can be satisfactorily controlled. Such a place is essential if there is no central air-conditioning. There the papers of value and all secondary materials used in framing, matting, and display can be kept under proper conditions.

The Effects on Paper of Harmful Factors: Suggested Controls

Dampness, Dryness, and Heat

Dampness causes hygroscopic materials to swell and, if it is excessive, permits mold to flourish within their structures. Dryness shrinks these materials and embrittles paper, at least temporarily, so that dry papers cannot be flexed without possible injury to the fibers. The damaging effects of these two extremes can be prevented by the control of relative humidity.

Relative Humidity

RH in the environment changes as the temperature changes. Usually, RH decreases as the temperature increases and vice versa. It is not an easy factor to control throughout a room even with air-conditioning, because if there are local variations of temperature, corresponding differences of RH accompany them. Cold surfaces, like outside walls, make the layer of adjacent air hold relative humidities higher than that of the room itself; conversely, low RH can be created in such situations as showcases heated by special lighting. Chimney walls or fireplaces can be hot or cold, making the RH in the air near them vary from low to high. A fluctuating condition is especially damaging to quickly reactive materials because it "exercises" them by causing them to swell and contract in response to the humidity changes.

Much has been written about the importance of RH and its control. Pertinent passages are quoted here from an article by R. D. Buck: "Hygroscopic materials have an everlasting affinity for moisture. Their moisture contents vary, always seeking an equilibrium with the relative humidity (RH) of the environment. . . . By controlling the relative humidity of the museum atmosphere, we indirectly control the moisture content of all the hygroscopic materials housed and retard

their deterioration.'' Speaking of the range of variations within a museum, he says, ''Most damaging are the long seasonal cycles that occur indoors in our temperate climate . . . the relative humidity in buildings without humidity control will range as high as 70 percent in the summer and dip to 10 or 15 percent in the winter.'' He also cautions, ''If automatic control [in an air-conditioned museum] is shut off overnight or over holidays, an intermediate cycle of humidity variation is introduced. A period of twelve to forty-eight hours is sufficient to permit a significant change in the moisture content of paper, fabric, parchment and even wood. The range of these variations can be as much as 20–30 percent RH. . . . The benefits of humidity control are not clearly observable in the condition of a collection unless the seasonal range can be reduced to 20 percent or less; that is, allowing a rise of 10 percent above an ideal specification [which he has established as fifty-five percent RH] during the summer, and a drop of 10 percent below it during the winter. One may expect greater security for the collection if the range can be further narrowed, but it appears that many air-conditioned museums find it difficult, if not impossible, to restrict the annual humidity range to 20 percent.'' Buck specified the best RH range for paper to be between forty and sixty percent.[21]

Because of its great susceptibility to mold and other damages caused by high humidity, paper is safest if its environment favors the drier end of the range. High humidities can cause acid papers to be degraded by hydrolysis (chemical decomposition by reaction with water), especially if the temperature is also high (and papers are acid more often than not). Minute factors in or on the paper, such as iron particles or mold spores or tiny dust clusters, can participate in harmful reactions of various kinds if the moisture content is high. Should localized dampness exist, mold-growing levels could be reached in those areas if the RH of the room were near sixty percent, whereas this chance would be less likely if the general RH were around forty-five percent.

Paper is often displayed in frames hung against outside walls. Condensation of moisture can take place there if the RH of the room is high and the temperature of the wall is low. For example, if the general RH is fifty-five percent at 75° F (24° C) and the temperature of the wall is 65° F (18° C), the RH near the wall would be seventy-five percent. An extreme example of this condition is a basement wall below ground level. During the summertime, if the walls have no thermal barriers, condensation can be excessive, requiring that everything susceptible to dampness be moved away from them and fans be positioned to keep the air near them in circulation. For many reasons, it seems best to keep paper in a room

whose RH range is between forty and fifty-five percent, or as close to it as other museum materials in the room permit: no higher than fifty-five percent for paper's sake, no lower than forty percent for the sake of its frequent companion, wood.

Rapid changes in the surrounding RH occasioned by sudden changes in temperature should be avoided, as when a framed and glazed paper, improperly packed, is taken too quickly from a warm interior out into cold weather. Even though some moisture-absorbing and -desorbing materials may be around it when the so-called thermal shock occurs, time is required for them to take effect, and in that time condensation inside the glass could occur. If a framed paper is to travel through extremes of temperature, its box should be equipped to give it thermal protection, as with lining membranes of Mylar (polyester), or polyethylene and expanded polystyrene. Inside the insulation there should be sterile conditioned hygroscopic materials in sufficient amount and of rapid response to humidity changes in order to keep the climate around the framed paper essentially stable. Fiberboard, cloth felt, and panels containing silica gel are some of the materials chosen for their hygroscopic properties.

When planning for the transportation of objects, the design of the packing case for control of internal environment is as important as its design for mechanical security. Both aspects have been carefully studied by such authors as Nathan Stolow, Caroline Keck, and Stephen A. Horne.[22]

Dryness

Although the consequences of high humidities are known (paper will suffer irreversible damage from mold growth in relative humidities above seventy percent), the percentage below which it will be permanently harmed has not been as clearly defined. Carl J. Wessel suggests that the lowest moisture content safe for paper may be considered to be that in equilibrium with thirty percent RH.[23] Paper shrinks as it gives up its moisture and, if restrained in this action beyond its tolerance, will split or become seriously distorted. Its folding endurance is low when it is too dry, so that, although papers that are not handled may be able to recover from dry states without harm, papers that have to be flexed, as do pages of books, may be injured.

Heat

Dry conditions are very often associated with heat, another harmful factor. Heat causes brittleness and other symptoms of deterioration. Indeed, it is used in a standard test to simulate the effects of aging upon paper. It speeds up processes

of chemical and photochemical degradation, acting in conjunction with humidity, light, pollutants, and biological agents. Temperature should be kept as low as possible, human comfort being the controlling consideration. Above all, it should be kept uniform. As Dr. Amdur says, "Good relative humidity control depends on good temperature control."[24]

Acidity

Acidity in paper is one of the principal reasons for its deterioration. Acidity causes loss of strength by catalyzing the hydrolysis of the cellulose molecules, a progressive reaction that, in time, becomes so general that the once-flexible, strong paper gets weak and brittle, allowing it to be torn even by the gentlest handling and completely split by folding. Papers become acid from a number of different causes, of which one has been described—that of acids derived from polluted atmosphere. It is demonstrated with what surprising rapidity paper is affected by airborne acids, especially if heat and moisture are present. Other causes can be intrinsic to the original materials: acid-inducing heavy metal ions or particles embedded in the fibers during growth and subsequently from manufacture; residues of bleaches and other acidic compounds; impurities such as are found in the noncellulosic content of wood pulp; acid sizings like alum-hardened gelatin and its more modern successor, alum-rosin sizing; acid design materials, paints, and inks, especially iron gall inks. So general is the tendency of paper to become acid that it is a normal part of its aging. Occasionally papers are found that have remained nearly neutral over long periods of time. They are papers free of impurities from the start, sheltered from polluted air and light as in the depths of cared-for books, or containing in their compositions (probably by good chance rather than design) an acid-buffering compound like calcium or magnesium carbonate.

The most seriously affected papers are those that have been made since 1860 or 1870 until the present day, containing unpurified wood pulp and alum-rosin sizing. Pages of these materials have become so fragile that many books are already unusable, and librarians anticipate that the funds needed for conservation may exceed those for acquisition. Some works of art are on such stock. Modern artists in their delight with immediate effects often show a carefree disdain for the toll time exacts from strawboard, newspaper, and fancy papers intended to last but a short while. Late nineteenth-century artists were interested in permanence for their major works, but their lowly sketches, so valued now, were

frequently done on stock of poor quality. Fortunately, however, many ''art'' papers (watercolor, drawing, printing, and the like) continue to be made at least partly of rag content or highly purified wood fibers. They have not always escaped acid sizing but, probably because of their thickness and density as well as their more stable fibers, they seem to be in less serious condition, generally speaking, than book papers of the same age.

Another major cause of acidity in papers of value is close association with acid secondary materials: adhesives and mounting papers, cardboards containing ground wood pulp or acid sizing, unsurfaced wooden backings, unstable plastic sheeting, and so forth. Acidity migrates from one material to another, especially when in close and prolonged contact, as in a mount or a frame.

Deacidification: A Cautionary Account

An acid paper cannot have a long life expectancy unless it is neutralized and alkaline buffered. Provided the materials of the paper object allow it to be possible, the best way to accomplish the purpose is to introduce into the paper an alkaline substance in large enough quantity both to neutralize the present acidity and to leave a sufficient protective residue to counteract acid for an extended period. The substance, of course, must be benign to cellulose, all other paper components, and design materials. A number of chemical agents have been tried, some successfully. Among them are the hydroxides and carbonates of some of the alkaline earth metals, specifically of calcium, magnesium, and barium. They are alkaline enough to neutralize the acidity present in paper and, when exposed to the carbon dioxide of the air, they change from the hydroxides to the stable carbonates. In this form, they can reside in the paper and protect it until their effectiveness against acid becomes exhausted. ''Deacidification'' is the general term for the treatment. However, in order to make the terminology more accurate and more descriptive of the several discrete steps involved, the steps can be called: ''alkaline washing''—the use of water made slightly alkaline with such materials as calcium or magnesium hydroxide or bicarbonate; ''neutralization''—water treatment with sufficient amount of one of the alkaline substances to counteract the existing acidity; and ''alkaline buffering'' or ''alkalization''—aqueous or nonaqueous methods that add enough alkaline reserve to remain in the paper for protection against future acidity. Whether each or none of the steps is taken depends upon the purpose of the treatment and the safety of the object.

Much credit is due to the late W. J. Barrow, a document restorer of Richmond,

Virginia, for developing practical ways of using some of these compounds. His methods, dating from the 1960s, are still employed: the two-bath system, in which the first bath of calcium hydroxide is followed by one of calcium carbonate; and his spray method of magnesium bicarbonate in water to which ten percent alcohol has been added. However, his treatments require the use of water solutions and consequently could be hazardous to art on paper, and can involve lengthy processing as in the treatment of a large number of archival papers or the many pages of a book. In order to offset the difficulties encountered with aqueous techniques, other innovators have designed deacidification systems that use non-aqueous solvents, notably the barium carbonate method of A. D. Baynes-Cope, the magnesium carbonate method of Richard D. Smith and its variant of George B. Kelly, Jr. Still others, like W. H. Langwell, and more recently John C. Williams and George Kelly, have investigated the use of gaseous alkalis, establishing the so-called vapor-phase methods.[25]

For mass treatment in which many books can be treated at one time, there are presently two important methods. "The Nonaqueous Book Deacidification System" designed by Richard Smith involves immersing packed vacuum-dried books in a solution of magnesium alkoxide in methanol or ethanol and a Freon, a method that produces magnesium carbonate in the books after they have been reconditioned to normal room atmosphere. The system has been in operation at the Public Archives of Ottawa, Canada, for five years, and 150 books can be treated per day. A unit is being constructed at the Bibliothèque Nationale in Paris for use of the same method.[26]

The second method, invented by J. C. Williams and G. B. Kelly, scientists formerly of the Library of Congress, is the diethyl zinc (DEZ) method, which leaves alkali zinc carbonate in the treated material as the buffering reserve. The drawback is that the operation must be carried out under carefully controlled conditions because diethyl zinc is explosive in moisture and inflammable in air. Therefore it must be used by trained technicians in a vacuum on thoroughly dried materials. In 1982, using a large vacuum chamber at General Electric's Valley Forge Space Center, five thousand books were tested in this method. The system was found to be reasonably safe for all materials in books and book covers. It is since being perfected by the scientists of the Library of Congress in a series of smaller tests. Confidence in the success of the method is indicated by Congress's allocating funds for the construction of a specially designed building where librarians can send books in large quantities for treatment.[27]

Thus a number of different deacidification treatments have evolved. Unfortu-

nately, however, their application to works of art on paper, especially by an untrained operator, has been questioned. Although it is understood that neutralization and buffering are needed if acid papers are to be preserved for a long period, the way in which the work is to be done for art objects, if it is to be done at all, remains controversial. Carefully tested books and some archival papers do not present such numerous and complex problems. But even in these cases, the indiscriminate use of any one of the methods by an inexperienced person could be harmful because of risk to the object or the operator or, in some cases, to both. Therefore, it may be of value to the conservation technician to present a list of some of the reasons that have caused uneasiness over the use of deacidification.[28]

a. Toxicity to the operator and to the subsequent handler of the treated paper: barium carbonate (used in a nonaqueous method).

b. Toxicity to the operator, if he does the work without good ventilation and/ or a respirator with the proper filters: methyl alcohol (used in nonaqueous methods). A fumehood gives the best protection.

c. Unpleasant odors during and after treatment, and loss of buffering effects if the treated material is not kept dry: the use of amines as the agents.

d. Alkalinity too strong for the safety of the object: the immersion in an aqueous hydroxide solution and the initial hydroxide phase of nonaqueous methods.

1) The possible injury to cellulose by high alkalinity is controversial among scientists. Some believe that a fragile paper that has been very acid cannot sustain even moderately high alkalinity. Some say that cellulose may have an alkaline limit, not yet known, that should not be exceeded even for a little while. Others say that the day or two during which the agents remain hydroxides before changing to the more nearly neutral carbonates is too short a time to be harmful, and also that the time could be reduced to an hour or so by exposing the treated paper to a moist carbon dioxide atmosphere. The period of high alkalinity should be as short as possible because, as one scientist points out, paper in this state is especially prone to oxidation.

Apparently the crucial factor is not so much the degree of alkalinity but its particular source. If the source swells cellulose, as do the monovalent alkalis like the hydroxides of potassium and sodium, it is injurious. If it does not swell cellulose—and divalent alkalis like calcium and magnesium hydroxides do not—no harm should follow to cellulose.

2) Some papers, especially those containing ligneous wood pulp, have been found to darken after nonaqueous treatment.[29] The scientists generally concur that the color change is a superficial effect and not an indication of damage to the structure of the paper. The developer of a widely used nonaqueous method, magnesium methyl or ethyl carbonate, has shown by accelerated aging tests that, in the passage of time, untreated papers will not only have become increasingly weak from acidity but will have darkened more than papers that have been treated. Nevertheless, to the conservator of works of art the alteration is not desirable because the aesthetic intention of the artist or the present aspect of the picture could be injured. He continues to hope for future methods that will not darken paper.

3) Some pigments, dyes, and inks can be faded or changed in color by alkalinity. The most well known of these pigments are Prussian blue, and greens whose blue component is Prussian blue.

e. Some coatings, fillers, dyes, and sizes in paper can be softened or solubilized in water or in ethyl and methyl alcohols (all methods except DEZ).

f. The embedded particles of magnesium or calcium carbonate could abrade or otherwise injure the fibers of the paper (all methods).

g. The paper is not sufficiently buffered against future acid attacks because the technique has not introduced enough agent into the substrate (the aqueous methods).

h. Uneven spread or penetration of the agent in the paper, leaving untreated areas (all spray methods when not correctly done, especially on nonabsorbent or thick papers).[30]

Undoubtedly, it may not be possible to develop a deacidification method that will be applicable to all materials, especially considering the complexities found in the field of works of art with its great variety of design materials as well as in papers from all periods and in all kinds of condition. If the premises are accepted that no one method can be universal in its application and that meticulous, detailed testing based on training and experience are requirements before treatment, there are procedures that can be used to extend the lives of some archival and art papers. Other such papers, however acid, cannot be treated if testing shows that harm or alteration could occur. None of the methods so far available should be used by a conservation technician unless he is specifically trained or works under the careful supervision of an experienced conservator.

Assessment and Control of Acidity/Alkalinity

After a little experience, the technician, simply by knowledgeable understanding of the visible evidence, will be able to form an opinion about the degree of acidity in the papers of value that come under his control. The amount of discoloration and embrittlement are clues, as are the quality of the paper, its age, and its past treatment. Although most unbuffered papers are inclined to become acid, should they seem to retain unchanged color and resiliency they may be considered sufficiently stable. Modern ''art'' papers that may test acid but are still bright and flexible may be thought safe for the present. Papers that have darkened somewhat, especially around the edges, and show a tendency to develop edge tears are moderately acid. There usually is no mistaking the fragility that characterizes very acid papers. They are lifeless, brittle, and marked by oxidation from corrosive substances and bad housing—objects whose general condition indicates major treatment by a conservator.

The technician should have some means of assessing the acidity-alkalinity of secondary paper materials, whether those that have been in contact with the art object or those that he acquires for backing and matting, as well as for assessing the solutions he uses in treatment. The judgment is made by means of the pH scale, a scale that grades from 0 to 14. The amount of hydrogen or hydroxyl ions present is a measure of the acidity or alkalinity of a water solution or, by extension, of a water spot that penetrates into a paper's structure. The pH of the solution is its concentration of hydrogen ions, expressed in terms of the concentration's reciprocal logarithm. pH 7.0 is approximately neutral; values from 7.0 to 0 indicate increasing acidity, and those from 7.0 to 14 increasing alkalinity. The scale is logarithmic, so that pH 5.0 is ten times more acid than pH 6.0, and pH 9.0 is ten times more basic than pH 8.0. The ideal pH for paper is neutral, pH 7.0, but there is a range around neutral accepted as safe—from 6.5 to 8.5.

The commercially available acid-base indicators are recommended for the technician's assessments in preference to the laboratory instrument, the pH meter, which requires fairly exacting techniques to arrive at answers more precise than he needs. Indicators are compounds that change color by chemical reaction when near specific degrees of acidity or alkalinity. They are easy to use and quite accurate, certainly accurate enough to tell if a substance is strongly or mildly acid, neutral, or mildly or strongly alkaline. There are two forms of the indicators required for the technician's purposes: papers impregnated with compounds that permit the determination of the pH of aqueous solutions, and liquids for use on

solid materials like papers and matboards. The former comes in tapes wound on dispensing spools[31] or mounted on plastic sticks.[32] Both spools and sticks can be obtained in single units that measure broad pH ranges: 1.0 to 12.0, 0.0 to 14.0; and in sets of short ranges: 4.0 to 7.0, 5.0 to 10.0, 7.5 to 14.0. It is well to have on hand a long-range indicator in order to establish the area where more precise determination can be made by the short-range papers, and should include high alkalinity indicators because pH above 9.5 should be avoided. After an indicator has been dipped into the solution to be tested, the pH of the solution is found by matching the changed color to a calibrated colormetric chart usually mounted on the container. Sometimes the answer can be read at once, and some-times a few minutes must be allowed for the color change to be complete, especially with the indicator sticks. If the solution is carbonated, the carbonation should be allowed to go off before an accurate reading can be obtained because the presence of carbon dioxide lowers the pH of the solution.

The indicator sticks were originally developed by E. Merck of Darmstadt, Germany, and now are also made by other science laboratories. They are com-posed of one to four small squares of paper adhered to the end of a plastic stick. Each square is impregnated with a slightly different indicator mixture. Their advantage is that the dyes are chemically bonded to the paper squares so that they will not bleed onto contacting surfaces. Therefore, they can be used to test not only solutions but also papers. If the head of a stick is pressed for about fifteen minutes onto a spot on the paper that has been wet with a drop of distilled or deionized water, its color change will indicate the pH of the paper with a fair amount of accuracy. Justifiably, an operator may not want to impress a stick onto a wet spot on an important paper for fear of making an impression and a difficult-to-remove water stain. The stick indicators are of great benefit in assessing the pH of colored papers, where the response of liquid indicators will be unreadably distorted if the paper being tested has a strong tone.

I choose a liquid indicator whose color changes occur at crucial points in the pH scale. Many conservators use a convenient device called the Archivist's Pen, whose felt tip is kept saturated from a reservoir in the pen's shaft with the pH indicator, bromocresol green.[33] However, bromocresol green changes color at pH 5.2, or well below neutral. Since the pH scale is logarithmic, 5.2 is very acid, and thus an undesirable range from 5.2 to 6.5 is not detected by this liquid. A better indicator seems to be chlorophenol red (one of the compounds in the kit made by the Applied Science Laboratory[34]), which changes color just at the

acceptable range for paper safety, pH 6.6. Below 6.0, it becomes a decided yellow. Near neutral it is reddish blue, and in the alkaline zone a bright purple.

It must be kept in mind that liquid indicators act like dyes whose stains can be removed only by harsh washing or bleaching, so that they should not be used directly on valuable papers. However, if a secondary paper or mat is present that has been in long contact, a test on it may give a close approximation of the pH of the primary paper.

A major use of indicator solutions is to permit judgment of the quality of secondary materials that have been, or will be, placed in contact with papers of value. Since they should be neutral or slightly alkaline, it is a good policy to obtain samples of the stocks from which supplies are to be bought in order to test them before purchase for their pH values, as well as for other factors. The kit mentioned above (formerly prepared under the control of the W. J. Barrow Research Laboratory, now under that of the producer, John Neves of the Applied Science Laboratories) is designed to be of help in making these judgments. It contains three color-change solutions: one, phloroglucinol, detects the presence of ground wood; another, aluminon, detects alum; and the third, chlorophenol red, indicates the pH. An explanatory booklet comes with the kit. As well as avoiding materials already acid, one would refuse to buy any papers or boards containing ground wood or alum. The first has lignin, which discolors and hastens destruction by acid embrittlement; the second, aluminum sulfate, will form sulfuric acid in time.

Alkaline Washing

Although the technician is urged to leave deacidification to someone trained for the task, there may be another way in which he can benefit his museum's collection. The following suggestion is offered in light of the facts that the quantity of papers needing care is so vast and that properly trained people are so few, that some initial treatment by a technician could improve the situation. In any collection, there probably are a number of papers whose moderately acid condition and whose discolored appearance could be improved by being treated in carbonized distilled or deionized water, whether by floating or immersion. This treatment will remove water-soluble acids, and with them some of the discoloration. Although it will not neutralize the paper, it will make it less acid, thus turning back the clock, even if a little way. It leaves no buffer, of course, so that the paper will become acid again. But the return to acidity may be appreciably slowed if

the treated paper is housed in a neutral, protected environment. Often old papers seem to be rejuvenated by the aqueous treatment, probably because the fibers are swelled and the sizing is reactivated slightly, reestablishing hydrogen bonding and a more firmly locked and intermeshed formation. Floating or immersion in water comes perilously close to major treatment because many papers and design materials can be seriously damaged by wetting. The resultant injury could be far worse than the acidity. Therefore it is important that the technician stay away from trouble and restrict his attention to those objects that he has determined by examination and tests to be able to withstand the wetting. In Part II, techniques for water treatment are described and a list is given of some papers and design materials that should *not* be treated by the technician.

Acid-Free Materials

Materials that are to be used in contact with papers of value should not only be near or above neutral, but should also have contents that can ensure long endurance. Rag-fibered papers and boards have always been respected as long-lasting and of high quality. Formerly, the best were imported from Europe and were cherished by artists, collectors, and curators for safeguarding their works of art. Furthermore, if properly cared for, they rarely proved disappointing. But such rag board is not a protector against acidity because it itself can become acid. Now, by good fortune, the problem has been met by a number of paper manu-facturers who are making acid-free materials that should be lasting and protective. The papers and boards having an all-rag fiber content are still considered to be of the first quality. Second to them, however, and still to be trusted, are materials made of chemically purified wood fibers. Because of the more severe pulping and bleaching methods required in the fabrication, their long endurance may not be equal to that of buffered all-rag. However, it is a good material that some conservators use for all of their matting. Others are glad to have it for the less-precious objects, for temporary exhibit, and for secondary backings.

These materials are manufactured in conformity with some of the specifications established by W. J. Barrow for permanent/durable paper: purified wood fibers partly of alpha cellulose (the most stable of the cellulose fibers); neutral synthetic sizing, like Aquapel of the Hercules Company; and the inclusion of the buffering agent calcium carbonate sufficient to bring the pH of the paper just above neutral. The development that originated with Barrow has resulted in a series of acid-free papers and cardboards whose different weights range from bond through cover

and bristol.[35] Extended by others, it has led to acid-free paper products of all kinds—mat boards, tissue, blotter, wrapping, file folders, storage boxes and envelopes, corrugated cardboard, and so forth, thus allowing the achievement of neutral housing for many objects.

"Acid-free" is the term now well-established and widely understood. Actually there are two slightly different materials that are designated by the term. One, whether of rag or of chemically purified wood fibers, contains the alkaline buffering agent; the other does not. The latter has a neutral pH and could very gradually become acid. It is made to accommodate those objects, like photographs, that are thought not to respond favorably to alkalinity. Technically, then, the first should be defined as "buffered acid-free," the second as "unbuffered neutral" paper or board.

Again the technician is advised before making large purchases to test and examine samples of various mat boards from different companies in order to choose the ones that have the properties and contents he wants. Some mat boards have too-soft surfaces, difficult to draw, erase, or paint upon; others may not be rigid or dense enough; some may tend to warp too easily; still others may be of undesirable color. Colored mats are good for specific objects. But some colors tend to fade in light, some to offset on contacting surfaces, and some to bleed in water. The names of a number of the manufacturers and distributors of acid-free materials are given in the notes as well as in Appendix I.[36] Acquiring their catalogues is essential.

Measures against Migrant Acidity

Methods of prevention are the best weapons against acidity from external sources. As has been stated, a technician should be confident that the spaces used for paper exhibition and storage are free from gaseous pollution and dust. Second only to the protection of the work of art is the protection of the mats to which it is attached. They also should be guarded from unclean contact. It is all too common to find evidence of careless disregard of mats, causing them to be needlessly soiled, thus forcing replacement, and, if attachment is involved, the unnecessary rehandling of the important paper. A few methods devised by some art museums to protect mats from soil are described in the paragraph on matting in Part II.

In exhibition, there are three rules of thumb that should be met in all manners of display: (1) the reverse of the mat should be protected from contact with table

or wall surfaces, as by covering it with a backing sheet of acid-free paper; (2) if the picture is glazed, there should be a spacer separating the work of art from the glazing material; (3) all edges and cracks of the housing or framing should be sealed against infiltration of impurities. With ingenuity, these requirements need not injure the desired effects of display. For example, a common method of temporary exhibition is an arrangement of unframed but matted and glazed pictures held against the wall with brackets or angle hooks. The appearance of the show would not be altered and greater safety would be achieved by the use of backing papers and edge bindings of 1-inch-wide transparent plastic tape.[37]

Study collections should be equipped with a number of acid-free folders of various sizes, so that any matted picture required for study can be placed in a slightly larger folder. The student should be instructed to use it as a carrier and as a protective sheet between the mats and the surface of the table. If the object has to be handled, the user should be required to wash his hands because even though they may be clean, they are by nature oily and acid. Also, he should be supplied with an instrument such as a wooden spatula (obtainable in Japanese-art supply houses) if he needs to lift the picture in order to inspect its reverse.

Matting and framing should be reviewed as soon as possible after papers enter the collection. No paper should be allowed to remain long in dusty, unsealed frames or associated with inferior materials. If time prevents rematting immediately after a paper has been removed from old mountings, folders made of acid-free stock will keep it safe in storage until fresh matting can be accomplished.

Most museums have two kinds of framing: permanent and temporary. In the first, the papers, often the most valuable holdings, are closed in frames that are considered particularly suitable to them whether because of elegance, design, or provenance. Unfortunately, these frames are seldom opened. In the second, papers are mounted in mats of standard sizes that fit matching frames so that the same frame can be used for any number of pictures. Actually no framing, short of hermetically sealed and monitored enclosures, should be considered ''permanent,'' but should be opened periodically every five to ten years for inspection. Harmful conditions can develop in closed frames and grow in severity with time. Acid pollutants can seep in, relative humidities can become too high or too low, materials can deteriorate, adhesives can fail, insects can intrude. The most salutary life for a picture on paper is that which temporary framing can offer. As a museum object, it must spend some time on exhibit, yet its life would be prolonged if it could remain at least double that time in the darkness of clean storage. The less time it is on show, the longer it will exist to be shown.

Light

Clear and concise discussions on light—its effects and its control—are found in the excellent articles by Robert L. Feller: "Control of the Deteriorating Effects of Light upon Museum Objects" and "The Heating Effects of Illumination by Incandescent Lamps."

All other factors being under control, paper seems to live best in darkness. This may be one of the reasons why many old papers have come down to us in reasonably good condition. Until comparatively recent times, collections often were kept in books or portfolios, drawers or cabinets, and only occasionally brought into the light for viewing. Today, the all too frequent practice is very different: papers are hung on bright walls for indefinite undisturbed periods, exposed to light at uncontrolled levels.

Strong light rich in high-frequency radiation can be responsible for photochemical changes or can cause photosensitized reactions if its energy is absorbed by the molecules of any organic material. It embrittles and weakens paper by causing the breakdown of the cellulose molecule and is assisted in the destruction by oxygen and ozone, by high relative humidities and temperatures, and by organic pollutants and impurities in the paper's structure. Whether discoloration also results may depend upon factors like the combined action of heat and light or upon the constituents of the paper. For example, pure cellulose bleaches in the blue wavelengths of visible light, whereas ultraviolet radiation causes lignified cellulose to become yellow. The light that can harm paper also can cause the fading of organic design materials such as dyes and pigments in paints, pastels, crayons, and inks.[38]

Light is that part of radiant energy to which the human eye is sensitive—an extremely small part of the electromagnetic spectrum. Measured in wavelengths, the eye can see from about 400 nanometers (or millimicrons) to 760 nanometers. The part of the spectrum that is present in building interiors extends on either side of visible light from the shorter wavelengths (or higher frequencies) of near ultraviolet (360 to 400 nanometers) to the longer wavelengths (or lower frequencies) of near infrared, 760 to 1,000 nanometers. Most harmful to sensitive objects are the higher, more energetic frequencies from ultraviolet through the violet and blue-green of the visible light. But all light can be damaging, the amount of damage done depending on its intensity and the length of time of exposure. Robert Feller expresses this reciprocity principle when he says, "1,000 lux (10 lux equals 1 footcandle) of radiation for 1 hour is expected to do as much damage as 10

lux for 100 hours, because the total exposure is 1,000 lux hours.'' To quote
Nathan Stolow: ''The extent of photochemical damage will be reduced in direct
proportion to the reduction of the intensity of illumination or the time of
exposure—no matter what the light source.''[39] All scientists concerned with the
effects of light on museum objects urge that photosensitive materials like paper
(1) be shown in very low light intensities and (2) not be placed on long exhibit.

Five footcandles has been suggested repeatedly as the highest light level for
paper exposure.[40] This light will seem dim on first consideration; indeed, it may
be hard to maintain in some situations. It should be aimed for, however, and
should not be exceeded by more than a few footcandles. Probably more than any
other restriction, the limitations of light may be frustrating to the collector or
curator. To have a beautiful object and to be unable to exhibit it to its best
advantage, to realize that soft watercolors or delicate line drawings may be too
obscured by the required light levels for true appreciation, could tempt him to
take chances. Rather, the determined conservation technician will accept it as a
challenge to his ingenuity and know-how to find ways of satisfactorily exhibiting
paper with the least harmful exposure.

Control of Daylight

Daylight as transmitted by window glass contains near-ultraviolet radiation,
and its levels can be excessively high so that, should it fall on an unshielded
paper, it could do perceptible harm in a short time. Therefore, it has been found
to be beneficial to cover openings to daylight with filters or reflectors or, if
circumstances make these procedures unfeasible, to protect photosensitive ma-
terials in filtered display cases and frames. Framed works of art on paper should
be glazed with filters, especially if they are to be sent away into unknown lighting
conditions, by the use of nearly colorless filters to avoid distorting the tones. The
nearer colored filters are, the more apparent the distortion can be. A viewer
probably would not be aware that the light in a gallery enters through tinted
glazing, whereas he might be conscious of the interference if the filter were nearly
adjacent to the object he is studying. (Synthetic filters, of course, would not be
used for objects whose design could be harmed by their electrostatic properties.)

For protection against the ultraviolet (UV) component of daylight, perhaps the
most practical material is UV-absorbing rigid-acrylic sheeting, such as colorless
Plexiglas G or, better still, the slightly yellow Plexiglas UF-3.[41] The first screens
out UV radiation beyond 360 nanometers; the second absorbs even some of the
violet and blue region of visible light. The latter is available in ⅛- and ¼-inch

thicknesses, a dimension important to consider in relation to the area to be covered because the sheeting tends to sag or belly if not appropriately thick. A thickness of ¼ inch might be suitable for expanses such as windows, ⅛ inch for frames and smaller showcases. Should it be placed horizontally, as over skylights, the thinner sheeting could be used, supported on the existing glass.

Flexible UV-absorbing plastic sheeting could serve a number of purposes: as a kind of drop cloth over objects in a sunny window or, held taut, as a removable filter over windows or any expansive display not otherwise protected.[42] Such sheeting comes about sixty inches wide, clear or toned in several different shades, and is obtainable in desired lengths and thicknesses, 4 or 5 mils being considered best for museum purposes. However, its most frequent use is as roll-up window shades made by the dealer to specific sizes. The same material in width and thickness but clear in tone is made with a water-soluble adhesive on one side for bonding to glass, as to that of showcases. All the films are claimed to have good transmission of visible light, yet cut off at four hundred nanometers so that they filter out almost all UV radiation.

Among the many UV absorbers that can be obtained in powder form, those that have been found to make the most efficient filters when incorporated in the thin layer of a surface coating are the benzotriazoles, Tinuvin 327, 328, and P, available from Ciba-Geigy Corporation. In an informative article based on thorough testing of a number of the absorbers, Raymond Fontaine of the Canadian Conservation Institute states that a varnish formulated with one percent concentration of any of these powders would remove most of the incident UV when applied in a thickness of 1 mil or greater.[43] All have removal efficiencies better than eighty percent at that concentration, and all are long lasting. The choice of a particular powder would depend on its solubilities, on its suitability to the varnish, and on its innocuousness to the material of the substrate. Tinuvin P, for example, is compatible with many of the synthetic surface coatings used in museum work—polymethacrylate, polyvinyl acetate, polyesters, and cellulose esters. For application to a showcase, a spokesman at Ciba-Geigy Corporation recommends Tinuvin 328 three percent in an acrylic resin varnish. These filtering varnishes can have many valuable uses, but because an even thickness is important, their application to glass does not seem as efficient as the use of one of the sheetings. However, the coating can be applied by special techniques recommended by the manufacturer.

To reduce the intensity of daylight through windows, a number of shielding methods have been devised. Louvers are sometimes used whose degree of opening

controls the amount of light emission. The operation of the louvers can be done manually by the maintenance staff, but most effective would be electrical control by photocells. Filters are achieved by tinted glass,[44] reflectors by glass or rigid plastic that has been surfaced with a fine transparent coating of metal. Tinted glass comes in various colors as well as shades of brown and gray; the reflector, which has a mirrorlike aspect on the outside of the treated pane, comes in several metallic tones. They are formed with the reflector coating either vacuum-deposited or baked-on during manufacture.[45] As part of a double assembly with tinted or other treated glasses, they can fulfill more than one function. For instance, they are of considerable help in the control of temperature within a building because in the summer they reduce inside heat from the sun and in the winter they reduce loss of heat through the windows.[46] Glass already in place may be made light-reflecting by the application of films of flexible plastic that have been coated with metal.[47] Because of their color and metallic surfaces, which are visible on the outside, reflecting glasses have a decided effect upon the appearance of a building. They can be a dominant part of the architectural design.

Control of Artificial Light

If daylight cannot be otherwise controlled, opaque covers or curtains could be used to exclude it altogether during an exhibition of pictures on paper and reliance placed on the more easily regulated artificial lighting. For the safety of photo-sensitive objects, however, the light rays from both fluorescent and incandescent lamps have to be restricted in wavelengths and intensities.

Whether direct or diffused, light from fluorescent tubes is very satisfactory for even, general illumination, and its color can be adjusted by the use of tubes selected for their color temperatures. The very nature of this kind of lighting involves the emission of ultraviolet radiation and the portion of it near visible light is emitted into the room by the lamps. Some tubes give off more UV than others depending upon their color[48], but none should be used as unshielded, direct light sources in a museum gallery, no matter what the claim of the distributor. Fortunately, there are several kinds of proprietary plastic covers or ''sleeves'' containing UV absorbers that are designed to fit over the tubes.[49] The sleeves, like all other plastic filters, have an effective lifetime and should be checked after seven to ten years. Although some modern tubes do not emit a great deal of ultraviolet radiation, users must still rely upon filters placed on the outside of the lamps. Fluorescent lamp manufacturers are presently placing emphasis on good (daylight) color rendering.[50]

As a quite different solution to this part of the lighting problem, technicians may be able to put to use the fact that light—whatever its source—reflected from a surface painted with lead or zinc white or especially with titanium dioxide has been found to be free of UV radiation.

Incandescent lamps do not give off much radiation in the ultraviolet range. Their faults lie in the emission of infrared (IR), which can generate heat in the lighted objects by stimulating molecular activity, and in the high intensities with which they sometimes are used as spotlights. If they have to be direct light sources, they must be placed at sufficient distances and/or be of low enough wattage to avoid injury to substances like paper. Infrared reflecting glasses can be placed between the light source and the object.[51] Of great value are the lamps that, by means of built-in dichroic filters, reflect much of the infrared radiation yet permit visible rays to pass into the light beam. The parabolic aluminized reflector (PAR) is the designation of the bulb in which the dichroic filter is usually installed.[52]

A most dangerous use of strong light is during photography, whether in the gallery or in the studio. Uninstructed photographers can turn on bright beams close to objects for extended periods of time, whereas much shorter periods would suffice during the actual picture-taking while using shielded bulbs of lower wattage at greater distances for focusing. If dichroic reflecting bulbs and infrared reflecting glass are not available for the photographer's lamps, a substitute could be fiber-glass screening material that diffuses light and is heat resistant.[53] Photography by electronic flash bulbs is recommended because it avoids the heat problem, and its light level, though high, lasts but an instant.

It may be beneficial to be aware of some of the restrictions museums place on filming or televising works of art in galleries:

a. Photographing or televising crews must be limited in number and must be accompanied by a staff conservator or technician to supervise lighting and other safety measures.
b. No piece of equipment can be placed nearer the works of art than six feet; or, if a piece of equipment is higher than six feet, it should be placed a little farther away than its height.
c. Lighting equipment is limited to two lamps per crew, and the lamps must be shielded by IR filters.
d. The periods of lighting of a work of art must be limited to five minutes, followed by intervals of off-lights.

e. The temperature of the surface of the object must not increase more than nine degrees and that of the room no more than five degrees.

f. Works of art must be touched only by authorized museum staff members.

g. There must be no smoking, eating, or drinking in the galleries.

Monitoring Light

Lighting for a museum gallery is a complex field. Therefore if a new system is planned or the existing one is to be revised, a well-informed lighting engineer should be consulted.[54] His knowledge is needed on the kinds, arrangements, and uses of the different sources of light and on their relationships to one another, to the room, to the objects, and to the comfort of the visitor. There are so many considerations: the general lighting should be uniform yet of such a level that objects, like paper, can have focused light no stronger than conservation demands; the avoidance of glare or of the too obvious presence of the light fixtures, and so forth. Visitors react well if there are windows in the room because windows allow them to orient themselves and feel less strange. But windows must be positioned or treated so as not to be disturbing bright spots that conflict with the viewing of the display.

For particular arrangements, the conservation technician should be able to judge the quality of light that strikes the objects he plans to put on display—whether there is present ultraviolet radiation from windows or fluorescent tubes and whether the levels of visible light are acceptable. An instrument that can accomplish both measurements is the fairly expensive UV-visible photometer IL 1351 by International Light.[55] A visible light meter that is particularly well suited for monitoring light is the Gossen Panlux Electronic Footcandle Meter, which is corrected for the cosine error of light falling obliquely on the object. It is sensitive to very low light levels and measures intensities from .05 to 12,000 footcandles. One of its advantages is the separate light sensor, or probe, attached by a cord to the meter so that the operator can place it in the position of the object for incident light reading without fear of casting shadows. Gossen's Ultra Pro is considered a highly refined and accurate photographer's meter. It has many advantages, including a switch that permits readings in footcandles. There are some photographer's meters, like Gossen's Luna Lux or Luna Pro SBC, that have conversions of the exposure scale into footcandles printed on their casings.

Measuring intensities by reflected light is not a simple procedure, particularly for three-dimensional objects, where the waverings of the needle in response to light from complex surfaces can be confusing. For two-dimensional objects, the

problem is not so great. If the white side of a photographer's neutral test card is placed in the position to be occupied by a paper, and if the maximum reading is taken by a meter rotated reasonably close to it at an angle to receive the reflected light of the strongest source, a good estimate can be formed of the levels in which the valuable paper is to be placed.

To determine if incandescent lamps are throwing out heat, a thermometer placed in the position of the object will be revealing. If the temperature rises more than three or four degrees, either the lamps should be moved farther away or dimmers or infrared filters placed in the light beams.[56]

It is difficult to know how the dyes of paints and the tones of inks will react to light during moderate periods of exposure. If a work of art or a document with paints or inks is to be sent off on loan for exhibition, it can be monitored by a matching procedure using the removable swatches of the comprehensive color charts in *The Munsell Book of Colors*[57] and a record made of some of the tones most likely to fade. The picture is designated as being light sensitive should any alteration be noticed upon its return.

An alternative method, more suitable if an object is to be exposed for a period of time in the owning museum, is the use of the British Blue-Wool Standards (BS 1006:1971 or the International Standards Organization ISO R105). The standards are a series of wool strips with dyings that fade at known rates, arranged on a card so that the lowest, or most fugitive, fades twice as fast as no. 2, no. 2 twice as fast as no. 3, and so on until no. 8, the most light-fast. A card can be placed beside the exposed object and both watched for fading. Of course, if any is noticed in the object, it is removed from exposure and its sensitivity assessed according to the fading of the standards. Dr. Feller has designated those materials that show alteration similar to any of the standard blue wool-strip numbers 1 to 3 as light unstable, those that respond to strip numbers 3 to 6 as intermediately sensitive, and those that respond to the standard strip 6 or greater as stable in light.[58]

Methods of Display for Limiting Exposure

There are several display procedures that are worth consideration. One of the most valuable is based on the adaptability of the eye to light levels. If the general lighting of a room is kept low and fairly uniform without spots of brightness, and if the eye has been conditioned by lowish levels in the preceding rooms, an intensity of five footcandles will furnish sufficient illumination for the general visitor. Furthermore, objects seem bright if lighted at a level somewhat higher

than their surroundings although actually sustaining low light levels. Another interesting fact is that, at low levels, warm light apparently seems more natural to people than cool, and therefore more acceptable. When warm light is kept low, there are fewer complaints about dimness than are received if cool light is used at the same levels.

The length of time of exposure to light can be controlled in a number of ways now long in practice by museums that own precious light-sensitive papers and cloths. No such object is put on constant display, the duration of its exposure being reduced according to its degree of sensitivity. Very valuable and fragile things are shown only a few weeks out of the year, as are precious scrolls in Japan and garments at the Metropolitan Museum of Art. Sometimes the most cherished artifacts are represented by reproductions and the originals shown only on request. During display, exposures can be reduced by such devices as timed switches, either at the room entrance or at a particular exhibit, so that the lights go out when no visitor is present; or sheltering curtains over cases or frames that must be drawn aside and replaced by the observer or by the museum guard. A practical method for temporary exhibition is the use of standard-size frames, already mentioned, which permit the interchange of papers, framed for exhibition and unframed for storage; or the use of display cases in which unframed objects are arranged for short periods.

Biological Enemies[59]

Mold

The molds with which the conservation technician has to contend are, like mildews, *saprophytic* fungi—that is, fungi that thrive on nonliving organic matter. They grow on almost any material that can offer moisture and organic nutrients: paper, leather, adhesives, food residues, sooty dust, and so forth. It has been said with little exaggeration that a greasy thumbprint can be a banquet. Their usual structure is composed of the vegetative *mycelium*, a network of rootlike threads (*hyphae*) that spread on or through the host material, and the above-surface bushy growth containing the fruiting bodies or spores. Most mold spores are extremely small and are capable of being airborne. Indeed, they seem to be omnipresent and apparently can remain inactive for long periods, ready to flourish when conditions become proper for growth: damp, still air in quiet places. Mme F. Flieder suggests a way of assessing the amount of contamination in the air of any room: open lidded saucers (such as covered petri dishes) containing a mold

nutrient (like maltose-agar) and place them in different positions in the room. Close the dishes after fifteen or twenty minutes, and then try to grow the molds in the dishes after placing them in a moist but sterile atmosphere (as under a disinfected bell jar) for two or three weeks. Growth from one or two spots of inoculation can be considered normal. But if there is growth of several different kinds of mold from a number of spots, a potentially serious situation could exist.[60]

Molds damage paper by hydrolysis, the chemical reaction of a substance like paper with water causing decomposition. They destroy the sizing and often cause patches of very persistent discoloration. The reddish brown freckle-like staining of paper called *foxing* is considered a fungal infection. Although it does not have the furry growth visible to the eye of the usual molds found in paper, it has other characteristics: hyphae and spores that can be seen under the microscope, fluorescence under UV radiation; and is a cause of acidity and loss of sizing in the substrate. Foxing has been the subject of interesting controversy. Some investigators believe it to be the result of chemical reactions between iron salts in the paper and organic acids released by fungi. Others do not find that iron salts or particles are always involved; they tend to think that decomposition products of cellulose have settled in the spots made spongy by the action of fungi and the spots have then darkened with time and dampness.[61]

In an environment of relative humidity below seventy percent, the moisture content of paper, as well as that of associated materials, is too low to permit growth of the kinds of fungi that live on these substances.[62] This fact is a primary weapon for the technician, since, with a certain amount of diligent care under normal conditions, he can contrive to keep paper in humidities below this level.[63] Other preventive measures of the highest importance are periodic inspections, strict cleanliness, and the avoidance of areas of damp, still air, which can exist in many out-of-the-way places such as shelving against outside basement walls or in closed unattended cabinets. Moving air can retard the development of mold by evaporating the encircling wetness created by its hyphae and needed for further growth. The placement of gently moving fans near the walls and close to the floors in unconditioned areas would be beneficial. Although active mold can be stopped from growth by putting the host material into conditions of controlled temperature and humidity, it will not be killed and will remain latent in the substrate. It even may be that all paper objects contain resident spores.

Without thorough housekeeping, molding objects are bound to occur, as in a museum where caches of paper may have been forgotten, left by staff members of the past. There are also those papers just entering the collection, often in dirty,

broken containers whose appearance and musty odor warn that contamination may be present. Storm, accident, and malfunctioning of the conditioning system can permit mold to flourish in an alarmingly short time. The conservation technician, therefore, must have a program for dealing with infected objects.

Control of Mold

Papers that have lived under mold-growing conditions can be thought of as having been exposed to disease and should be treated according to the apparent symptoms. Those that have no indications of fungal attack simply can be placed and kept in an atmosphere that will prevent mold from developing. The avoidance of the use of even mild pesticidal chemicals and fumigants is a fairly recent and quite logical approach to the problem. It is based on the opinions of some scientists and conservators who believe that because the air is filled with spores and because the fumigants have no residual effect and indeed may not have killed all the spores in the treated papers, the objects will be recontaminated after leaving the disinfecting chamber. They advocate the following methods: persistent control of the relative humidity, especially in unconditioned areas, so that wherever books and papers are kept the RH should not rise above sixty percent at the most; below-level walls and basement floors sealed against penetration of dampness from the outside; upper-story vents and fans used to pull air through the building; prevention of moisture from such sources as open doors and windows, interior decorative fountains, plantings, and so on. This approach has the great added advantage of protecting the operator from exposure to the toxic fumes of the gases.

As yet there is no safe treatment used directly on paper that leaves a residual effect. If, then, treated material is returned to the same damp and undisturbed conditions from which it was taken, mold will certainly grow.

On the other hand, if active growth is found on papers, clearly apparent by the presence of hairy spots of mycelia, and affirmed by fluorescence under ultraviolet radiation, most conservators and technicians will want to kill off as much of it as possible before removing the growth and preparing the papers for the collection. If the attack is serious and widespread, usually the result of a disaster, the aid of an experienced conservator, entomologist, or certified exterminator should be sought at once.

For localized incidents confined to a reasonable number of papers, the technician should have available some kind of disinfecting chamber where mild fumigants can be used. A suggested construction of such a sealed chamber is shown in Figure 4. Based on the recommendations of the Center for Occupational

Hazards, it is equipped with an exhaust system to clear the air before the treated material is removed.[64] It should be placed in a room of its own, away from the concourse of people, and the exhaust system should be so arranged that its operation will not interfere in any way with the systems of the rest of the building. In it is placed a source of low heat from 15- to 20-watt electric light bulbs in order to stimulate the emission of fungicidal fumes by volatilizing crystals placed in dishes above the bulbs. The crystals of either thymol (methyl isopropyl phenol) or orthophenyl phenol (OPP) can be used for the purpose. Thymol has been the traditional material for disinfecting papers. But recently OPP is preferred because it has been found to be more effective against mold and less toxic to man. Details about the use of this chamber will be given in Part II.

A simpler method of fumigation if only a very few papers or books are involved and if a chamber is unavailable is the homemade sealed container with troughs of folded cardboard to hold crystals of naphthalene or paradichlorobenzine (PDB) away from direct contact with the papers of value. Thin tissue laid over the papers would protect them should the vapors tend to recrystallize. The container can be a suitably sized, thoroughly dry cardboard box wrapped in an airtight bag of polyethylene, a plastic that does not soften in the fumigants. Three to four weeks is required for an effective cure. It is advisable not to use PDB, the less toxic of the two chemicals, for colored objects—such as watercolors and pastels—because they could be bleached by the chlorine gas released from this material.

During the use of all of these substances (thymol, OPP, PDB, naphthalene), the operator must keep his personal well-being constantly in mind: avoid inhalation of the vapors; avoid putting contaminated hands near eyes, nose, and mouth; avoid long exposure; use protective neoprene or nitril gloves and safety goggles. After treatment, open the container in a fumehood or in a well-ventilated area, or even outdoors. All these chemicals are eye irritants and, with the exception of OPP, can be absorbed through the skin.

Insects

The technician is advised to have as a basic reference *Pest Control in Museums: A Status Report (1980)*, a book that he will want to consult repeatedly. Also, he should obtain a copy of Thomas Parker's concise and helpful paper *Integrated Pest Management for Libraries*. Parker is an entomologist who has worked for many years on the problems faced by libraries and museums. In his paper, he describes and illustrates the insects and rodents that harm paper and paper products, giving in detail their physical appearances, life cycles, and habitats, con-

cluding with the best and safest methods of control. His philosophy is that no single system can be used to prevent and destroy all kinds of pests; rather, that a combination of various approaches can be most effective. He turns his attention to the building itself, enumerating ways of barricading it against the intrusion of flying and crawling insects as well as of rodents: installing well-fitting screens; placing rubber flanges on the bottoms of doors; removing vines from the walls and leafy debris near the foundation; sealing and caulking cracks and small openings as around windows and pipe fittings; keeping lights that attract bugs at a distance from the building. For control in the interior, his emphasis is upon vigilance, particularly in areas where insects and rodents could establish habitats according to their natures, by carefully vacuum cleaning these areas and the approaches to them. He advocates the use of insect and rodent traps and other pesticidal procedures of minimal harm to the knowledgeable technician.

Many insects seek conditions similar to those favored by fungi, such as undisturbed damp places of still air. Almost all prefer the dark. The following insects are among the most destructive of those that thrive on the constituents of paper and book bindings:

1. Bookworms, white or pale yellow wormlike larvae of the ''drugstore'' beetle and of the ''cigaret'' beetle, eat the glue of the bindings and covers of books. When they become adults, they emerge, leaving small round holes filled with book powder. The presence of the powder is evidence of active infestation. If the holes are empty, they were probably made during a past attack. In this case, the book needs no treatment.

2. The starch- and protein-loving silverfish, or bristletail, a common pest, is found in papers, books, wallpapers, and dry walls. They are small, wingless insects characterized by three long bristles protruding from their posteriors. Their damage is recognizable by their habit of eating completely through the paper in some places and only partly through in others. They tend to concentrate on undesigned areas of prints and watercolors.

3. Several kinds of cockroaches, large, strong insects that prefer starchy materials, carry out their very destructive attacks during the night, leaving behind roughly eaten ragged edges of paper and cardboard and sometimes smeary excrement.

4. Book lice are tiny blond insects that can exist in vast numbers if allowed to propagate undisturbed. Fortunately, they do no harm to paper or books,

getting their nourishment from microscopic mold. Their presence can be considered an indication of dampness in the affected objects.

5. The common fly does not actually find nourishment in components of paper, but does seek sheltered places, as in stored books and framed artworks, leaving behind scattered dark droppings that are acid and corrosive.

6. Then there is the extremely destructive house mouse, gnawing its way through piles of unattended papers and books during the night. Evidently, mice establish home ranges from which they venture only in twelve-foot circuits. Therefore, their nests can be located by the concentration of droppings.

Insect Control

Cleanliness, prevention of damp areas, and periodic inspections again are of the greatest importance, thus reducing the need for poisonous chemicals and vapors. Until recently, museums and libraries confidently resorted to sealed vacuum chambers into which strong pesticidal gases were introduced, gases such as ethylene oxide and methyl bromide. Upon completion of the treatment, the gases were exhausted into the outside air, and, after a number of cycles of fresh air alternating with renewed vacuum, the objects were removed from the chamber and put back into use. Now such activity has been stopped in most institutions, largely because of the strong emphasis placed upon the toxicity of the fumigants. According to today's regulations, the level of ethylene oxide permitted into room air is one part per million. Only the most modern and expensive chambers can meet the requirements: perfect seals, monitored entry rooms with their own duct and air systems, exhausts into the outside air situated well away from all vents into the resident building and into neighboring buildings even after the vapors have been made innocuous by chemical change before exhausting, the operators furnished with protective garments and telltale badges to gauge the amount of exposure.[65] Another major concern is the so-called outgasing from the treated objects. Research is planned at the Library of Congress, using their new chamber, to determine the rates at which the fumigants leave many different kinds of materials. Already it is known that leather objects give off ethylene oxide vapors for weeks after treatment. Furthermore, the effects of the gases upon the components of the objects have yet to be determined.

If infestation is discovered, action must be taken without delay.[66] What kind of action depends upon the severity of the attack, how widespread it is, what

types of insects are involved, and whether the affected spaces and objects are used by human beings. A severe attack, which could require room fumigation or extensive spraying of insecticides, should be referred to a certified professional operator, who by his experience and training can assure that his treatments will not harm either people or paper. If a considerable number of portable objects is involved that could be cured most quickly and thoroughly in a modern fumigation chamber or freezer (see below), the technician should find the locations of such facilities whose use could be placed at his services.

A fairly new method of mass treatment that is safe for both objects and people is the deep-freeze technique, first developed for books at the Beinecke Library of Yale University, where it has been in use since 1977. The procedure is to wrap the books, whose moisture content has been stabilized, in plastic bags, and to place them in a freezer at $-20°$ F ($-29°$ C) for three days. The bagged material is brought back into room temperature and left unopened for a day or so to prevent condensation on the objects. The treatment has been found to be effective in killing insects, their eggs, and larvae.[67] The method has attracted considerable interest among librarians and research scientists, and Richard Smith has fashioned a freezer that is commercially available.[68]

Another convenient and safe method has been suggested by Parker to be used for emergencies in remote locations. It is to place infected papers and books in an ordinary household oven for three hours at its lowest temperature setting that should be no higher than $140°$ F ($60°$ C). To prevent the material from drying out during treatment, he suggests that a small pan of water be included in the oven. He has found that all phases of insects have been killed in this way.

For less serious infestations of household bugs, there are a number of chemicals and proprietary mixtures available to the technician.[69] He must conscientiously adhere to the rules for use, which by federal requirements are printed on the containers.

1. Baygon (phenyl methyl carbamate) acts as a contact poison. It can kill silverfish, spiders, and roaches by spraying directly on the insects, on their tracks, and on infested places.
 Caution: The spray pesticides should not be sprayed into the air because most of them contain petroleum distillate, which could leave oily spots on books and papers.
2. 2% Baygon Cockroach Bait is made of two percent baygon in bran mixed

with molasses. This bait, which looks like sawdust, is applied sparingly to infested areas.

3. Insecticidal glue boards or sticky traps can be placed where silverfish are a problem. They are effective also for any insect that crawls over them, such as for boring beetles and cockroaches.

 Note: To aid the specialist so that he may know the locations and kinds of infestations with which he may have to deal, the building staff should accumulate all pertinent data and physical evidence, including dead insects.

4. Insecticidal dusts, such as finely powdered silica gel combined with pyrethrum, may be placed in void spaces below bookshelves and cabinets. Silica gel is a desiccant and kills by drying out insects. The dust should be spread on a paper that can be withdrawn periodically to remove the dead insects that otherwise would form food for boring beetles.

5. Very effective are insecticidal resin strips, such as the No-Pest Strip, which contain Vapona (dichlorovinyl dimethyl phosphate). The strip is best used in closed, confined spaces—cabinets, vaults, small storage rooms. There the vapors from one strip can protect one thousand cubic feet of space for three to four months.

6. Paradichlorobenzine crystals in a tightly closed space or in a box covered with polyethylene can kill silverfish and book lice. The recommended dosage is one pound per one hundred cubic feet for fourteen days.

7. Pyrethrin, a derivation from pyrethrum flowers (chrysanthemums), is one of the least toxic pesticides. It is most effective as direct hits on crawling insects (silverfish and roaches). It forms the ''knock-out'' part of insecticidal dusts made of finely powdered silica gel (see 4, above).

Never use a poisoned bait for mice. They may die in the walls or other inaccessible places where they will provide food for boring beetles and even for other mice. There are a number of mouse traps on the market besides the spring type, such as Mouse-Pruf II by d-Con Company.

Toxicity and Safety

In the last decade, the effects upon the human body of materials used by man in his various occupations have been explored more carefully than ever before. The investigations have established that many of these materials are injurious to the

extent that some should not be used at all, and others used only with caution, proper protection, and obedience to limiting regulations. To protect the climate and the land, the Environmental Protection Agency constantly issues directions about toxic chemicals to cooperative services that are required by law to be in every state. Often the service is vested in the agriculture or entomology department of the state university. For the direct protection of the working individual, the Occupational Safety and Health Act (OSHA) has established safety and health standards to be exercised in the workplace and the laboratory. The National Institute of Occupational Safety and Health (NIOSH), an agency of the federal Department of Health and Human Services, issues publications based on research about suspect materials and investigates the safety of questioned premises.[70]

Many of the materials that the conservation technician uses are toxic in varying degrees—solvents, pesticides and their solvent carriers, synthetic adhesives, paint media, powdery pigment particles, and so on. Toxic materials can enter the body in three principle ways: (1) by skin contact that can damage the skin and penetrate to enter into the blood stream; (2) by inhalation that damages the lungs and enters the blood stream through the lungs; (3) by ingestion, whether accidental or during eating, drinking, or smoking in the laboratory. He must learn what effects each substance has upon the human body and how to protect himself against them. The informed person equipped with protective clothing and devices and working in a well-ventilated area can use these substances safely without fear.[71]

There are a number of valuable reference books available. If the technician has no other, he should have a copy of the *Merck Chemical Index*. Beside listing the formulas and characteristics of most chemicals, it describes toxic effects and gives antidotes should exposure occur. *Artists Beware* by Michael McCann has become a kind of handbook for conservators as well as for artists. Another good reference work is *Safety and Health in the Paper Conservation Laboratory*, Volumes 5 and 6 of *The Paper Conservator*. The titles of some of its chapters are "Fire Protection in the Laboratory/Workshop," "Storage and Disposal of Toxic and Inflammable Materials," and "Local Exhaust Ventilation: Fume Cupboard Specifications." The Center for Occupational Hazards publishes many short pamphlets on the protection of health in a laboratory. A list of the pamphlets may be obtained through the Center.

Factors Harmful to Paper: A Summary

Light

The region of the electromagnetic spectrum admitted into interiors by window glass is the visible wavelengths (400–760 nanometers), plus the invisible near ultraviolet (320–400 nanometers), and the near infrared (760–1,000 nanometers). UV is also emitted by fluorescent lamps, and infrared is emitted by incandescent lamps. UV is damaging to paper because of the destructive energy of its high frequencies, and IR because of its radiant heating effect.

Light acts in conjunction with oxygen and moisture in the air and with pollutants to break up the cellulose molecule by photochemical reaction, causing fading, embrittlement, and sometimes discoloration.

Control
A. Control of intensity of exposure (measured in footcandles) and time of exposure (hours).
 Means
 1. Avoidance of high intensities of any kind of lighting (optimum level of illumination on paper is five footcandles).
 2. In exhibition, reliance placed on adaptability of the eye by gradual introduction to dim lighting and elimination of bright spots in exhibition room; use of apparent brightness of the object by making it a little lighter than background; use of warm lighting rather than cool at low levels.
 3. Reduction of levels of daylight by use of window louvers, curtains, filters (tinted glass, reflecting glass, reflecting plastics), and so forth.
 4. Reduction of artificial light levels by lowering the voltage and/or reducing the number of lamps and/or increasing the distance between the light and

the object; by the use of diffusers or "wall washers" or other indirect lighting.

 5. Avoidance of long exposures.
 Devices for Measuring Light Intensity
 1. Footcandle meters
 2. Photometers, UV and visible
 3. Photographer's light meters

B. Limitation of range of radiation that strikes upon paper objects.
 Means
 1. Removal of ultraviolet rays from daylight sources and fluorescent tubes by UV filters (usually flexible or rigid plastics) over windows, skylights, fluorescent tubes, and glazing of cases and frames.
 2. Reduction of infrared rays from daylight and from spotlights, or any strong incandescent lamp, by IR-reflecting or IR-absorbing coatings on glass or by multilayered interference film reflectors placed between light source and object; use of dichroic bulbs; use of fans to circulate air and reduce heat, as in a showcase.
 Monitoring Devices
 1. UV monitors
 2. Thermometers
 3. IR-sensing thermometers

C. Elimination of oxygen and other injurious gases.
 Means
 1. Use of hermetically sealed containers filled with an inert gas: argon, helium, or nitrogen.

Acid

Acidic conditions in paper destroy the cellulose molecule by catalyzing hydrolysis to cause degradation and embrittlement.

Sources

A. Inherent in paper: sizes, inks, and dyes; residual chemicals (e.g., bleaches); residual "impure" raw materials (e.g., lignin); factors of deteriorating processes (e.g., oxycelluloses, hydroperoxides).

B. Transmitted: from prolonged contact with acid materials—wood, ground-wood pulp paper or cardboard, unstable plastics, acid adhesives; from handling, and lack of care.

C. Environment: oxides of nitrogen from car exhausts (oxidizing acids leading to ozone and peroxides); oxides of sulfur from heating and industrial fuels (reducing acids leading to sulfuric acid). Other polluting gases less common or less dangerous to paper—hydrogen sulfide from tidal flats, marshland, and rubber products; hydrochloric acids present in salt sea air; random acids in interiors.

Controls

1. The only control for inherent acid in paper is by deacidification, a process not recommended to the conservation technician for works of art on paper.
2. Avoidance of transmitted acids by housing papers in neutral atmospheres and in contact with clean, acid-free materials.
3. Avoidance of unnecessary handling.
4. Avoidance of danger of putting mineral salts into papers during treatment by using distilled or deionized water for the wash water. To make the water more beneficial by adding a small percentage of calcium or magnesium bicarbonate.
5. Acids from outside the building excluded by some form of air filtering and cleansing at the air intakes, as in use of alkaline sprays and activated charcoal filters, and from the interior by control of fumes from furnace or other fossil-fuel burners.
6. In enclosures such as showcases, avoidance of natural or synthetic rubber products, especially with papers that have designs in metal point or white lead, or avoidance of any material that could injure other materials by vapor or contact.

Monitoring Devices

1. For atmospheric acids: chemical tests, pollution test kits, information from local Environment Protection Agency.
2. For the acidity of papers, paste, and aqueous baths: pH meter, different kinds of acid-base color-change indicators.
3. For presence of acid-producing factors in papers: color-change indicators, such as for groundwood, alum, or rosin.

Relative Humidity

RH is the amount of water vapor actually in a volume of air, expressed as a percentage of the total water vapor the same air could hold at the same temperature. Paper is a hygroscopic material that has a moisture content under normal circumstances of six to seven percent.

High RH causes the growth of mold, which destroys cellulose and sizes, and aids in hydration of cellulose and in photosensitized reactions. Low RH causes embrittlement, so that a paper cannot be flexed when dry without the possibility of injury to the fibers.

Fluctuating RH causes damage by "exercising" hygroscopic materials, making them swell in high RH and contract in low.

Control

A. Maintaining the temperature and the moisture vapor content of the air as evenly as possible. For the sake of all hygroscopic objects in a museum, the RH should be kept between forty and sixty percent. For the sake of paper alone, it would be better between forty and fifty percent.

Means

1. Use of air-conditioning and/or humidifiers and dehumidifiers.
2. Use of conditioned desorbent/absorbent materials such as cloths, papers, and silica gel, within tightly closed cases.

Measuring Devices

1. Psychrometers
2. Hygrometers
3. Recording hygrothermographs
4. Dial hygrometers
5. Cobalt-salt-impregnated indicators

Temperature

Changes in temperature cause corresponding changes in relative humidity. Under normal circumstances, a rise in temperature produces a fall in RH and vice versa. High temperatures aid in speeding up chemical reactions. (A rule of thumb among chemists: For every 10°C rise in temperature, the rate of reaction is doubled.) A sudden drop to low temperatures can cause condensation. Localized high temperature can cause drying conditions within that area, such as in a showcase heated by exhibition lamps. Especially with low RH, high temperatures can cause yellowing and embrittlement.

Control

A. Maintaining the temperature as evenly as possible throughout the twenty-four hours of the day, all through the year.

Means
1. Use of air-conditioning and/or window units in summer; use of automatic thermal switches to control louvers in skylights or windows.
2. Use of fans and other air-circulating devices.
3. Avoidance of cold surfaces such as outside walls, and of surfaces heated by sunlight or artificial lighting.
4. Keeping temperatures as low as is consistent with human comfort.

Measuring Devices
1. Thermometers
2. Recording thermographs

Pests

A. Mold spores are omnipresent and will grow in or on nearly every substance. Those that are found on paper usually do not grow if the RH held by the ambient air near the paper is below seventy percent. They will flourish increasingly as the RH goes from seventy percent to one hundred percent. Mold seems to grow more rapidly in saturated, still, warm air than in saturated, moving, cool air. It destroys cellulose and size, increases acidity and local RH, and sometimes causes deep discoloration.
B. Most of the insects that harm paper objects prefer still, damp, undisturbed, dark conditions where their nutrients are available: grease, proteins, carbohydrates, water, and so on.

Control
A. For both mold and insects: strict cleanliness; constant vigilance; periodic inspection; prevention of still, damp air.
B. For mold: keeping RH below sixty-five percent; prevention of growth during a period of emergency by placing saturated papers in refrigeration around -5°F until they can be further treated.

Means
1. For mold: Removal of affected object to drier moving air where mold cannot grow. Use of fumigating chambers with vapors of o-phenyl phenol for six days; or fumigating boxes (sealed container holding trough of crystals of naphthalene or paradichlorobenzene) for three weeks.
2. For insects: Removal of termite-infested building materials and associated

passageways, and reconstruction with treated materials. Sealing all openings and cracks above or below ground to prevent entrance of insects. Use of insecticidal dusts, traps, and resin strips (such as No-Pest Strips). Painting the backs and undersides of shelves with a residual insecticide. Use of services of professional certified operator.

PART II

Procedures

In order to strengthen the plea that the conservation technician take a wise and cautious approach to the actual handling of papers of value, two statements may be in order, quoted from the *Code of Ethics* of the American Institute for Conservation of Historic and Artistic Works (AIC). Although the statements are addressed to the trained conservator, the technician can be inspired and guided by them: "All professional actions of the conservator are governed by unswerving respect for the esthetic, historic and physical integrity of the object." And: "It is the conservator's responsibility to undertake the investigation or treatment of an historic or artistic work only within the limits of his professional competence and facilities."

To persuade the technician to become a member of AIC is not the purpose of this book. However, associate membership, a category open to him, would have advantages: knowledge of the field, its principles, practices, and advances; receipt of valuable publications covering all phases of conservation, especially those issued by the Book and Paper Group of AIC; meeting with and getting to know established conservators both at the annual meeting of AIC and at meetings of one of the smaller satellite groups that have sprung up in many big cities all over the country. Whatever he may decide upon this matter, his primary goal should be to establish an association with a conservator who is willing to be his counselor and guide.

Some suggested procedures are outlined in this section that are not meant to be considered exacting or fixed. They are intended to show how a work of art on paper can be handled safely, how some minor weaknesses in its structure can be corrected, and how housings can be formed that, it is hoped, are protective enough to slow the tendency toward decomposition of all organic substances. There are objects for which some of the methods must be modified or not used

at all. Unless he is directly aided by a conservator, the technician should not undertake any treatment that could lead him into problems beyond his control—treatments such as extensive mending and patching; compensation for losses in the design; handling of difficult papers like tissues, laminated or impressed papers, or papers larger than his equipment can accommodate; deacidification; bleaching; and so forth.

The paper upon which the design is drawn, printed, or painted is referred to as the *support*. The secondary paper or cardboard, if allover attached, is called the *mount*; if unattached or locally attached, the *mat* or *backmat*. By *backing*, as in *backing materials*, is meant unattached papers or cardboards placed behind the backmat in framing.

5

Receipt and Examination of a Work on Paper

Receipt Form

Museums, historical societies, galleries, or any institutions that temporarily receive valuable property of outside ownership design their own receipt forms, often with legal help. The wording may differ, but the basic purport of the forms, duly signed and dated by the owners or authorized agents, is to protect the institutions from blame or liability should the deposited property be lost or damaged during the stay. Usually a form describes the object, gives the reasons for its admittance, and accepts the owner's evaluation and his insurance coverage. At the bottom or on the reverse, space is allowed for the date the object left the premises, also duly signed, returned in the hands of the responsible person who brought it. An example of such a form is given in Exhibit A.

If the organization for whom the technician works does not have a receipt form, he should make up one himself, primarily for his own protection and as an aid in keeping accurate records of the objects he has treated and released. There have been instances of serious trouble when a valuable artwork had been lost and the institution that held it failed to note its return.

Examination

The technician should make as thorough an examination as his equipment allows and should begin to record his observations even before he starts to handle the object, first noticing the condition of the housing or packaging as it is when it comes to his attention. In the examination of the work itself, the aims are: (1) to establish and to record as accurately as possible what materials it is made of, including the identification of those not original; (2) to establish and record their

Exhibit A

RECEIPT FORM AND AUTHORIZATION FOR EXAMINATION
AND POSSIBLE CONSERVATION TREATMENT

OBJECT(S):

OWNER'S NAME AND ADDRESS:

OBJECT(S) INSURED BY OWNER?
 DURING TRANSIT?
 DURING ABSENCE FROM OWNER'S PREMISES?

OWNER'S ESTIMATED VALUE:

DELIVERED BY:

RECEIVED BY: DATE:

REASONS FOR OBJECT(S) BEING SUBMITTED FOR CONSIDERATION:

AGREEMENT WITH CONSERVATOR:

 I, the owner or authorized agent of owning institution,
assume the sole responsibility for the object(s) deposited by
me in the custody of , including arranging for
insurance coverage.
 I understand and agree that any object deposited by me
with is deposited at my own risk as to possible
loss thereof or damage thereto resulting from work performed
upon it or from fire, flood or other unavoidable accident.

SIGNATURE OF OWNER OR AUTHORIZED AGENT OF OWNING INSTITUTION:

DATE:_____

TO BE SIGNED WHEN THE OBJECT(S) IS RETURNED TO THE OWNER.

RECEIVED BY:

SIGNATURE OF THE OWNER OR AUTHORIZED AGENT OF OWNING
INSTITUTION:

DATE: _____

conditions; and (3) on the basis of the finds, to determine what corrective measures, if any, should be taken. If defects are present, the technician must decide whether they can be stabilized by treatment in his workroom or whether they are of a nature requiring the attention of a conservator.

Examination Form

The technician should develop an examination form that satisfies him and meets the requirements of his museum or workshop. As an example to aid him, the form given in Exhibit B is described below. It is one actually in use in a con-

servation laboratory and therefore may be more detailed than he wants, but it suggests the kind of scrutiny into materials and conditions that is required if an object is to be seriously treated. This form is a four-page folder, a convenient arrangement that permits associated papers and photographs to be held within it.

Page one

The principal purpose of this page is to identify the particular object and to describe the character and condition of its housing. Distinguishing marks, if present, can help in exact identification. Whether they are accidental marks (imperfections in the paper's manufacture or in the printing plate) or deliberate marks (artist's signature or collector's mark), they can differentiate the object being examined from any other.

Page two

Here the materials of which the object is composed are described, exclusive of their condition. It is as detailed as time permits and need requires. An object of value and/or one that needs treatment and/or one made of unfamiliar materials receives more attention than one in good condition made of almost certainly known materials. If technical identifications are not made by tests or analyses, however, the statements are modified by the word *estimated*.

An important bit of information on this page should be the effects, determined by tests, of any agent that might be used in treatment upon the design materials and upon the sizing and color of the paper. Sometimes, especially for modern works of art, this is the only information upon which to make decisions. The materials could be of unknown character, except in their reactions to water or other solvents or to manipulation. On this page, there is also space to enter observations of factors not apparent except by high magnification or the use of laboratory instruments and techniques.

Page three

On this page, details about condition are given. Under the first entry, *Weakness of Materials*, assessment is made of the acidity, the brittleness, or the limpness of the paper or of an inherent tendency toward failure of the design materials. In the assessment of acidity, indicator dyes are not used on the paper of value. Usually the color of the paper and evidence of weakness is testimony enough of acidity. Sometimes a backing paper that has been in contact for a long time can be tested with the dyes to indicate roughly the acidity of the object.

```
                         EXAMINATION FORM
 Object:                           Owner:

                              Address:

 Sizes (inches or centimeters):
                 Height 1)      Width 1)      of Support
                        2)            2)         Platemark
                        3)            3)         Design
       (Unless otherwise indicated, the height is taken along the
       left side; the width along the bottom.)

 Shape:
 Distinguishing Marks:

 Condition Photographs (kind; before, during or after treat-
 ment):

 Description of Framing and Matting as Received:
   Construction or Materials:

     Glazing:

     Windowmat:

     Attachment of Object:

     Backmat:

     Backing Materials:

     Retaining Nails:

     Frame:

   Condition:
     Glazing:

     Windowmat:

     Attachment of Object:

     Backmat:

     Backing Materials:

     Retaining Nails:

     Frame:

 Examiner:
```

Exhibit B

```
 Examination Form                                        Page 2

                    MATERIALS AND CONSTRUCTION

 DATE AND PROVENANCE OF OBJECT:

 SUPPORT:
      Materials (fibers, coating, etc.):
        If Laid Paper:  Intervals of Chain Lines:
                        Intervals of Laid Lines:

      Watermarks:

      Surface Character and Original Color:

      Effects of Water and Solvents on Sizing and Color:

      Former Treatment:

 DESIGN:

   Media:

   Techniques:

   Solubilities and Reactivities:

   Former Treatment:

 SURFACE COATING:

   Material:

   Solubility:

   Original or Later Application:

 OBSERVATIONS BASED ON LABORATORY EXAMINATION (microscope, dif-
 ferent lights, chemical analysis, or other):

 FURTHER COMMENTS:
```

Examination Form Page 3

 DESCRIPTION OF CONDITION

INSECURITY

 1. Weakness of Materials (acidity, brittleness, etc.):

 2. Defects in Construction (mounting, adhesives, etc.):

DISFIGUREMENT

 3. Accretions:

 4. Bulge, Warp, Cockle or Draw:

DAMAGE

 5. Wrinkle, Fold or Crease:

 6. Abrasion:

 7. Scratch:

 8. Disjoin or Cleavage:

 9. Flaking or Chipping:

10. Crackle of Crazing:

11. Tears:

12. Missing Parts, Holes or Thinning:

13. Fading:

14. Darkening, Yellowing, Discoloration:

15. Stains:

16. Corrosion:

17. Mold or Insect Damage:

18. Other:

Examination Form Page 4

 PROPOSED TREATMENT

 ESTIMATED COST (including materials and time):

 Examination and Report: _____

 Conservation Treatment: _____

 Matting: _____

 Rigid Mount: _____

 Reframing: _____

 Glazing: _____

 Backing: _____

 ESTIMATED TOTAL _____

 To owner or responsible person:
 If the proposed treatment and cost are acceptable, please sign
 and return. Otherwise, so not sign, but send comments. Treat-
 ment can begin when the authorized permission is received.

 SIGNATURE OF OWNER OR RESPONSIBLE PERSON:
 DATE:

For some of the listed defects, it has been found helpful to use single-word qualifications, as *severe* or *extensive*, *moderate*, *slight*, or *minor*. If the defect is general, that indication is made; if it is local, its position is described. For positioning a defect, it has become a custom to indicate by letters the areas of the paper as *C* (center), *TR* and *TL* (top right and top left), and *BR* and *BL* (bottom right and bottom left).

Page four

This page enumerates in order the proposed steps of treatment and the cost. It requests the signature of the owner if he approves of both. Only then can work proceed. If acceptance is granted, the Laboratory Treatment Form (Exhibit C)

LABORATORY TREATMENT FORM

Object:

Date: Treatment:

Exhibit C

comes into use. There the technician describes the actual treatment and the hours taken for each step. Should he find that the actual work and its cost are going to be different from the proposal, he must stop and consult further with the owner to establish an acceptable compromise.

Photography

Obviously, the camera should be used to illustrate the conditions described in the report. Black-and-white 4 × 5 photographs developed from 35mm film (Kodak Plus X) are the best for permanent records, provided both the negatives and the prints are carefully processed according to the ANSI rules for archival procedures.[73] As many are taken as are needed for illustration: shots of the whole and of details, by normal and raking light. Color photography is very descriptive of the disfigurement of paper. It differentiates clearly between the various kinds of discoloration, such as patterns of oxidation, stains, foxing, soil, and splatters, and describes better than can black-and-white prints the degree to which the design is obscured by the defects. Color prints enlarged from 35mm film (Kodacolor 25) to postcard size are adequate for the purpose. Since the rendering of color does not have to be exact, the prints can remain descriptive for quite a number of years. Color slides are good if a lecture or a demonstration to a group is contemplated, but prints are more convenient for consultation during treatment and for comparison afterward to determine the visible effects of treatment.

6

Unframing and Unmatting

This operation should be the responsibility of the technician or the conservator, not the registrar. Much can be learned about the condition and past history of an object by observations made while unframing and unmatting it:

1. Is there dust within the frame?
2. Are the mounting materials brittle and discolored?
3. Have the tapes, hinges, and other kinds of attachments caused harm?
4. Is the support itself weakened and patterned by communicated disfigurement?
5. Was the present matting, or some previous one, responsible for the pattern?
6. Is it stained or cockled by its present attachment or locally thinned by the removal of past mounting tabs?
7. Are there evidences in any of the materials of insects or mold attacks?
8. If so, are they of recent occurrence, or so old as to be no longer harmful?

Procedure
1. Place the frame face down on a surface with a soft covering like carpeting or rubber matting. A satisfactory material for the purpose because it stays clean and can be easily rolled or hung out of the way when not in use is open-meshed padding of polyethylene.
2. Remove the wire and hanging devices, tear away the backing paper completely, and remove the retaining nails or tacks. Save all labels. Sometimes the retaining nails are difficult to remove if they have rusted or been driven in too far. One way of withdrawing them is by direct pulling on line with the nail, using pliers and holding the frame firmly against the body. If a leverage action is necessary, the pliers can be braced against the wall of

the frame's rabbet while protecting the wall from injury by interposing a narrow metal strip under the pliers.

3. If the glass is not fastened separately into the frame, the entire enclosure can be lifted out, first angling it upward by lifting one corner with the fingers placed below the glass, and then grasping it securely.

4. If the glass is fastened, place the frame on edge, pitched slightly backward. Then, with an instrument like a sturdy spatula, the papers can be eased out in a single package that will fall against the hand.

5. Another method that works well if the operator makes sure that there are no places of interference for easy removal, is to cover the reverse with a rigid panel of hardboard, like Masonite, larger than the frame; to invert the assembly onto the table; and then to lift the frame away from its contents. *Caution one:* For large, heavy objects, two people should assist each other in the unframing.
 Caution two: If the paper is stuck to the glass and moderate heat (such as by repeated applications of blotters dipped in hot water) does not cause a separation, the frame may have to be opened up at the corner joints. Separation from the glass will require consultation with a conservator.

6. Lift the glass away, if possible, and approach the work of art with great care, determining the manner of attachment before lifting high any of the papers. Common methods of attachment of the paper of value are:
 a. No direct attachment at all.
 b. Hinged to the backmat.
 c. Directly adhered to the backmat with spots of adhesive.
 d. Allover mounted to the backmat.
 e. Directly adhered to the windowmat with spots of adhesive or by continuous edge attachment.
 f. Sandwiched between the windowmat and backmats, which have been adhered together around the edges.
 Caution: This method can present dangerous difficulties if the edges of the support are involved in the adhesion between the mats. The only way to make this determination is to dig a narrow channel through the windowmat. If the edges are involved, the windowmat must be removed without injury to the fibers of the support before the support is freed from the backmat. This work should be done by the conservator, or under his guidance.

7. Mark all items that are to be kept (object, frame, decorated windowmat,

historical evidence, and so on) with an identifying number, usually the acquisition number. Refasten the glass, backed with protective cardboard, into the frame with a few retaining brads, and distribute it and the important secondary materials to logical holding places or according to the regulations of the registrar's office.

Caution: Only a pencil should be used for marking. In fact, fountain, ballpoint, and felt-tipped pens should never be used near papers of value.

8. Loose hinges and back papers held by spots of adhesive can be cut or torn away, leaving generous sections still adhered for more careful detachment later. At this juncture, however, all secondary materials whose removal requires placing the design face down should be left in place.

Preparation for Treatment

Work Surface

Strict cleanliness of the top of the work table is important. If it is a hard, nonporous, washable surface like Formica, toweling it with a mixture of household ammonia and water will achieve the purpose. If it is a grainy, porous material like wood, it can be covered with good-quality wrapping paper that can be changed whenever soiled.

Protective Papers

1. A smooth-surface paper, cut somewhat larger than the paper of value, is made to use between it and the table top to protect from abrasion. The protective paper permits shifting and turning of the object, as during examination, without actually touching it. Rectangles of acid-free wrapping paper are good for this purpose. The color is usually in definite contrast to the color of the paper of value, preventing any confusion.
2. If the obverse of the object requires being touched, the area on which the hand must rest should be protected with a soft paper such as paper towel. Alternatively, the hand can be covered with a glove or the fingers with surgeons' finger cots. White cotton gloves are sometimes recommended for this purpose, but surgeons' thin synthetic rubber gloves or cots seem safer because they are smoother, better fitting, and lack the fibrous character of cloth.

 Caution: In all treatments, the object is handled as little as possible and then with freshly washed hands. The fingers should never rest on a paper for a period of time without protective covering.

3. A folder made of a sheet of acid-free paper serves as a carrying envelope, a device for turning the paper over without touching it, and a temporary housing until the object is permanently matted.

Treatment

Removal of Old Matting Material

1. An allover adhered mount, whether cardboard or paper:
 a. If there is little or no evidence that it is doing harm, it can be allowed to remain.
 b. If the support appears to be under rigid strain, if there is discoloration from the adhesive, if any part of the mount is made of ground wood pulp or straw pulp, if pH indicator tests show the mount to be acid, it should be removed and the work referred to a conservator.
2. Mats adhered to the support by hinges or spots of adhesive:
 a. If the designs are of powdery material—pastel, chalk, charcoal, soft graphite—they should never be placed face down against a surface. Yet much of the unwanted attachments can be removed while the picture is held on a spacer in its frame, provided the support is strong and no downward pressure is exerted. A safer arrangement would be to tape a spacer to a fixed frame of approximately the same size. The spacer could be a thick windowmat or one made of foam-cored cardboard, the opening tailored to touch the object only at the outer edges. Straps of masking tape attached to the reverse of the picture could hold it to the spacer provided that immediately after treatment the tape and the traces of its adhesive are removed with swabs dipped in heptane (*not* hexane) or benzine (*not* benzene). The assembly could be held nearly upright by bracing it against a vertical surface or clamping it on an easel.
 b. If the design materials are friable, cupped, and tenuously attached— thick or opaque watercolors, contracted surface coatings, collages—they should be examined under magnification to see if placing them face

down will cause trouble (if there is flaking paint, brittle protrusions, and so on). Even if such materials seem secure, no weight should be placed on the reverse, and the pictures should be subjected only to very local manipulation.

c. The secure design on a strong support—print, translucent watercolor, ink, or hard-pencil—can be placed face down on a protective paper and held against movement with strategically placed weights while the old matting is removed.

1) With attentive care, the greater part of old matting held by local spots of adhesive can be trimmed, cut, or torn away with scissors, knife or scalpel, tweezers, or fingers, leaving only the small sections of the matting that lie over the adhesive spots. These pieces can then be reduced to thin layers by pulling them off with fingers or tweezers, keeping the hand low and pulling parallel to the surface while the fingers of the free hand hold the area against the strain. Care must be taken that this action pulls the scrap of matting away from the adhesive, not the adhesive from the support, thus injuring it. Keep in mind that an indication of incompetence on the part of an operator is the thinning of a paper support by unknowing, careless, or impatient removal of mounting materials.

2) If the last procedure threatens to thin the support, the scraps of old matting can be further weakened by putting small drops of water on them. Should the surface be moisture resistant, abrading it with a scalpel before wetting, or adding ethyl alcohol to the water, will help penetration. After a moment, the dampened upper part can be scraped away with a scalpel held nearly flat. Sometimes the wetting and scraping have to be repeated. The residues of the adhesive are removed in the same way, wetting and scraping, until no tackiness remains. Removals should be done with as little dampness penetrating to the support as possible.

Note: Unfortunately, many papers, especially old ones, tend to water stain. Therefore, care must be taken during local water treatments to guard against staining because once such a stain has set, it is difficult to remove. There are several ways of preventing stains by hastening evaporation: (1) by including ethyl alcohol in the water (1 part to 1 part), (2) by constantly swabbing the edges of the spot with ethyl

alcohol until the spot is dry, and (3) by drying the spot with forced warm air, as from a hand-held hair dryer.

3) If a strong support with a stable design is fastened directly to a mat with spots or lines of adhesive, sometimes the support can be raised enough to permit undermining one spot at a time by cutting into the top layers of the mat with shallow strokes of a scalpel held to cut downard. Then, with the thumb thrust in the cut and the fingers spread on the protected surface of the support, a lifting action effected by an upward pull and a slight turning of the wrist will tear off the top layers of the mat in a section that tapers upward beyond the undercut place of adhesion. Care must be taken that the support remains smoothly arched and that creases do not develop during the treatment. Sometimes a cardboard tube of suitably broad diameter can be helpful. It can be so positioned over the area of attachment that when the free portion of the support is turned up over it, the area to be undermined can be more easily seen and the incision more easily made. The separation can be achieved without strain on the support by a gentle forward pressure on the roller while the free hand controls the tearing with a scalpel.

d. Adhesive residues that are thin and do not affect the conformation of the support can be allowed to remain. If they are distorting and if the support is thin and weak, the problem should be one for the conservator. However, provided the support is strong and provided neither it nor the design will be affected by the treatment, the following attempt to reduce the adhesive could be made: place a dampened scrap of blotter over it and lightly touch the blotter with a very warm tacking iron to send steam into it; keep the blotter in place and dampen it again; while still damp, curl the blotter away rather than lift it off; scrape away the softened adhesive with a scalpel; repeat with fresh scraps of blotter until no tackiness remains.

Removal of Pressure-Sensitive Tapes

1. Pressure-sensitive tapes should be removed at once, unless they reinforce tears or span areas of design material reactive to the necessary solvents.[74] In these cases, the conservator should do the removal. Also, the problem

should become his if spot tests show that the solvents affect the sizing of the support or its color.

2. Solubility of the tape is dependent upon its age and condition. Whenever there is an adhesive that is not water soluble, attempts should be made to determine the solubility, first with a mild solvent (heptane or benzine). If unsuccessful, toluene should be attempted, then acetone or ethyl alcohol. The solvent tests should be small drops that are then pressed with blotters after a moment to see if the adhesive has been softened. If the tape is fairly fresh, heptane should work satisfactorily. Occasionally, the adhesive of the tape may have become so hard as to be insoluble. This extreme is usually accompanied by brittleness of the plastic backing, allowing it to be cut off bit by bit. Often the hardened insoluble adhesive has to be allowed to remain. *Caution:* Some design materials, like wax crayon, cannot tolerate these solvents. As with water, spot tests should be made with solvents in order to be confident that neither the design nor the paper will be injured.

Procedure

1. The solvent is fed underneath the tape by dabbing a moistened swab along its edges and over the reverse of the area it covers.

2. When the area has been kept wet for a few seconds and the adhesive has softened, one end of the loosened tape is lifted with a scalpel, grasped with tweezers, and gently pulled backward, a small section at a time, after each section is further treated with the solvent. Remove the blotter carefully with more solvent.

3. When the backing of the tape has been removed, it may be found that the adhesive has not dissolved but has formed a swollen mass that clings to the paper. The mass can be rolled off, with swabs wet with the solvent, onto another surface, as onto a slip of paper or Mylar placed just beneath it.

4. If swabs should not be manipulated over the area because of the presence of a design, turn the support down onto blotting paper and lightly bounce on the reverse with cotton balls wrung out in the solvent.

5. A more prolonged exposure for difficult tape can be achieved by placing a blotter under the area and keeping it wet with the solvent. This method should be used very cautiously because a stationary source of solvent like the blotter could cause a ring. Another method might be to moisten the area with both toluene and acetone applied in alternation.

6. For difficult cases, Robert Futernick has suggested a small solvent chamber made by stuffing a jar with blotters that are saturated with solvents in such an amount that there is no drip when the jar is inverted. The mouth of the jar is placed over the adhesive tape and left for ten to thirty minutes, allowing the plastic backing to be removed and causing the adhesive to swell.[75] Other conservators recommend the solvent tetrahydrofuran as effective on difficult tapes and on reducing the stain caused by the adhesive.

Caution: Of the solvents mentioned, toluene and especially tetrahydrofuran are the most toxic. Consult the *Merck Index* for all solvents.

Spot Testing

The Paper Support

1. Reactions to water: Make a small swab of a round toothpick by winding a strand of cotton batting around one end. With the swab, place a drop of a mixture of water and ethyl alcohol (1:1) on an inconspicuous area of the support. Allow the drop to dry. If a faint ring is formed, or if the color or conformation of the paper is altered, test another area with alcohol alone. If the alcohol has no effect, the first result must have been caused by the water. Therefore, it may be considered that the support would stain or distort if straight water were used locally. If no rings occur, repeat the tests on one or two other parts of the paper for confirmation.
2. Reactions to solvents: Every solvent to be used in treatment must be carefully tested in the same way. Sizes and colorants could be injured even by mild solvents, especially if the paper is of modern manufacture. The results are best judged under magnification or in a raking light in which the dislodged sizing or the altered color could be most obvious.

The Design Materials

1. Reactions to water: Tests are made first with water at room temperature, then, if the results are negative, with warm water—a more severe test to approach the far greater exposure of actual treatment. With the toothpick swab, place tiny drops on unimportant lines or areas of the design. Watch under magnification for swelling or crumbling. After a moment, press the spots with clean, white blotters to see if there is transfer. If so, water should not be used near the design. If there is no apparent reaction, repeat the tests several times on the same spots for greater

assurance. Every material and every color of the design that would be involved in the treatment is tested separately. Any reaction would condemn the general use of unmodified water.

Note: In all aqueous treatments, the reactions of water can be modified by adding ethyl alcohol because the alcohol reduces the effects of water. First, straight ethyl alcohol is tested to be sure that it has no solvent action. Then, a solution of one part water to one part alcohol is tried. If that solution proves to be safe, small increments of water can be added until the proportion is reached when harm could result. The greater the water content, the more effective will be the treatment. However, since the exacting and repeated tests are troublesome and even damaging to small objects, usually the one-to-one proportion, if successful, is accepted.

2. Reactions to solvents: Testing with solvents is done also with small drops blotted after a moment to determine if the design materials are soluble. Each solvent to be used is tested on every variable in the design. Watching the effects under magnification before blotting is especially important with solvents that can be more penetrating and evaporate more rapidly than water.

10

Disinfecting by Fumigation

Figure 1, as well as the previous section on mold, describes a suggested design for a gastight chamber planned for the use of vapors from the crystals of ortho-phenyl phenol or thymol. Like most disinfectants, the vapors do not secure papers permanently against fungus but should kill many of the spores present and give a very short period of immunity. If the papers are kept in a museum climate after being fumigated, they should be reasonably safe, cured of most of the old mold germs, and not likely to develop growth under the controlled conditions.

Caution: The vapors of thymol have a solvent action on oil paint and natural resin varnish, causing them to become tacky. Although many printing, drawing, and writing inks have oil or oil-resin media, inks appear to be stable and can withstand the required exposure. As far as is known, there have been no reports of injury to inks by thymol vapors.

The papers that should be disinfected are those that have active mold growth. When this condition is found, the paper and its container should be taken away from other mold-sensitive materials, blown slightly as with a gentle use of the blower brush to get rid of loose dust, and then placed at once in the disinfecting chamber. It is better not to remove the mold growth from the paper before treatment because it can be spread unnecessarily and become embedded in the fibers. All secondary papers and containers should be discarded. If a frame is involved, it should be brushed with a disinfectant.

Moldy leather objects, such as leather-bound books or boxes, can be exposed. However, the leather may need to be lubricated after treatment, for instance with a mixture of anhydrous lanolin and neat's-foot oil.[76] There are some objects that should not be placed in the chamber, even though mold growth is present:

a. Designs containing oil or resinous paint.
b. Photographs. Photographs have been exposed without apparent damage, yet there have been fears expressed by some conservators that any fumigation could injure photographic emulsions.
c. Parchment or vellum that contain oily substances.

These objects should be taken to an airy place, preferably to a sheltered spot outdoors, and the mold removed by picking it up with kneadable eraser or a good-quality wallpaper cleaner or with tweezers, finally whisking the area with

Figure 1: Suggested design for a fumigation chamber.

a soft brush or blowing it with a blower brush. Then, if the design permits, the areas can be washed with a swab dipped in ethyl alcohol to disinfect and to remove dark residues.

Use of the Chamber

1. The quantity of crystals, which should be divided among the containers, is at least fifty grams per cubic meter, or two ounces per thirty-five cubic feet. The containers are placed close over sources of low heat, as is shown in Figure 1 where 20-watt bulbs are suggested.

 Caution: The crystals do not need much heat to give off vapors at a satisfactory rate. In fact, more than mild heat is inadvisable because if the crystals are rapidly liquified, they could recrystallize on nearby surfaces. This effect can be offset not only by keeping the heat low but also by covering the objects with tissue paper.

2. Lay the papers to be disinfected on pieces of thin, permeable paper that can serve for handling but not block passage of the fumes, and place them on the screened shelves. If the paper is already matted, insert plastic rods between it and the mat for better penetration. If a book has to be treated, penetration can be achieved by inserting the rods every fifty or so pages. Broad-diametered plastic drinking straws have been found to be useful for the purpose.

3. The door is latched tightly so that the gasketing around its edges seals the chamber. Then the heat is turned on below the fumigant, stimulating it to send vapors throughout the interior of the cabinet. The heat should be left on for about three hours per day for four days, and the objects left in the chamber for six or seven days.

4. After fumigation, any mold residues should be removed by picking them off or whisking or blowing them away. To remove residues from pastels or charcoals, see step 4 under Dry Cleaning.

Dry Cleaning

Dust and dirt that have not been ingrained into the paper, and an appreciable amount of handling soil and minor grease marks can be removed by dry cleaning. On the other hand, aged oxydized stains probably will not respond to the treatment, and embedded dirt or migrated pigment often can be only slightly reduced. Such defects may have to be accepted as permanent damage and be covered from sight as much as possible by the windowmat.

Cleaning with Brushes and Forced Air

1. As mentioned above, unattached dust and other accretions can be blown off stable designs by a blower brush.
2. Loosely attached particles can be dusted from the reverse and margins with a soft ox-hair or sable brush that is kept clean for the purpose. The brush should be used with whisking strokes, applying little or no pressure lest the dust be rubbed into the paper.
3. For large papers and those that are considerably coated with loose soil, the reduced force of an air jet from a dry spray gun may be used. A convenient rig for the purpose is a pegboard larger than the object that is held on a slant by a back support. Before the board is pitched on its support, the paper is positioned on it, and eight pegs, one at each side of all corners of the paper, are placed in the holes so that narrow cloth tape can be strung along them and run diagonally across the corners of the paper to hold them from blowing up in the air jets. This arrangement can also be of benefit for cleaning the reverse of objects whose design could be injured by the pressure of erasure: light erasing on the reverse followed by blowing off of the crumbs.

4. Somewhat clinging accretions like cobwebs and residues of mold often can be picked from the design areas—even of charcoals and pastels—by barely touching the pigment particles with a sable watercolor brush or tweezers. The brush is made more effective if it is given an electrostatic charge by flicking it against a piece of plastic or a fibrous material like wool cloth, the tweezers by securing a small narrow strip of masking tape, the adhesive side outward, to one of its jaws.

5. Fly specks, other insect deposits, and metallic grains that are attached to the surface of the paper can be dislodged by direct picking with a surgical needle held nearly upright to undermine the deposit with minimal disturbance to the paper. The work is done under high magnification.

Cleaning with Erasers

A good deal of general soil can be removed by various kinds of erasers. Again, testing is necessary to establish what kind of eraser and how much pressure can be used without scuffing or otherwise disturbing the surface of the paper. On very fibrous or porous papers any kind of erasing could be harmful. All selected erasers should be reasonably soft, smooth, and free from grit. A study of several of the erasers used in conservation and their effects upon indicative papers, made at the Conservation Center of New York University, came to surprising and disturbing conclusions.[77] As a result of that study, conservators have chosen to use vinyl erasers (even though composed of polyvinyl chloride), like Magic Rub and the Staedtler products, in preference to natural rubber erasers because the latter, like Pink Pearl, is more abrasive and leaves more microscopic particles within the fibers of the paper than does Magic Rub. The residual traces of the natural rubber are more resistant to removal than those of the vinyl eraser.

1. The use of eraser crumbs is the least abrasive of the cleaning methods and is a good way to reduce general soil uniformly over an area. The crumbs are scattered fairly thickly on the soiled paper and rubbed over the surface with a circular motion of the flat of the fingers. If there are marks that require more concentrated pressure, it can be supplied by gently rubbing the eraser crumbs over the spots with a dry cotton swab or, for more persistent marks, with a good-quality block eraser held flat or turned only slightly on edge in order to avoid making lines of overcleaning. Excellent utensils for this operation are porous cloth bags filled with crumbled eraser, like the Opaline Cleaner, which can be twisted and shaken to dust the paper

with the cleaning material; or Dietzgen's Skum-X, crumbled eraser in a small dispenser with a spout permitting direct application of the erasing material. For cleaning in narrow places or close to the design, pencil erasers that can be sharpened to small diameters are used, like Faber's Racekleen or Staedtler's Mars-Rasor.

Caution: The treatment should not be used on the design, but should be limited to the reverse, the margins, and blank spaces in the design area.

As soon as the crumbs become dirty, they should be brushed away and, if necessary, replaced with a fresh supply. The brushing or blowing off of the crumbs should be done with care and thoroughness.

2. Follow-up cleaning with block or pencil erasers for persistent marks will often be necessary. However, at no time should hard pressure be used. For a picking or sucking action, the kneadable rubber has advantages. It should be used with caution because it contains a mineral oil that makes its crumbs particularly hard to remove. It can be shaped to required sizes, even to a point, to pick up disturbing soil in small areas of the design.

Cleaning with Nonaqueous Solvents

Although solvent treatment will have little, if any, effect on old and oxidized stains, mold, and foxing marks, for fairly recent and surface stains like greasy fingerprints the use of nonaqueous solvents may reduce the disfigurement. Heptane, benzine (or other low-boiling-point petroleum spirits), toluene, ethyl alcohol, and acetone would form a good range of solvents to have on hand. They are given in the approximate order of their solvent strengths for greasy soil. They should not harm most papers, except for some modern papers, as mentioned above. Since heptane, toluene, and acetone are missible, a series of compounds could be made of increasing strength: beginning with one hundred percent heptane, adding increasing increments of toluene to one hundred percent toluene, then adding increasing increments of acetone to one hundred percent acetone. None of the substances should be used without careful tests both to the paper and to the various components of the design that would be involved in the treatment.

Application by Swab; Immersion

The paper is placed on a blotter, and the selected solvent applied over the soiled areas with a soft brush or with the rolling action of a cotton swab. When possible, complete immersion in a shallow pool of the solvent can be beneficial because the dissolved materials of the stain can disseminate throughout the pool.

Sometimes, after the greasy medium of the soil has been weakened by a solvent, a second use of erasers may remove the loosened dirt.

Caution: Only good grades of solvents should be used on paper: reagent grade or better.

The Poultice

If immersion is inadvisable, as it is most of the time, prolonged exposure to the effective solvent can be achieved by local application of a poultice. The method could be called for if the stain is slowly reactive or if some of the agent that caused the stain is also present. Poultices can be made of any absorbent material that can be closely packed and retain enough of the solvent to be effective, yet not allow much of it to bleed around the edges. Some of the materials that have been used are: shredded and wadded white blotter, analytical filter pulp, fuller's earth (a highly absorbent clay), infusorial earth (a white powder derived from diatomaceous earth), and kaolin (a white clay). Because of the possible grainy nature of fuller's earth, which is nevertheless one of the most widely used poulticing materials, it might be beneficial to lay a piece of Japanese tissue paper between the stain and the poultice.

Impregnate the poultice with the solvent to a puttylike consistency, and layer it over the stain. To control the spread of the solvent, dikes of the dry poultice are built close to the edges of the wet material. Even so, tidemarks may occur, and they must be feathered out with swabs dipped in the solvent while they are still fluid. The poultice is allowed to dry because it is during drying that the stain and its discoloration are drawn into the poultice.

The Suction Table

Since Marilyn Weidner announced her invention of the suction table in 1975, the table has become indispensible in nearly every conservation laboratory. Her article "A Vacuum Table of Use in Paper Conservation" describes its various usages, and Stefen Michalski's article "The Vacuum Table, History and Behavior" describes the functions of its component parts. The removal of stains and other discolorations is one of its outstanding advantages. Suction through a rigid but porous surface over a chamber, the pull of whose lowered pressure can be regulated, draws fluids directly through the stained paper into underlying blotters, thus causing often remarkable removal of the stain and prevention of solvent rings. A technician who has access to such a table can substitute its action for some of the methods detailed above.

12

Aqueous Treatments

Before discussing aqueous procedures, water itself must be considered. If the technician relies on tap water, he should request an analysis from the city or county water department in order to know if there are chemicals or minerals present that could be harmful to paper. Tap water not only carries trace minerals from the ground but is often treated with additives like chlorine to make it safer for human use. It can also accumulate impurities in its passage through pipes. To counteract such additives, the conservator, under the belief that water that was cleansed as much as possible would be best for his paper objects, began to use distilled or deionized water. Then it was found that paper treated in distilled or deionized water was, after artificial aging, weaker than paper treated in tap water.[78] This finding lead to the realization that distilling and deionizing removed not only injurious ions but beneficial ones as well. Now many conservators still use distilled or deionized water, at least for final washings, but compensate for the loss of good ions by introducing small amounts of calcium or magnesium carbonate. It has also been found that paper treated in alkaline water behaves better after artificial aging than does paper bathed in water that has an acid pH.[79] For these reasons, water containing one of the carbonates and brought to a pH between 7 and 8 seems best for aqueous treatments. If two percent of saturated calcium hydroxide or of magnesium bicarbonate is added to deionized water, several advantages will be met: (1) the pH of the water will be slightly alkaline, (2) the beneficial ions will have been replaced, and (3) if calcium or magnesium carbonate is present in the paper, it could act as a sequestering agent that might prevent oxidation caused by embedded metallic particles and ions. For this protective behavior, most scientists seem to prefer magnesium.[80]

Note: This modification of water for the treatment of paper must not be confused with deacidification (alkalization). To repeat: the addition of magnesium or cal-

cium carbonate, in far smaller amounts than are needed for an alkaline reserve, is done (1) to replace beneficial ions lost in distillation or deionization, and (2) to be present as an agent to inhibit oxidation catalized by metallic particles.

In all the aqueous treatments to be discussed—dampening, immersion, floating, and especially local use of water, the effects of water can be reduced by the addition of ethyl alcohol, ten percent to fifty percent, depending upon the reactivity of the object.

13

Relaxation by Dampening

This most gentle of the aqueous methods might be the extent to which some fragile and reactive works of art can be carried. Its main purposes are: (1) to permit flattening of the plane of a paper distorted by cockles and creases; (2) to permit flattening in order to establish correct register before mending; (3) to permit flattening of a paper after drying following such treatments as immersion and floating; (4) to remove some discoloration from objects that will have no further aqueous treatment; and (5) if necessary, to restore the moisture content after immersion in a nonaqueous solvent. Usually one of the drying methods follows while the paper is still damp.

Procedure
A. For sturdy papers with stable design or for printed documents:
 1. Place face down on a blotter.
 2. Press lightly and repeatedly with a block sponge from which the water has been well wrung out, until the paper is uniformly damp.
 3. Cover with plastic sheeting to retain the dampness until the next step.

<div align="center">Or</div>

 1. Brush the reverse with a Japanese waterbrush that has been dipped in water and then well shaken.
 2. Stroke the reverse of the paper lightly and repeatedly from the center outward in all cardinal directions until it is uniformly damp.
 3. Cover with plastic sheeting to retain the dampness until the next step.
B. For delicate papers and water-sensitive designs, use a humidity chamber. If

there is no chamber designed for the purpose, a tray considerably larger than the object can be used.

1. Place a quantity of water in the tray.
2. Place the paper with an interleaf of tissue on a support that lifts it above the water. The support can be made of polypropylene screening stretched on an aluminum silk-screen frame that has been formed to fit in the tray.
3. Place a humidity indicator card in the chamber.
4. Cover the whole with transparent plastic sheeting held closed around the edges with weights or tape.
5. Low heat from a lamp outside the sheeting will give more rapid humidification.
6. Watch the setup most carefully to prevent overwetting; judge the humidity level by the indicator card.
7. Avoid reaching high percentages by opening air passages around the edges of the sheeting.
8. Occasionally touch the paper in a number of places to determine if it is damp enough for flattening.
9. If drops of condensation form on the sheeting, disassemble.

C. For very fragile papers or designs readily reactive to water; for complex supports like prints on mounted thin paper (*chine collé*):
 1. Enclose in a blotter sandwich made up as follows: a damp blotter at the bottom; two or three dry blotters; the object, face up; a dry blotter on top.
 2. Cover with plastic sheeting closed around the edges with weights.
 3. Check frequently; more dampness may have to be added or the damp blotter may have to be removed.

D. For large and thick papers; for watercolors that are fairly stable in water; for already treated papers before the final drying:
 1. Spread on a flat surface a piece of polyethylene sheeting somewhat larger than the object and place over it a protective piece of thin tissue paper; lay the object face down on the tissue.
 2. Spray the back of the paper lightly but evenly with water; hold it against curling. (A good tool for this purpose is the soft spray from a pressurized can like the PreVal Sprayer.)
 3. With repeated sweeping strokes of a broad brush like the Japanese waterbrush, spread the water drops as evenly as possible.
 4. Cover the paper with a second tissue and a large sheet of polyethylene; keep the dampness within the envelope by weighing down the edges with

weights, such as long narrow "snake" weights. Allow the paper to "marinate."

5. After about thirty minutes, or when the dampness should have permeated the paper, open the sandwich and place the damp paper face up on a blotter and proceed with a drying process.

14

Immersion in a Water Bath

The chief reasons for immersing and soaking a paper in water are: (1) to remove some discoloration; and (2) to reduce acidity (see the section on acidity). Therefore, the papers to be considered for treatment are those that are yellowed and moderately acid and, it is again emphasized, those that the operator has thoroughly tested to be sure that no harm will be done by immersion. Although only water of room temperature is used for the bath, the drop tests on the design materials should be done with warm water. The higher temperature of the drop will give a more severe test and thus compensate in some measure for the prolonged exposure that the object will experience in the cool bath.

Some of the objects that the technician may find advisable not to treat unless guided by a conservator are:

1. Designs done in inks or paints that can be injured by, or are soluble in, water: opaque and some translucent watercolors, some synthetic paints, many iron gall inks, some modern black inks, some Oriental inks, and colored inks of all ages.
2. Designs done in any medium or method that can be dislodged or smudged: pastel, charcoal, heavy graphite pencil, mezzotints, aquatints.
3. Coated, heavily surfaced or sized papers like illustrator's papers.
4. Prints done on mounted "India" paper (*chine collé*). It was a common practice, especially in the nineteenth century, to print on this paper, a very thin tissue, while it was mounted on heavier feltlike paper. Water immersion causes areas of separation between the two, resulting in raised blisters and a very difficult situation indeed.
5. Appliquéd papers like collages and papers with impressed designs.
6. Papers with bad edge tears that could be extended in the treatment.

Figure 2: Support for flexible plastic sheeting to make a variable sized water bottle.

7. Papers with mends or patches that could be removed in bathing, causing a major repair job.
8. Fragile, brittle, and broken papers, especially with high ground-wood content: modern newspaper, fancy papers, and so on.
9. Contemporary papers whose components react to water, especially colored ones whose dyes are found to be unstable in water.

As is well known, normal paper is extremely weak when it is wet, its weakness varying directly with the degree of wetness. Therefore, the procedure for total

immersion is designed to permit a paper, often already fragile, to be taken out of a water bath after a period of soaking without direct handling. Only the lightest brushing to dislodge accretions should be done while the object is under water.

Procedure

A. For fairly strong papers:
1. Select or form a basin (see Figure 2 for a suggested way of making a basin) at least eight inches larger in both dimensions than the object.
2. Place in the bottom of the basin a piece of screening whose edges have been bound (Saran, polypropylene, or any other inert, open-meshed material that will not float) and that is larger than the object. This screening serves as a safety device on which the paper can be lifted from the water immediately if incipient trouble is noticed. For the thinner papers, soft netting like Dacron net should be spread over the screening to protect the paper from the harsher weave of the more rigid plastic.
3. Run a shallow pool into the basin of filtered tap water.
 Note: Most treatments are repeated at least once, the paper being allowed to dry between each washing. Filtered tap water can be used for the first, but the last should be done with the alkaline wash water described above.
4. Drop the paper, face up, flat onto the surface of the water; hold the edges lightly against curl; wait until the paper has relaxed and lies more or less smoothly on the water.
5. Choose a broad-diametered glass or plastic rod long enough to span the paper and extend a little beyond both sides; immerse one end of the paper by pressing it down with the rod; holding the rod at its ends, slowly roll it down the whole length of the paper, thus immersing it and driving out trapped air. If the paper tends to float, it can be held sufficiently under water by placing over it a second piece of polypropylene screening interlayered with a protective piece of Dacron net, or simply by spanning it with one or two glass rods.
6. Allow it to remain in the water for half an hour or so. Toward the end of this period, soiled, undesigned areas can be gently brushed with a very soft brush.
7. Remove the paper from the water as follows:
 a. Remove the upper screening or rods if they have been used. Spread on the surface of the water a piece of polyethylene sheeting or polyester

web larger than the object. Polyethylene is the preferable material because it is more transparent, allowing the operator to watch the object more easily.

 b. Place a spatula below one corner of the paper and lift it up to the corresponding corner of the plastic; lift the two corners clear of the water.

 c. By slowly lifting, extend the area that is clear of the water along a short side, controlling the attachment of the paper to the plastic with the spatula. When a sufficient area has been raised, the paper will cling to the plastic so that little direct touching of the paper is needed.

 d. Very slowly lift the two from the water, being extraordinarily careful if there are edge tears. Should there be some, the lifting action is stopped when one of them reaches the surface of the water. The lower section of the tear is guided into contact with the plastic by means of the spatula, and the lifting can then continue.

8. Place the paper, still covered with the plastic, on a blotter while a rinse bath is drawn. This bath should be filtered tap water. Rinsing is needed if the water of the first bath has been turned brown by discoloration washed from the object.

9. Place the paper into the rinse water by putting both it and the plastic down onto the surface and slowly curling away the plastic. The curling action will immerse the still-wet paper.

10. After a short period of rinsing, remove the paper as above.

11. Allow some of the excess water to drip off, and then place the assembly on a blotter.

12. Beginning carefully at one corner and then progressing along one short side, slowly roll the plastic off, using a very sharp curvature, doubling it back on itself. Again, special care must be observed at edge tears.

13. If there are still remaining residues of water-soluble adhesive on the reverse, the paper, after it has become nearly dry, can be sandwiched between two blotters and turned over, and further attempts made to remove the residues.

14. Allow the paper to air dry in order to judge the effects of the bathing: whether any undesirable alteration has occurred; whether the discoloration, which can appear to be quite dark while the paper is still damp, has been satisfactorily reduced.

15. If the paper has withstood the bathing without harm, form the final bath

with distilled or deionized water to which two percent magnesium bi-carbonate has been added. If the pH of the water is still below about 8.5, add a few drops of ammonium hydroxide, just enough to bring the pH to 8.0 or 8.5. Immerse and remove as described above, 4–7.

16. Place on a blotter, remove the plastic, and let the paper remain in this position, uncovered, until it is no longer wet but is simply damp. This step is important because if the paper is turned face down and/or put under pressure while it is still wet, pigment will be lost and the texture of the paper could be injured.

17. If pools of water remain on the surface of the paper after any of these procedures, they can be absorbed by wicking them up with paper towels.

18. Proceed with the drying method considered most suitable for the object.

B. A thin paper or a crumpled paper with many small edge tears (dog-eared) can be bathed if it is protected between two layers of Dacron netting and the whole supported on polypropylene screening. The edges of the Dacron netting can be held closed, if necessary, with running, loose stitches of thread. After the washing, the envelope is removed from the screening and placed on a blotter. The netting is not removed from the paper until the paper is merely damp. Paper that is still crumpled is placed on wet polyester film (Mylar) and, protected with paper toweling or thin blotter, the crumples are straightened with finger pressure or with the flat of a spatula. For persistent crumples, the crests of the creases may have to be painted with water and the area placed under light flat weight, such as a small weighted rectangle of plate glass or ¼-inch Plexiglas. When flat, the paper can be uniformly dampened again before proceeding to one of the drying methods.

C. For larger papers to be handled safely, they should be supported throughout the bathing process. There are two setups that can be used for the treatment:

1. A large sink.

 a. Place the paper in a sandwich whose bottom layer is polypropylene screening and whose upper layer is thin polyester web or Dacron netting; tack the plastic materials together in a few places with thread, leaving generous room for the paper to expand after it has been put into the bath.

 b. Place at the bottom of the sink an inert, fairly rigid panel which, when the bathing is done, can serve as a drain board. The panel could be made of Plexiglas or aluminum.

 c. Fill the sink with water deep enough to permit the assembly to be immersed.

 d. The assembly can be immersed and the air evacuated by holding it down with a wooden or glass rod placed near one end of the paper and rolling a second rod down the length of the paper, progressing slowly without tension as the paper becomes saturated.

 e. After bathing and after the paper has been drained by placing the panel on a slant, and has dried somewhat, the plastic layers are removed one at a time. The paper, still damp, is placed face-up on blotters.

2. A temporary basin constructed with polyethylene sheeting as shown in Figure 2.

 a. Sandwich the paper between two pieces of thin polyester web or Dacron netting; tack the edges of the sandwich together with thread.

 b. Construct the basin, the Masonite panel shaped to be reasonably larger than the object; mount the basin on a larger panel supported over a sink or drain; position the corners with the triangular sections between the two panels; pull the string through the holes in the corners and draw it taut to be the support of the edges of the sheeting, thus forming the walls of the basin; place the sheeting in the basin, fitting it into the corners and attaching it to their top edges with clip-type clothespins.

 c. Fill the basin with water deep enough to permit the sandwiched object to be immersed. Immerse it with two rods as described above.

 d. After bathing, the water can be drained from the basin by shaping a funnel-like opening in the sheeting to allow the water to flow into the sink below. The upper panel can be pitched to complete the drainage.

 e. Carry the sandwiched object to the blotter on the sheeting; place it on the blotters and allow it to dry somewhat before removing the sandwiching material. The paper, still damp, is placed face-up on blotters ready for the drying process.

Floating on a Water Bath

There are some works of art on paper that could benefit from water treatment, but whose design materials are such that total immersion could cause some injury. This statement does not suggest that materials readily reactive to water can be treated, but rather those that can withstand wetness but not the movement of flowing of water as it covers the picture. Works that could benefit from floating are heavy graphite drawings; prints with thickly applied ink; prints whose ink is not well bonded to the paper, such as many mezzotints and aquatints; some documents hand written on one side; and some translucent watercolors whose every tone has been tested for reasonable stability to water.

Caution: Papers with bad tears and interior losses probably cannot be treated in this way because the water will seep into the weak or broken places and spread over the surface.

Procedure

1. Place in the basin a support larger than the object, made of heavy Dacron netting or polypropylene screening stretched on an aluminum silk-screen frame.
2. Fill the basin with filtered tap water deep enough to be no more than a quarter of an inch above the screening, which does not need to be in contact with the object. Its purpose is twofold: to permit rapid removal, if necessary, and to prevent the paper from sinking into the water, should that be its tendency.
3. Drop the paper, face-up, flat onto the surface of the water; hold the edges lightly against curl; wait until the paper has relaxed and lies smoothly on the water. If the paper has a marked tendency to curl, it can be relaxed

before floating by a light water spraying and brushing on the reverse, followed by a short period of "marination" between plastic sheets.

4. Allow it to remain on the water for half an hour or so.
5. Spread a piece of polyethylene sheeting, a little larger than the object, so that it lies smoothly over the entire surface of the paper.
6. With the hands placed at the ends of one edge and the fingers curled under the object, grasp it and its covering sheet and slowly lift the two from the water with slight tension between the hands to prevent dishing.
7. Place the two on a blotter while a rinsing bath is drawn to the same depth as the first.
8. Repeat the procedures of floating and removal.
9. Lay the two on a blotter and remove the sheeting as described above.
10. Follow with the final floating in carbonated distilled or deionized water.
11. Allow the object to become merely damp before starting the drying process.

Flattening Crumples

Local Treatment

In cases involving design materials readily reactive to water, such as sensitive translucent watercolors or opaque watercolors, or in cases involving coated or dyed papers, or papers whose previous repairs should be kept, local treatment may be the only safe method to correct deformation. Small creases, folds, and wrinkles often can be successfully removed by proceeding as follows:

1. For complex crumpling in which parts or tongues of the paper are accordion-shaped, often with some sections turned back on themselves, it becomes a game like jackstraws to decide which crease to flatten first in order to reshape the whole area most effectively. When the decision is made, brush along the edge of the crease with a wet watercolor brush and ease it into place with finger pressure over a soft protective paper like a scrap of paper towel. Repeat on every crease. Sometimes the wetness will cause the deformation to almost correct itself. Sometimes the area can be difficult, and a number of creases have to be treated at one time and repeatedly.

2. For local soft cockling, the correction could be made by pressing a strip of damp paper towel (wet blotters may introduce more moisture than needed) against the area for a short time. Then, working on a protective blotter, smooth over the spot with the flat of a spatula.

3. While damp, dry between blotters covered with small weighted panels of plate glass or ¼-inch Plexiglas.

4. The local use of a warm tacking iron should be used only to speed up final drying or to hasten drying if there is fear of water stains. It is used without

pressure. Ironing with pressure can flatten the paper rather severely in the treated area. Also, it will make a difference between the low moisture content of the area and that of the rest of the paper, possibly causing cockling.

17

Methods of Drying Papers

There are four basic methods for drying papers: air drying, suction-table drying, in a blotter sandwich under flat pressure, and edge restraint. Some of the factors that a conservator has to consider in choosing a method are the effects upon the plane and the surface conformation of the paper, as well as upon the design materials and the possible stresses put on them. The degree of wetness of the paper before treatment is an important consideration because of its expansion when wet and because it expands differently in one direction than in the other. Even handmade papers have this difference to some extent. With the possible exception of smooth, thin papers, usually the drier a paper is before being compressed or stretched, the safer the treatment. Yet if suitable flatness is to result, it must be damp and the dampness must be uniform.

Until the conservation technician gains experience, some of the decisions he must make for drying a particular paper will be difficult. He has already assessed the reactivity of the object to water, now he must consider its behavior under pressure or stress. Since experience is the best teacher and because trial runs and testings are not usually possible for drying techniques, he should seek the advice of his conservator-counselor, at least at first. In order to avoid the dangers of using too much dampness and too great pressure or tension, he might try to imagine what the object was originally like. Was it very rigid, smooth, and flat? Did it tend to curl? Was the design material pressed into the surface? Did the design material show signs of its attachment weakened by shear?

Air Drying

Allowing a paper to become thoroughly dry in the air is, of course, the method safest for the object. The paper should reestablish most of its normal moisture content, and the surface should not have been harmed. The design materials,

already tested for stability, should not have been disturbed. Unfortunately, many papers do not recover the flat lie or plane imposed on them by their manufacture, but tend to buckle and cockle. However, some old and some modern handmade papers that were not heavily sized or calendered lie beautifully after drying and do not need further flattening.

Air drying is a step often taken by the conservator after a final aqueous treatment to let the paper rest for a while and to determine if flattening is needed before the next step.

a. The paper is laid uncovered on a blotter that is changed a number of times, or is laid on a drying screen that allows drying of each side of the paper at nearly equal rates. Printers and book conservators have racks of these screens on which many papers can be treated at one time.

Suction-Table Drying

If done without too much force of suction, this method is very effective and safe for the object. It can hold the paper in proper plane all during the drying process without constriction, except by the force of the air. With proper control, the suction should be able to draw out the moisture while not disturbing the ingredients of the paper or of the design. It should not flatten impressions in the paper or its surface. It has been found to be an effective method for the treatment of collages.

a. The paper is allowed to dry to uniform dampness.
b. It is placed on the suction table on top of thin blotters that are changed frequently at first. A layer of two or more blotters can be used to reduce the suction force.
c. Because this method takes a fairly long time to dry a paper thoroughly, the paper is often removed when nearly dry, the final drying accomplished by the blotter-sandwich method.

Blotter Sandwich under Flat Pressure

If correctly done, the blotter-sandwich technique can be very effective, and by planning and adjustments it can be made safe for most objects. The setup of the sandwich is:

a. A support with a hard, flat surface, such as a Formica-topped table.
b. Two white acid-free blotters that enclose the object.

 c. A pad made of rubber (white synthetic sponge rubber, ½ inch thick; or white gum rubber, ¼ inch thick; or a pad made of papermaker's felt, moderately firm, ¼ inch thick).

 d. A plate-glass panel, ¼ inch thick.

 e. Weights.

There should be a supply of blotters both thin and thick, a number of plate-glass panels, and a number of both rubber and felt pads for slightly different uses. The pads and panels should be approximately the same size (24″ × 18″ has been found convenient for medium-size objects; 15″ × 12″ for smaller). If a large object is to be treated, the pads can be fitted together, as can the panels, for overall coverage. Convenient weights are sandbags of different shapes, sizes, and weights (see Appendix II). They are easily handled and, if not overstuffed with sand, can conform to the surface and spread a little on it.

Procedure

a. The paper should be uniformly damp and relaxed enough to lie flat and to permit adjustments of tears and wrinkles. If it has developed spots of dryness, it should be redampened by one of the systems outlined above, preferably by the marinating procedure. Dampness need not be great as long as it has uniformly penetrated the paper. Some papers may need to be damper than others for proper flattening, such as thin smooth papers and papers that have been badly creased.

b. Before being placed between blotters, the design should be tested once more to be sure that there will be no transfer.

c. The initial pressing can be done between thin blotters and with only enough weight at the edges of the panel to hold the assembly flat. The purpose is to remove some of the moisture, to distribute it more evenly, and to determine how the paper is going to behave under pressure. Thin, responsive papers may need no weight on the glass panel. For them, and for smooth-surfaced papers, felt pads or natural rubber pads seem better than sponge rubber.

d. After about half an hour, the paper is uncovered and checked. It should still be relaxed but drier. If more than superficial transfer of the design material has occurred, drying under the edge-restraint method should be considered. The paper should indicate by its conformation whether it needs more or less pressure and whether it would be improved if the weights were arranged down the center of the panel rather than at the edges. A tendency to curl can be

modified by placing the paper alternately face up and face down in succeeding pressings, and to use as little weight as possible.

e. Thicker blotters are used for the second and succeeding pressings. However, if the paper is thin and smooth, it may be better to continue with thin blotters under a felt pad, and if any weights are used, they should be light ones so distributed that the panel is held flat. If the paper has a plate mark, a blotter (thin blotter for a shallow impression, thick for a deeper one) is tailored to the size of the plate mark and carefully positioned before the covering blotter is put in place. Should there be a seal impressed into the paper, a hole is fashioned in the covering blotter the exact size of the seal and placed over it to protect it from pressure.

f. After about an hour, the blotters should be changed again, the positions of the paper and weights altered as called for by the lie of the paper. It may be helpful not to remove the damp blotters in the successive pressings, but to place them above the dry cover blotters. This step has several advantages: it keeps some moisture in the package so that drying is slightly slowed down; it makes a thick, soft pad above the object; and, incidentally, it helps to flatten the used blotters.

g. Blotter changing continues as long as they feel damp to the touch. The object is kept between the final blotters under the panel, but without weights, as long as is practically possible—at least during several days—to be sure that it has adjusted to lying flat. Its exposure in room air during subsequent treatment will allow it to regain its normal moisture content.

h. Very thin, glossy surfaced papers, like Japanese gampi or tracing paper, can be treated in a different kind of sandwich: the paper is made quite wet and spread smoothly on a sheet of Mylar, brushed down if possible, covered with thin blotter, rubber pad, panel, and weights. The blotter is changed frequently until the paper is thoroughly dry.

Edge Restraint

This process is a most ingenious method first developed by the Japanese for drying mounted papers with delicate designs. It has been adopted and sometimes modified by the conservator as an effective, almost essential way of flattening papers whose design materials cannot withstand direct pressure. It is based on the physical fact that paper expands when wet and contracts bit by bit as it dries. An ideal paper, which perhaps the best Japanese papers approach, would shrink in a predictable way, rapidly at first, then more slowly as it approaches dryness,

and behave more or less the same in both directions. But such paper does not exist, certainly not Western machine-made paper. Therefore, the operator should establish how much the paper will change in dimensions from a damp state to a dry one. In consequence, when in the drying process, the paper can be placed under restraint without the danger of too great strain on the paper and too much shearing action for the tolerance of the design materials. Because so many major considerations are involved in the process, it is suggested that the technician submit the operation to an experienced conservator, or do the work under his direct guidance.

a. The Japanese method, sometimes exactly copied by the conservator, is to attach a carefully dampened, lined paper to a drying board by means of strong adhesive all around the extended outer edges of the lining paper. In drying, the shrinking of the papers strain against the fixed edges, building up tensions that flatten the papers. (For information on the drying board, see Appendix II.)

b. To reduce dangerous tensions and to compensate for differences in shrinking, Katsuhiao Masuda, an outstanding Japanese conservator and teacher, suggests extending the lining paper by adhering all around its edges a paper that has been crumpled or pleated. The outer edges of the extension paper are then adhered to the drying board. As the shrinking progresses, the "give" of the crumpled paper will reduce the strain on the mounted object. This procedure also can be used on unmounted objects by directly attaching the crumpled extension to the edges of the object by temporary adhesion.

For modifications of this technique, reference is made to the following articles: "Some Helpful Hints for Use in Paper Conservation" by Cathleen A. Baker, and "Methods and Makeshift" by Robert Futernick. A most interesting departure is described by Keiko Misushima Keyes in "The Use of Friction Mounting as an Aid in Pressing Works on Paper."

Mending Edge Tears

Papers with serious tears, especially if they intrude into design areas, should be referred to a conservator. Successful mending not only requires techniques and skills that perhaps anyone manually dexterous and experienced in artist's materials can perform, but also demands dedicated time and patience, to both of which the conservator is committed. However, the technician who is able to secure edge tears can benefit the papers under his care. Like tears in cloth, those in paper constitute places of weakness that can be extended or crumpled by careless handling and accidental snagging.

1. Equipment
 a. A moderately fine to medium, pointed watercolor brush serves for the paste brush.
 b. It is advisable not to use a proprietary paste, but rather to use paste prepared according to a conservator's formula or to the directions given in Part III. Dilute the needed amount to the consistency required for the weight of paper being mended. It would be better to err on the thin side because paste that is too stiff can cause troublesome contractions after the mend dries. A good test to determine the tack of an aqueous adhesive is to press a smear of it between thumb and finger and observe its ''pull'' just before it dries. For dilution, magnesium bicarbonate water can be added to distilled or deionized water so that the paste registers neutral or slightly alkaline.
 c. Prepare the mending material from long-fibered Japanese paper:
 1) If the paper to be mended is thick or moderately thick, tear narrow strips, about ⅛ to ¼ inch wide, of soft, heavier paper, like Minokichi, Usugami, or Sekishu, so that fibers fray out from both sides of the strip.

For short strips, form a crease and tear along it with short pulls between thumbs and fingers or wet the edge of the crease by running it along the tongue. To keep the edges of longer strips straight, it is better to place the mending paper on a firm, thick paper like Manila and to paint a line of water on it with a brush run along a straight edge. When the wet line has been drawn, impress it fairly firmly with a bamboo or bone knife and then tear along it while it is still wet, pulling against the straight edge or between thumbs and fingers.

2) If the paper is thin, like the average book paper or thinner, shred a very narrow strip of thin Tengujo, Tosa, or other easily shredded Japanese tissue, so that the structure is somewhat broken down into a chain of loosely webbed fibers. The idea is to weld the edges of the tear together by bridging the break with the inconspicuous webbing. To keep the narrow scarf of fibers from blowing away in the slightest air current before use, place it on a dark cloth with a nap.

2. Preparation for Mending

a. Place the paper to be mended face down on its protective sheet and prepare the edge tear.

b. If there are crumples at the tear, slip a piece of flexible but hard-surfaced plastic, like 3 mil polyester film (Mylar), under it, paint the crests of the folds lightly with a wet watercolor brush, and similarly dampen any other place at the tear that resists the flat lie of the paper. Draw the edges of the tear together as closely as possible without strain. Press the area into position with the fingers. If the edges will not close completely, accept a slight gap rather than cause a warp by forcing closure (the gap will be filled with the mending tissue). Substitute a blotter for the Mylar, press the tear again into position with the fingers, partly dry the paper between blotters weighted for about five minutes with small plate-glass rectangles. Then, if necessary, finish the drying by holding a warm tacking iron over the area. Should water staining be a danger, warmth from the iron could be used throughout the treatment.

c. If the edges of the tear are dirty and the fibers compressed, place a strip of Mylar between them and clean the edge on top of the plastic and at the same time fray out its fibers by lightly scraping it with the tip of the blade of a scalpel. Repeat for the other edge. Turn the paper over and do the same thing on the front. Again place the paper face down and position the

tear. If it is long, or if the paper is apt to curl, hold the edges in register with flat weights.

3. Mending

 a. Polyester web is always placed below an area being pasted because it is resistant to the adhesiveness of paste.

 b. If the paper tends to water stain, work with the paste as dry as possible. Drops of paste can be placed on a piece of paper towel or blotter and the paste used after some of the moisture has drained out of it. Use as little paste as possible, brushing it on the towel before putting it on the paper. After application, letting the paste dry a little before pressing sometimes reduces water rings. Other ways of drying it more rapidly are the warmth of a tacking iron (do not press with the tacking iron); brushing the area of the not-quite-dry paste with ethyl alcohol (a method used only if tests show that the solvent will do no harm); or the use of warm (not hot) forced air from a hair dryer.

 c. As a first step, brush any overlapping or beveling of the edges along the tear, even the slightest, with a very small amount of paste, enough to cover the overlap but not spread beyond it. Place under pressure between pieces of polyester, and dry. If the bevel is deep enough and extends the full length of the tear, reinforcement may not be necessary.

 d. For reinforcement of thicker paper, place a mending strip a little longer than the tear on a piece of blotter and brush it with the paste. Brush repeatedly to soften the tissue and drive off some of the moisture, and brush so that the edge fibers remain extended. Pick up the strip at one end with tweezers and position the other end a very little distance beyond the inner end of the tear. Press the end down into firm contact with the paper. Lower the strip loosely over the tear. When completely laid, press firmly with a cotton ball to smooth its contact and remove some of the moisture. Place between polyester web and weighted blotters for a while. Finish drying by removing the web and replacing with fresh weighted blotters.

 e. For reinforcement of thin paper, paint lines of paste along the edges of the tear. Pick up the mending web at one end with the tweezers and position it as described above. After it has been pressed with the cotton, attach its edge fibers on either side of the tear by lightly brushing them down onto the paper with outward strokes of the paste brush. Dry as above.

5. Toning the mend

Since the reinforcement is on the reverse, no toning is really needed. However, it can be done with a mixture of powdered pastels of suitable colors. Form a small swab by wrapping an end of a round toothpick with a wisp of cotton batting. Roll the swab in the mixed pastel and put touches of it along the mending strip. Blending the touches of the pastel with the swab should accomplish the toning.

Spray Deacidification of Secondary Papers

As has been stated above, the use of deacidifying agents on papers of value should be avoided by the technician. But the treatment of secondary materials sometimes can be beneficial. Occasionally it will be found that papers used for hinging and mending are acid. Also, if a valuable paper is acid, placing it against a buffered back paper may help to retard further exposure by absorbing random acidity and neutralizing the housing. There are proprietary papers with buffers built into the furnish that could serve the purpose, such as acid-free bond or text papers, and especially the soft, alkaline Promatco tissue. The buffering properties of the papers could be improved by the method to be described, or, if neither the papers nor the tissue are available, a substitute could be made by treating a sheet of Sekishu or a similar soft but strong Japanese tissue.

The spray method using magnesium bicarbonate, developed by W. J. Barrow,[81] is suggested here principally because it is hoped that the technician will be able to make this agent himself. He also may want to use it as a neutralizing diluent for water-soluble adhesives. Because in the act of spraying some of the bicarbonate changes to the carbonate and settles on the surface of the paper, penetration is not sufficient to establish a reliable, long-lasting buffer. Therefore, this technique is not beneficial enough as a deacidification agent for use on papers of value.

Procedure
1. Spread a sheet of polyethylene on a flat surface. Place on it a protective tissue paper and on the latter the paper to be sprayed, face down.
2. Place ninety percent magnesium bicarbonate water and ten percent ethyl alcohol in the container of a spray gun—one operated by a pressurized can, like the PreVal Sprayer, is quite satisfactory if an electric spray gun is not available.

3. Spray the paper, making passes first in one direction and then in the other, until the paper is quite damp (not wet). Brush the paper for more even distribution with sweeping strokes of a broad soft brush like the Japanese waterbrush. Absorb the excess water on the plastic near the paper with toweling to prevent its wicking into the paper and causing staining.

4. Cover with a tissue paper and a second sheet of polyethylene. Close the plastic envelope by weighing the edges down with ''snake'' weights.

5. Allow the paper to ''marinate'' for three to four hours, permitting the magnesium bicarbonate to penetrate into the structure of the paper.

6. Open the envelope, place the paper on a blotter, and let it dry, uncovered, in the air of the room. The carbon dioxide of the air will change the magnesium bicarbonate in the paper to the more stable buffering compound magnesium carbonate.

7. If the paper needs to be flattened after drying in air, it can be sprayed lightly with distilled or deionized water, ''marinated'' between tissues and plastic sheeting for a short time, and then dried in a blotter sandwich under flat pressure.

Matting

In the usual manner of matting, the windowmats and backmats become the most intimate parts of the housing of the work of art on paper. Together they form a protective, supporting envelope that remains in prolonged contact whether in frame or storage box. To be beneficial, the components of the envelope must be of neutral, enduring materials, free of deteriorating impurities. The matboards described in Part I are considered to be the most suitable materials for the purpose.

Only the standard methods of matting, together with a few modifications, will be described here. Justifiable variations will be necessitated by particularities of framing and design. Modern attitudes toward presentation may even reject traditional matting altogether. Any arrangement is acceptable provided the basic requirements for preservation of the object are upheld: that contacting materials be clean, harmless, and acid free, and that they furnish the needed amount of structural support and of protection against injurious factors in the ambient atmosphere.

Procedure

1. Two pieces of acid-free four-ply ragboard (or, if desired, acid-free, chemically purified sulfite board) of the same shape are cut for the windowmat and backmat. Ideally, the outside dimensions would be established by considerations of design to give margins of pleasing proportions. Yet very often other factors, such as an existing frame, control size. Also, the choice may be limited if the method of temporary framing in standard-size frames is practiced. Then the mats must be cut to fit the most suitable of the sizes. Curators using this system may want to select their own dimensions. However, there is a set of sizes widely used in the museum world that permits pictures not only to be interchangeable in matching

frames but also to fit into one or another of proprietary storage boxes: 11″ × 14″, 14¼″ × 19¼″, 16″ × 20″, 19″ × 24″, 22″ × 28″, and 30″ × 40″. If the use of proprietary framing strips is planned (the so-called section-frame kits), mats can be any full-inch size from five inches to twenty-four inches, and then to any two-inch size up to forty inches. Of course, the strips can be cut to any desired length.

One of the functions of the windowmat is to act as a separator between the glazing and the picture. The space acts as an air pocket that protects the picture from high or low humidity at the warm or cold surface of the glazing. Because of some characteristic of the support or of the design, it is sometimes necessary to make the window thicker than four ply. This is a requirement for large pictures so that their centers do not bulge against the glass, and for those glazed with polymethyl methacrylate (Plexiglas), a less rigid material than glass that can cup out of plane. Adequate spacing is particularly important if powdery substances, like pastel, are used in the design. They are seriously injured by contact with glass and should never be glazed with electrostatic synthetic materials like Plexiglas. Also, they are quite prone to mold. Greater depth can be achieved by the use of eight-ply matboard, an expensive material, or by double or even triple layers of four ply. This arrangement does not necessarily mean the difficult cutting of matched of the windows. The lower windows could be recessed behind the outer one or, if desired, placed forward in steps of decorative proportions. In some instances, as when pictures are framed without win-dowmats or when they are very large, spacers are built into the frame's rabbet. If the spacer is of wood, it should be surfaced with a sealer, like shellac, or a paint that could be colored to suit the design of the frame. Whatever the surfacing, strips of four-ply matboard should be adhered to the spacers where they come in contact with the paper support. A good-quality polyvinyl acetate emulsion, like Jade No. 403 or Promatco A-1023, is adequate for attaching the plies of the windowmats together and the matboard to the spacer.

2. The window opening is planned and ruled onto the matboard with light pencil marks. It is best for the window just to overlap the edges of the paper support in order to hold it evenly flat without constriction. However, sometimes it is required to expose the edges of the paper within the window.

The window is cut with either beveled or right-angled edges. There are

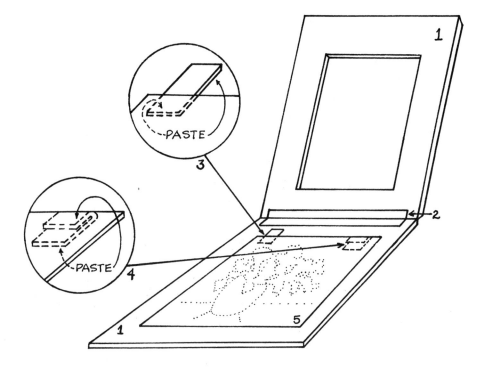

Figure 3: A method of matting a work of art on paper.

1 Window and supporting mats made of 100% ragboard or purified, buffered sulfite board.
2 White cloth gummed tape.
3 Hanger of Japanese long-fibered paper adhered with wheat-starch paste. The hanger is used if the edges of the object are to be covered by the window mat.
4 Hinge of the same material. The hinge is used if the edges of the object are not to be covered by the window mat.
 If cross-strips of Japanese paper are to be used for reinforcement, they should be placed just above the edge of the object in the case of 3; and below the folds of the hinges and a little below the edge of the object in the case of 4.
5 The print or drawing.

various devices for cutting mats. Some operators with steady hands can cut bevels of constant pitch simply by running a razor-sharp knife along a straight edge; others prefer a hand-fitting pod that holds a blade of set depth and pitch, like the Dexter Cutter, also guided along a straight edge. Then there are the more elaborate tools in which the cardboard is held in a clamp and the cutter is controlled on a track. All methods require experience and practice.

The window is made as trim as possible. Feathery corners can be corrected with a scalpel; fibrous and sharp edges and slight unevenness can be removed with sandpaper or emery board. If so desired, the edges of the window can be made glossy by burnishing them with an agate.

3. The two mats are placed on the work table with their inner surfaces upward and the edges that are to be hinged together aligned against each other with a narrow crack between them. They are held in place with weights.

It has been found best to use a long side of the mats for the joining hinge; that is, a vertical window should be hinged along the left side like a book; a horizontal along the top. The principal reason for this convention is that it makes finding one matted picture among a group of others in a storage box easier and safer because all the hinged sides lie on the same side of the box. However, if a vertical design is to be framed or is to spend most of the time in a frame, the top edge of the mat is used for the hinging.

A strip of one-inch gummed white cloth tape to serve as the hinge is cut a little shorter than the length of the crack between the mats. The tape is folded in half lengthwise, the gummed side outward, to give the hinge a set crease and to establish a central guideline. It is laid on a blotter and the adhesive thoroughly wet by slowly drawing a well-saturated cotton ball along it with a steady, continuous movement. Going back over the wet tape should be avoided because it will remove adhesive. A convenient wetting device is the porcelain roller moistener, which is used for sealing envelopes. Excess water is allowed to drip off. The tape is put in place with the crease running along the crack between the boards, and pressed firmly into contact by rubbing it with a cotton ball that has been wrung out so that it is but damp. The tape is allowed to dry, having been covered with a blotter or toweling and weights.

4. When the tape is dry, the windowmat is turned to cover the backmat, and

the edges are checked for proper alignment. Any needed adjustment is made. The picture is positioned under the window and, protected with a covering paper, held in place with a weight. The windowmat is opened again, and the locations of the upper corners of the picture are indicated on the backmat with light pencil marks. The picture is removed from the mat and placed face down on a protective paper awaiting the application of the mounting tabs.

5. The mounting tabs are planned and formed of long-fibered Japanese paper. Usually their shapes tend to reflect those of the paper they are to support; for example, large and horizontal tabs for large, horizontal papers. The heavier weights of Japanese paper, like Minokishi or Sekishu, are used for large or thick paper supports; the lighter, such as Usugami or Kizuki-banshi, serve to hold small or thin papers.[82] The edges of the tabs are torn rather than cut in order to feather them and so avoid the danger of impressing sharp lines on a support. They should be placed at the top edge of the support whether the design is vertical or horizontal, the number being determined by the weight and character of the paper. Often two are sufficient, placed near, but not at, the side edges. Sometimes multiple tabs are required if a large picture is being matted or one that otherwise would sag.

Caution one: Proprietary tapes that should not be placed in direct contact with art on paper (although some of them are useful for secondary purposes) are pressure-sensitive, transparent tapes and masking tapes because of their staining properties and difficult solubilities; gummed cloth tape because it is thick and could make impressions and because it has a strong adhesive that could cause cockling; gummed paper tape, whether the heavy brown ''butcher's'' type or the glassine stamp-hinge type because they are acidic, especially the former, and the adhesive of the latter is not long lasting; the modern contact and wettable tapes with synthetic adhesives because their eventual altered solubilities may make removal difficult.

Caution two: A frequently practiced kind of mounting is to place the tabs on the left edge of a vertical design, a method that is unsatisfactory because the unsupported side tends to sag when held upright in frame or mat. Other mounting customs that should not be followed are to attach the paper to the windowmat by hinges or by continuous stripping around all edges. In the first method, the paper could be torn when the mats are

opened, pulling it suddenly away from the backmat; in the second, the paper, being thin, will react more readily to moisture changes than the mat and suffer severe stresses.

6. The wheat-starch storage paste is prepared for the particular job, the amount of dilution depending upon the weight of the paper to be supported. Naturally, the larger and heavier paper needs a denser and stronger adhesive. On the other hand, a dense adhesive will cause a thin paper to pucker and distort. In neither case should it be watery, a characteristic of diluted pastes if they are kept beyond a day. Magnesium bicarbonate water may be used in the dilution (see Part III).

 Caution: The eventual removal of mounting tabs should be considered a certainty, so that easily water-soluble paste adhesives should be used. If, as infrequently happens, an adhesive is required that is not water soluble, a notation should be placed on the reverse of the backmat stating its nature and solubility.

7. One at a time, the mounting tabs are placed on a blotter and a third of its width brushed with paste by repeated strokes so that some adhesive penetrates the tissue. The tab is lifted with tweezers and, after a moment's pause to allow some of the moisture to evaporate, placed in the planned position on the back of the support with the upper edge of the pasted area nearly on line with the top edge of the paper. After another moment, the back of the tab is pressed with a cotton ball to remove more moisture and to establish good contact. If there is danger of forming a water ring, see the procedures suggested under Mending Edge Tears, above. Drying is accomplished first by pressing with light weights placed on top of protecting pieces of polyester web and blotter, then completed under a fresh blotter without the web.

8a. The mounting tab used as a hangar. The more secure method of attachment is to suspend the picture by its tabs on the backmat, a method that can be used when the windowmat covers the edges of the support. The paper is positioned on the mat with its top corners at the pencil marks and held from movement with light weights. The upper two-thirds of the tabs are turned down onto a protective strip of wax paper or Mylar and painted with paste. The tabs are turned up and pressed into contact with the backmat by means of a cotton ball, then dried as above. It is important to be sure that no paste penetrates below the support so that it is completely free of the mat and can be lifted, if necessary, for examination of the reverse.

8b. The mounting tab used as a hinge. When the edges of the art paper are to be exposed within the window opening, the upper part of the tabs are folded down to form hinges. The folds should be placed a little below the top edge of the paper so that the tabs will be concealed behind it. The picture is turned face down and placed above the pencil marks with its upper corners positioned on them. Again, the unattached two-thirds of the tabs are painted with paste, pressed into contact, and dried.

If the picture cannot be turned face down, a strip of polyester web inserted between the two parts of the hinge will permit attachment without danger of the hinge sticking to the backmat. In this case, weights will have to be placed on the protected upper front of the picture. If this cannot be done, as with thin paper, for fear of impressing the shape of the hinge upon it, the paper will have to be held on a braced support at a high enough angle to permit the part of the hinge being attached to the backmat to be pressed after pasting and dried.

Pictures whose edges are not caught by the windowmat should be observed in an upright position for a while to see if they tend to curl outward. If this is the case, small additional hinges will have to be placed at the side edges near the bottom. These subordinate tabs can be attached by folding them after pasting them around a strip of polyester web and inserting them into place. After drying under light pressure, the web can be removed with tweezers.

9. Placing an alkaline paper between the support and the backmat is a good precaution if the mats do not contain a buffer (see the first paragraph under Spray Deacidification above). It can be held in place with small tabs of a self-sticking tape, such as 3M Scotch Brand Tape, provided the tabs do not come in contact with the valuable paper. Otherwise it can be adhered to the backmat with spots of paste.

Variations in Matting[83]

Museums whose works of art on paper are used a great deal for exhibition and study have sought ways to modify the matting so that the essential part of it does not have to be replaced too frequently because of handling soil. Simple matting—a windowmat and a backmat, as described—can become marked and smudged in a discouragingly short time without proper care. Even the user knowledgeable in the treatment required by valuable objects often considers the matting

quite dispensible, if he gives it any thought at all. Yet not only is its replacement expensive, but the valuable object has to undergo possible hazards in unmounting and remounting.

The use of double windowmats is one of the modifications some museums have adopted. The outer window that must be kept clean for show, whether an unadorned, well-cut mat or a painstakingly decorated one, is so hinged that it can be turned back behind the backmat while the object is available for study. In this position, if handling soil must occur, it will be on the reverse of the show mat and on the inner windowmat, which will be covered during exhibition.

Another excellent modification is the use of a double backmat, or it might be thought of as a secondary support. The object is attached by hanger or hinged tabs in the normal way to the inner backmat, which in turn is attached by tabs to the outer one. If the inner mat is made of a pliable material like two-ply board, the reverse of the object can be inspected by arching up the mat so that the object need be only gently supported with a light touch. The inner mat should, of course, be larger than the object, yet, if possible, smaller than the outer mat. The attachment of the object can be very long lasting, provided always that the inner mat is made of acid-free materials. The outer mat can be changed as frequently as conditions require without having to disturb the object of value.

21

Framing

Standard Framing (see Figure 4)

This method of framing, the most generally practiced among conservators, is designed to provide a dust-free, acid-free housing made of good-quality materials that should have slow deterioration rates. It forms a closed, but not airtight, frame so that there is interchange between the enclosed air and the air of the room. Because of the hygroscopic character of the paper and cardboard contents, the housing probably can counteract the extremes of dryness and moisture experienced by the room, unless they are of long duration. In other words, it functions best in a museum climate but can endure non-air-conditioned atmospheres if, during a period of prolonged high humidity or sudden, severe drop in temperature, it is returned to a conditioned storage or, failing that, is placed under a moisture-absorbing cover such as a blanket or thick layering of soft paper.

The objects that should be closed in permanent frames rather than mounted in standard-size mats for temporary framing are those that might suffer more from handling than benefit from periods of rest in storage boxes: large cumbersome pictures, collages, pastels or other friable design materials, fragile or "sick" pictures, pictures that have frames especially suitable to them, and those that are on frequent display. However, like the unframed objects, they should be kept for the better part of the time in the dark of storage or protected in some other way against long exposure to light.

Procedure

1. The frame and its contents should have been kept in an atmosphere conditioned to RH between forty percent and fifty-five percent for at least two weeks, or long enough to ensure that the moisture contents of all the materials have reached equilibrium with that level of humidity.

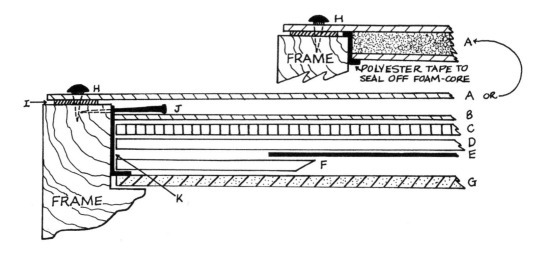

Figure 4: A cross-section of a packed frame.

A Backing paper and dust cover: could be a good quality wrapping paper like heavy Kraft, or acid-free wrapping paper from Process Materials, or polyester web like Hollytex, or a stiffer material like Bristol board.
Or, for large pictures: styrene-cored, light-weight board like Bainbridge's Featherweight Board. If this backing is used, B can be omitted. Or, if a package of the enclosures is formed, B can be Mylar (polyester film) for the back member of the sandwich, the glazing the front member, and all edges closed with pressure sensitive tape like passe-partout.
B Acid-free barrier paper to absorb random acidity entering the frame: could be acid-free text or cover paper.
C Backing cardboard to be a stiffener and protection against mechanical damage from the rear: could be acid-free purified sulfite board, 2-ply.
D Back Mat. (See Figure 3.)
E Art Object. (See Figure 3.)
F Window Mat. (See Figure 3.)
G Glazing.
H Rubber headed tacks, or, to avoid hammering, rubber bumpers with contact adhesive, placed at the bottom corners of the frame to permit air to circulate behind it.
I Adhesive seal around all edges: could be double coated 3M tape No. 415, ¼" or ½", or, for heavy backing material, water-soluble proprietary glue.
J Retaining nails: should be rustproof like brass escutcheon pins.
K Dust seal (if a package is not made); could be pressure sensitive tape like 3M's No. 810.

2. The frame is turned face-down on some kind of protectively soft material between it and the hard surface of the work table. Large frames can be placed on two padded horses. The rabbet is thoroughly cleaned.

3. After the glazing material is cleaned,[84] it is rested on the back of the frame, and strips of transparent plastic tape, such as 3M Scotch Brand Tape, are attached to form a dust seal. The strips are firmly adhered along

all edges for ⅛ inch or less, so that it is not visible from the front. When the glazing is placed into the frame, the tape will angle up over the walls of the rabbet where it can be secured with finger pressure. If the rabbet is deep, a higher layer of tape is added in order to seal off any contamination from the wood.

Glazing Materials

a. Glass. Single-strength window glass is satisfactory, unless (1) the picture is very large, then double-strength glass or light plate glass or rigid plastic sheeting is required, or (2) the picture is to be sent on loan by public carrier, then the glass should be stripped in both directions by closely spaced strips of masking tape, or rigid plastic sheeting should be substituted.

b. Reflection-proof glass. Contrary to some other nonglare glasses, the product Denglas does not have to be in contact with the object and remains virtually invisible at all viewing angles without distorting the aspect of the object. It is effective whether near to the object, as in framing, or at a greater distance, as in a shadow box. Although its surfaces (thin fused metal coatings) cannot be scratched easily, care should be exercised in dusting and cleaning. It is inert and without a static charge; therefore, it is harmless to all design materials. It has the breakability of ordinary glass, making it unsuitable for the glazing if the object is to be shipped.

c. Gedolin is a glass similar to Denglas. It has a nonglare, antireflecting coating that is a UV filter and that reduces static electricity.

d. Polymethyl methacrylate sheeting (usually Plexiglas in the United States). Whether clear Plexiglas G or, to filter out ultraviolet rays, Plexiglas UF3 is used, it should be appropriately thick for the size of the frame to give the rigidity required for the expanse. Because the plastic sheeting is less rigid than glass, greater space between it and the picture should be allowed.

Caution: This material is fairly inert chemically, but its electrostatic property is a serious threat to loosely bound substances like charcoal and pastel. Available from plastics dealers, there are antistatic polishes, anionic or cationic surfactants that tie up (neutralize the effects of) static charges. They are most beneficial when applied to both sides of the sheeting. Therefore, the outer coating should be renewed occa-

sionally because it can be rubbed off by handling and dusting. Apparently, the presence of the film within the enclosure of a frame will not create an internal atmosphere injurious to paper. It is not volatile and is either neutral or slightly alkaline. In any case, there should be a separator, as usual, between the glazing and the object. Nevertheless, even with the antistatic coatings, it seems a little foolhardy to use the plastic sheeting with pastels and charcoals.

If Plexiglas is used, care must be taken to protect it from abrasive contact. Lenders should be warned by labels on the reverse of the framing that it is present, lest they, mistaking it for glass, strip it with masking tape for protection during travel.

e. Lucite AR and SAR (Abrasion Resistant and Super Abrasion Resistant) are materials developed to be scratch resistant. They have a polymethyl methacrylate core to which are bonded surfaces of a hard, clear plastic. Although somewhat electrostatic, they are appreciably less so than Plexiglas. They are more expensive but may be well worth considering for the glazing of valuable pictures. They can also be obtained with ultraviolet filtering cores: Lucite AR UF3 slightly yellow and Lucite AR UF4 colorless.

Note: Dr. Robert Feller, the scientist who has done so much work with light, advises that all framed pictures on paper be glazed with UV-absorbing material. He believes that paper as well as light-sensitive design materials would be protected from considerable damage by light in this way.

4. The glazing is given a final cleaning, and it and the matted picture are dusted with a soft brush to remove all stray particles. The picture is placed into the frame.

5. A sheet of buffered paper, like acid-free text paper, is placed over the backmat. As has been described under Deacidification of Secondary Papers, the paper can have been given a greater buffering capacity by having been sprayed with magnesium bicarbonate water. The paper is cut so that its edges come as close as possible to the walls of the frame, even cupping slightly along them. The paper protects the backmat from soil, but its principal purpose is to absorb acidity, both that within the frame and that intruding from outside.

6. The depth of the rabbet controls the thickness of additional backing materials. To protect the picture from mechanical damage, the sturdiest ma-

terial that the space allows should be included, such as acid-free bristol board for shallow rabbets and acid-free mounting board for deeper ones.

7. Thin brass escutcheon pins make good retaining nails, being rust proof. Should their heads be troublesome because of the shallowness of the rabbet, they can be snipped off or flattened. The retaining nails should be placed fairly close together, such as every three inches for an average-size frame, so that they will hold the mats in even register with the glass but not pressed down hard against it. The Brad Fitting Tool is invaluable here. It is a device with a triggered handle that can be compressed to draw a hooked piston in the sleeve of its shaft toward an adjustable stop. When the stop is placed against the outside wall of the frame and the hook against the head of the nail, the action of the trigger draws the nail into the wall without the jarring or abrasion that hammering can cause.

8. Acid-free wrapping paper is used to cover the entire back of the picture. A piece is cut larger than the frame and spread on a soft surface like a blanket; an adhesive that remains water soluble as glue is brushed on the back of the frame and smoothed with the finger or a cotton swab so that none can flow into the frame; the frame, face up, is positioned on the paper; and weights are placed on its protected surface to hold it down against the paper until the adhesive has set. A most satisfactory adhesive for this purpose is double-sided Scotch tape no. 415. The paper is then trimmed near the back edges of the frame with a straightedge.

 For large pictures, Featherweight Board makes a lightweight, very strong backing board. It is composed of a plastic-foam core bonded between thick, heavily surfaced papers. The papers are not acid free, but their coating and the buffering within the frame should prevent any acidic migration to the work of art. The board can be tailored to fit the frame by cutting away the inner paper and the core to the dimensions of the inside of the rabbet and adhering the overlapping outer paper to the back of the frame with glue. The exposed core can be sealed off with strips of 3M Scotch Brand Tape.

9. The favored hanging devices are those composed of metal loops hinged to plates that can be screwed into the back of the frame. They come in several sizes, from small to those strong enough to support heavy frames. However, they do not come small enough for very little frames, so tiny screw eyes must be used for this purpose, augmented by loops of picture wire.

In the actual hanging of a picture, it is obvious that the use of two points of support, whether wall hooks or wires from hooks on a picture molding, are twice as safe as the use of one. Most museums do not hang pictures on one hook from wires spanned across the backs of the frames.

10. Finally, rubber-covered tacks or bumpers should be placed near the bottom corners of the frame to lift it a little away from the wall and so allow air to pass behind it. Rubber bumpers come in different sizes and shapes and have a pressure-sensitive adhesive backing.

Sealed Framing

Collectors without air conditioning are sometimes advised to close their framing with 3- or 4-mil polyester (Mylar) sheeting. It can be applied either across the back of the frame by being adhered with double-sided tape or, far better, used to form the back of a package enclosing the contents whose front is the glazing and whose walls are strips of plastic tape that overlap the edges of the glazing in front and those of the Mylar in back. The whole package can then be placed in the frame. Although this kind of enclosure is not hermetically sealed, it is sealed enough to slow down air interchange decidedly. Mylar is almost as impervious to moisture and gases as is glass. Therefore, care should be taken that all materials included within the package are inert and free from dampness. However, there is the possibility that should dampness get into the enclosure during long periods of high humidity, it might not easily get out. Another possibility might be that since the amount of material contained within the package is greater than the unoccupied air space, the response of its internal relative humidity to changes in temperature could be opposite to that in open air; that is, the internal RH may increase with the increase of temperature. The situation is like the closely packed and sealed shipping case described by Nathan Stolow.[85] If this kind of framing is used, it would be well to include a sachet of conditioned indicator silica gel, placed so that it is visible through the backing Mylar to act as a stabilizer and as a telltale of the internal RH of the package.

Temporary Framing in Standard-Size Frames

The conservatorial purposes of this kind of framing for objects on standard-size mats are to allow: (1) any one picture to spend most of the year lying flat in the darkness of a storage box; (2) a review of its condition and the condition of its secondary materials in periodic inspections or whenever it is handled for

exhibition; and (3) cleaning of the interior of the frame before each use, together with a check of the dust seal and a renewal of the backing papers.

Many ingenious methods of closure have been devised for temporary frames, usually employing solid backboards that fit into the frames in some manner. A few examples are:

a. A backboard with tongued edges on three sides that fit in grooves in the walls of the frame. Attached to the board is the fourth side with ends mitered to match the ends of the rest of the frame.

b. A backboard with one or two battons pivoted on its central axis so that they can be turned to latch into slots in the walls of the frame.

c. A simple method is to fit a backboard into a secondary rabbet in the back of the frame's wall whose depth is a little greater than the thickness of the board and to hold it in place with turn buttons or spring clips.

The backboards are made of any suitable, reasonably inert material: hardboard, tempered Masonite, aluminum panel. To prevent the board from communicating any soil or acidic contamination to the interior of the frame, its inner surface should be coated with a material that can give a cleanable and fairly impervious finish, like synthetic varnish (polyurethane), enamel paint, allover-adhered acid-free paper.

Section frame kits, mentioned above under Matting, are very convenient devices for temporary framing. Obtainable in art stores, they come in different styles and colors. They are wooden or metal channels equipped with right-angled bars for fastening the assembly at the corners, arch springs to hold the contents from movement, and links for hanging. The matted object to be so framed should be packaged with Mylar backing and self-sticking edge tape, as described under Sealed Framing, above. Sufficient backing material is included in the package to form a thickness that will fit easily into the channels of the framing strips. Cardboard (acid-free, of course) makes adequate backing material, except for the larger frame sizes, which are prone to torque. Then a more rigid backing is required, such as painted hardboard or tempered Masonite.

Encapsulation and Folders for Unmatted Material

In addition to the collections of works of art on paper, there is a category of single-sheet papers, often of high value, for which matting is not particularly suitable: documents of all kinds, maps, newspapers, book illustrations. They are usually not intended for display, except in temporary, topical shows, yet they must be available for reference and reproduction. Should they be used for prolonged exhibition, however, matting may be the best protection; windowmat in front and, if both sides of the document are important, windowmat in back, or a photograph of the reverse.

Complete Encapsulation

Each unmatted work on paper should have its own separate housing to keep it as safe as possible, guarded from dust, from crumbling in a folder, from direct handling. For large documents, for fragile ones, and for those that have information on both sides, encapsulation makes a suitable housing. Developed at the Library of Congress, it is a method found to be extraordinarily protective.[86] Fragile or dog-eared material seems not to be harmed mechanically even by frequent handling. Yet, unlike the older method, lamination,[87] the paper can be easily recovered from its enclosure. Encapsulation involves placing the paper of value, conditioned to an RH around forty-five percent, between two pieces of polyester film (usually Mylar D, 4 mils thick) all four of whose edges are sealed except for air passages at the corners.[88] The sealing can be done with double-sided 3M tape no. 415, allowing one inch of separation between the paper and the tape lest the paper shift its position a little and come in contact with the tape. Methods differ slightly, chiefly on how large should be the air passages at the corners. They must be there, otherwise the paper is sealed in with all its imperfections, a situation that could create a harmful internal atmosphere. Tests con-

ducted at the Laboratory of Research and Testing of the Library of Congress came to interesting conclusions: that the rate of deterioration of the paper was slowed if it had been deacidified before enclosure; that the larger the gap at the corners, the more slowly the paper aged; and that encapsulation of an undeacidified paper with a sheet of buffered paper caused the paper of value to behave in the same way as it would have had it been deacidified.

Encapsulation cannot prevent the breakdown of cellulose caused by internal acidity any more than can lamination. If, for one reason or another, a paper cannot be deacidified, complete encapsulation should be considered only as a temporary housing until the paper can be further treated. Its safety over a long term would also depend in part upon the inertness of the polyester film and its actual time-related behavior. It is considered to be the most stable of the transparent flexible plastics with far better endurance than cellulose triacetate, the material used in lamination.

Partial Encapsulation

Undeacidified archival papers that should be seen on both sides can perhaps most safely be held by partial encapsulation—folders or envelopes made of polyester film that are closed on one, two, or three sides. Of course, the folder type is the least able to keep the paper from shifting its position, and therefore may be used only as a quick enclosure while the object is being considered for purchase or while awaiting cataloguing or examination. The folder can be formed simply by very sharply creasing the plastic. Encapsulating envelopes with two and three sealed sides are of great advantage, especially the latter. They can hold paper over long periods, apparently without any more deterioration than would occur in normal aging. They offer constant protection, whether for single items in a storage box or for pages of a book or multiple pieces of closely related material held in post bindings or hinged with polyester web in bound book form.[89]

Caution: There are proprietary envelopes and folders made of many kinds of transparent plastics still available in department and stationery stores that should not be bought without questioning their composition. Much of the material is not meant for archival use. They may have built-in plasticizers and acid acceptors, which eventually could break down and give off substances harmful to paper. Good examples are some of the plastic folders with black paper inserts perforated for inclusion in ringed notebooks. Not only is the plastic bad, but black-dyed paper can be very acid unless manufactured with good-quality fibers and an alkaline additive.

Weld Sealing of Polyester Film

The high melting point of polyester film that first led to sealing with tape has been overcome by welding techniques, whether by ultrasonic or by electromagnetic methods.[90] The development of welding machines has greatly benefited the use of encapsulation because they can perform the sealing of edges quickly and attractively. Furthermore, they make the enclosures safer for the object by eliminating the chance of contact with the sticky tape. Tape sealing is still widely used, however, especially by institutions that do only occasional encapsulation. Yet a technician without a welder might wish to have the most valuable documents treated at an equipped library or conservation establishment. Also, some of the businesses that sell conservation supplies and services, like Conservation Resources International and Conservation Materials Limited, can make welded envelopes of any specified size, shape, and amount of closing, as well as offering for sale prewelded containers of many sizes designed for various purposes.

Acid-Free Cardboard Folders

For single papers that have information or design on only one side, a satisfactory protector and support can easily be made by sandwiching it between Mylar and two- or four-ply matboard. The Mylar is cut about ½ inch larger than the matboard on all sides, the edges are creased to form a rectangle the size of the mat, and the corners are mitered widely so that there will be a little air space at each one. After the object has been fastened to the matboard with hinge-type tabs, the two are positioned face down on the Mylar, and the edges are folded over to be attached to the reverse of the matboard with double-sided tape.

For objects that do not require transparent mountings, such as small pamphlets and multileaved documents, there are commercially available ready-made acid-free folders and cases as well as sheets of buffered papers and cardboards from which special containers can be easily fashioned in the conservation workshop. Figures 5a and 5b, for example, show handy patterns that can be used for objects too thick to be held in folders. They were designed by Willman Spawn, former conservator of rare books of the American Philosophical Society, to permit unbound pamphlets to be shelved and be safely accessible to the users of the library.

Boxes

Boxes made by the technician will be needed, whether shallow ones for the safekeeping of materials that should not be touched, such as unframed pastels, or thicker ones for fragile, deteriorated books. The developments in box design

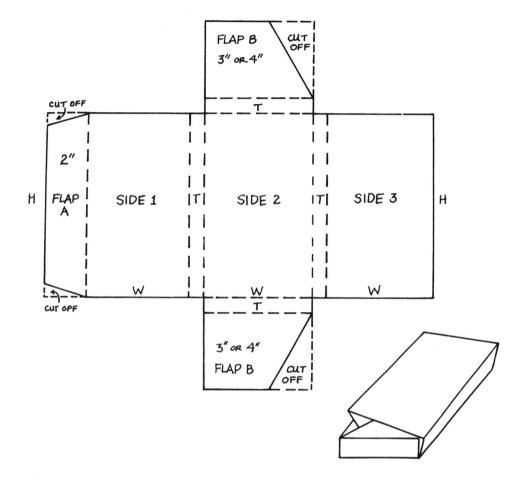

Figure 5a: Protective folder to permit the shelving of packets of papers, pamphlets, or thin fragile books.

Designed by Willman Spawn, former conservator of the American Philosophical Society Library.

To be made of acid-free material like Bristol board, 10 mils, as follows:

1. Measure the maximum length, width and thickness of the object. Make the pattern according to the diagram below, allowing 1–2 mm for each fold.
2. Score and crease all folds. Lay object on side 2. Fold over side 3 and the two flaps B. Fold over side 1 and tuck flap A into the diagonals of flaps B.
3. When using an inner protective cover or heavier weight material, increase the widths of sides 1 and 2 by 1–2 mm.

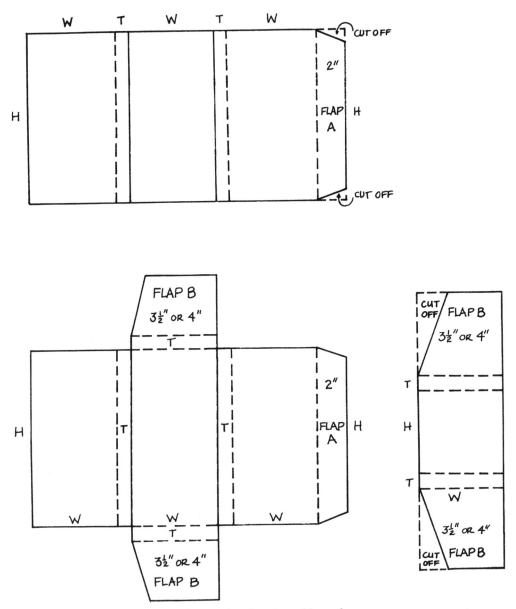

Figure 5b: The Spawn folder made of strips of board.

This design uses less material than the form shown in Figure 5a.

1 Cut a strip of board which is the height of the object and three times its width, plus twice its thickness, plus 2″ or more for flap A. Score and crease along dotted lines.
2 Cut another piece of board the width of the object, plus two times its thickness and plus a minimum of 3″ for each flap B. Score and crease along dotted lines.
3 Adhere the vertical strip to the horizontal one, as shown, with PVA emulsion adhesive, Jade No. 403. Place under pressure to dry. If necessary re-crease on dotted lines. The object is put in place and the folder closed as for Figure 1A.

by the Preservation Office of the Library of Congress are invaluable. The useful phase box that can be quickly made is a great contribution that has protected many weak and broken books from further damage. The ways of making all the major styles of boxes are described in generous detail in *Boxes for the Protection of Rare Books: Their Design and Construction*, compiled and illustrated by Margaret R. Brown. The ideas put forth in this book could be indispensible to the conservation technician and could lead to modifications such as for thick paper objects like a pack of matted, related works of art that should be kept together in a fitted box. Acid-free board for phase boxes can be obtained from the conservation supply houses. Conservation Materials offers directions on how to make them, Hollinger and Pohlig Brothers sell equipment for shaping and creasing them. Proprietary boxes of many kinds, shapes, and styles—from practical enclosures to the more elegant—also can be purchased from conservation suppliers.

A Showcase Design for Control of Internal Climate in a Non-Air-Conditioned Room

There are probably many ways in which a standard museum case can be modified to meet this purpose. One possibility might be the following.

The case section should be light enough so that it can be wheeled to and from the conservator's air-conditioned workroom. It should be constructed with tightly sealed joints. Its wooden parts, if there are any, should be coated on the inside and outside with a synthetic varnish like polyurethane to act as sealer and moisture barrier. Thus it would be fairly airtight except for the cracks of the opening through which most of the changing air would pass. In order to reduce the rate of air change, as well as to prevent the intrusion of dust and acidic impurities, the inner edges of the opening could be lined with linen or cotton tape that had been treated with calcium or magnesium bicarbonate, and the outer edges could be further sealed after closure with inconspicuous self-sticking plastic tape such as 3M polyester tape no. 850. Everything placed in the case should be free of ingredients that could be harmful to the enclosed climate or to the displayed papers. Woods with strong odors, like cedar, or of resinous character should not be included. Wood of any kind wanted for supports should be wrapped in alkaline covering to absorb organic acids from it. Other substances that could do harm are rubber products, proteins like wool and animal glue, sulfurous adhesives, nitrocellulose coatings and adhesives, unstable plastics, cloths with unreliable dyes, and decorative papers that could be acid. However, as much moisture-stabilizing material should be included as the design of the show will permit: cloths that have been washed and tested and acid-free papers. A closed showcase containing such hygroscopic materials may not require further sorbents like silica gel, especially if the periods of display are short. Yet for long display times, its presence could contribute to a more stable RH.

Silica gel, a form of polymerized colloidal silica, is a hard, inert, very porous

material that remains dry to the touch even when saturated. It has high moisture-absorbing and -desorbing properties and can react relatively quickly to changes of RH; both are functions of the tiny pores that cover the surfaces of the particles or beads. There are many types of silica gel that vary in density, porosity, and bead size, and therefore in the amount of surface area exposed to the air. The form used for most museum purposes, and available from conservation supply houses, is regular-density silica gel of small mesh. The suggested amount for controlling humidity in closed spaces is twenty kilograms per cubic meter. The beads could be held in thin (about ½-inch) panels made with aluminum honeycomb cores between several layers of small-gauge polypropylene screening. The size of the panels would be dictated by that of the case, so that they could be fitted over the nonglazed surfaces, whether laid at the bottom or built vertically at the back. Another form of silica gel is called Art-Sorb, obtainable in bead, sheet, or panel form.[91] It is a mixture of regular- and intermediate-density silica gel and is considered to be a far more effective moisture buffer than regular density, especially for relative humidities fifty percent or above. The sheet form (20″ × 20″ × ¹⁄₁₆″), which avoids bothersome handling and which can be cut to required sizes, is composed of Art-Sorb gel of very small bead size held in inert plastic sheeting. A proprietary panel (6″ × 6″) can also be of considerable benefit. It is formed with an acrylic grid whose cells (½ cubic inch) are filled with Art-Sorb, the whole covered with Gore-Tex, an expanded polytetrafluoroethylene (PTFE), or Teflon.[92] The unique porosity of the Gore-Tex film permits the Art-Sorb to control the humidity of a sealed space; one conditioned panel controls the RH for each 1½ square feet.

All objects put into the case, including silica gel of any form, should have been preconditioned for at least two weeks to the desired relative humidity at the average temperature of the gallery. Display papers or cloths can be used to conceal the utilitarian panels. The case, containing a small dial hygrometer carefully calibrated before enclosure, should then be ready to be placed in the gallery. If long display is necessary, or if the display also involves nonhygroscopic substances like metals, with the result that the internal RH changes significantly, the case should be returned to the workroom and reloaded with fresh materials that have been kept under controlled conditions. As a needed step in reconditioning the used panels of silica gel, they must be dried in a warm oven not above 212° F (100° C) for half a day, then kept at the desired temperature and humidity for two weeks.

Suggested Storage Methods

Framed Pictures

Vertical stalls are the favored storage for framed works of art on paper. The stalls should be narrow enough so that each can hold only two pictures separated from one another by a suitably thick spacer, such as rigid foam-cored board or corrugated cardboard cut to fit the stall and bound at the edges with masking tape. The flooring of the stalls should be carpeted or otherwise padded to prevent harmful vibrations and frame injury. Storage on standard museum screens is another possibility. Yet the action of movable screens is often too jarring for delicate objects, and the hanging or removing of large pictures made heavy with glazing can be troublesome, even dangerous. If lights must be kept on in the room where framed pictures are housed, the storage area should be curtained off so that these objects will have their share of darkness.

Unframed, Matted Pictures

Many museums and libraries keep unframed, matted pictures in metal or wooden drawers. This arrangement, however, requires the shifting of upper items in order to remove a lower one, and the user is often in uncomfortable reaching or stooping positions. Storage in shelved, shallow boxes seems to be the better method. Then an entire box can be taken from its shelf to a convenient table and the upper items lifted completely out to secure the needed one. Each box, which should be no more than 2¼ inches deep, can contain a number of pictures of more or less equal size, but not so many as to make the box too heavy to handle safely. The windowmats should prevent the lower pictures from being compressed by the upper ones. If a picture cannot withstand flat compression, however, an

individual portfolio or box or permanent framing should be considered for it.

a. Acid-free print storage boxes, often called solander boxes, can be obtained in two basic types: (1) Boxes made of thick, acid-free cardboard sometimes lined with buffered white paper or with inert synthetic paper like Tyvek, a tough, durable polyethylene. There can be little objection to these excellently designed containers. They are lightweight, offer safe storage for papers, and are not expensive. Yet their opening and closing are not always easy operations, the cardboard is somewhat inclined to fray and discolor with use, and the larger sizes lack rigidity. (2) The Spink & Gaborc box is strong, easy to use, and long lasting. Made with wooden frame, it is rigid, so that it can be handled without sagging or twisting. The lid, which is bound and hinged to the bottom of the box, can be opened to lie flat on the table, allowing removed items to be rested in it. When closed, it fits over the lip of the box and is held fastened with two clasps. The exterior is covered with dark binder's cloth that does not scuff easily, and the inside with heavy, white, glossy-surfaced paper or with Tyvek. Unfortunately, the material with which these boxes usually are covered is, like most cloth-bound library books, impregnated with pyroxylin (nitrocellulose), a substance that could give off nitric acid as it deteriorates over time. If these otherwise valuable boxes are used, they should be kept on open shelving. But if they must be kept in closed cabinets, the cabinets should be aerated. A method for doing this could be to open panels in the back covered against dust intrusion with metallic grids such as are used for radiator enclosures, and to insert a small panel of the same material in front. The passage of air so provided could sweep any impure vapors out of the cabinet.

b. Before being stored away, the picture and its matting are inspected, superficially cleaned, or otherwise treated as the need demands. A piece of neutral glassine or reflex matte paper is inserted between the picture and the windowmat to guard the design from abrasion. Both of these materials are sufficiently transparent to allow the picture to be seen clearly enough for reference or identification and would have to be withdrawn only for study. As slipsheets, they are easy to handle, unlike soft tissue paper, and have no electrostatic charge or harsh edges, as do the flexible plastics. Each picture and each box is numbered and arranged according to the curator's cataloguing system.

Materials Stored in Flexible Containers

In storage, objects in this category, such as those that are encapsulated or held in Mylar folders, should be protected from the compression of heavy piles and from slippage by being kept in shallow boxes or partitioned drawers. It would be beneficial to place an associated sheet of paper below each flexible plastic envelope layered in a box or drawer. The paper could help to stabilize the interior humidity as well as to prevent slippage, and could furnish a surface for identifying numbers or titles. By proper selection, the heavier weights of paper or board could furnish rigidity to the larger objects.

PART III

Requirements for the Care of Paper

In a crowded museum, where space is already at a premium, it may be difficult to allocate special rooms for paper holdings. Yet a determined review of the building could turn up unused or inefficiently used space that with ingenuity could be converted to the purpose. A separate area is the most practical way to care for this damage-prone material so affected by environmental conditions. There should be at least two rooms, one for storage and the other for the technician's workroom. It must be an area whose atmosphere can be controlled: the air washed and filtered, the temperature kept at a level consistent with human comfort, and the relative humidity maintained as evenly as possible, preferably between forty and fifty-five percent. If there is no central air conditioning, control must be effected with humidifiers or dehumidifiers and circulated air. The rooms should be interior ones not under the roof or in the basement. There need be no natural light; in fact, it would be better to have none in the storage room. The general artificial lighting, when needed, should be fairly low yet evenly distributed.

Furniture of the Storage Room

1. Double- or triple-decked racks of open-ended carpeted slots or bins, sufficient in number and size to hold at least half of the framed papers of the collection with space for expansion. The middle sections can be broad unpartitioned areas to hold objects that should not be stored vertically.

 Or, if screens are preferred, the stationary ones with ample walkways between them should be used. Movable screens are apt to vibrate or move unexpectedly when a picture is being hung. Also, they restrict the use of the unoccupied area of the room.
2. Cabinets or open shelves for the print storage boxes, the shelves placed close enough together so that the boxes cannot be stacked one on top of another.
3. File cabinets for cards on all papers of value in the collection, including curatorial information, condition and restrictions on use, conservation history, and location.
4. A small table on wheels, or a large cart, on which a required box can be placed directly from its shelf rather than having to be carried to a designated place.
5. A lightweight stable stepladder of sufficient height to permit the easy handling of the highest box or frame.
6. A study table with one or two hooded lamps.
7. Safety devices:
 a. Small emergency light.
 b. Smoke alarm.
 c. Fire extinguisher (Halon or carbon dioxide).

Furniture of the Workroom

1. A stainless steel sink as large as the space will permit or a large plastic photographer's sink—the faucets equipped with efficient filters.
2. A small utility sink with long counter; above it, cupboards for utensils; below it, drawers and vertical slots for trays, panels of plate glass, Masonite, hardboards, and so forth.
3. A small laboratory oven capable of holding an even temperature with a range up to 200° C.
4. If possible, a fumehood; otherwise, an adequate exhaust system so that work with toxic chemicals can be done safely.
5. Airline outlet with pressure gauge.
6. Safety equipment:
 a. Personal: goggles, respirator equipped with filters for organic vapors, nitril gloves, laboratory coat.
 b. Laboratory: eye-wash station, first-aid kit, safety can for used solvents, covered waste receptacle, smoke detector, fire extinguisher.
7. A metal safety cabinet that meets OSHA requirements for solvents and other inflammable liquids.
8. A small laboratory refrigerator.
9. Pegboard racks for tools; a supplementary tool kit equipped for any emergency or routine work away from the laboratory.
10. A tiered rack for large rolls of paper.
11. At least one large shallow-drawered map cabinet for stocks of papers and cardboards and for work in process.
12. In the center of the room, or in a position so that it is free on all sides, a large, wheeled, fairly low work table (thirty inches high); or, even better,

two moderate-size tables of the same heights so that they can be wheeled together for big jobs. All work surfaces should be covered with a cleanable material, such as Formica.

13. Several incandescent or filtered fluorescent lamps to supply work light when needed.

14. A lamp, either portable or on a floor stand, of clear stable light to be used for examination and color matching, such as a high-intensity Tensor Lamp. A good lamp for the purpose, but fairly expensive, is the Castle Examination Light Model 2410, which is designed for use in surgical rooms of hospitals.

15. An area set aside for examination: a table with an adjustable top, such as a drafting table; a binocular "operation" microscope with good working distance (ca. five inches) and a range of magnifications from 5X to 30X; a chemist's polarizing microscope equipped with both reflected and transmitted lighting systems; as much analytical equipment as suits the technician's needs and abilities.

16. A light box.

17. Camera(s), tripod(s), lights, stands, and films for the in-house photographic procedures.

18. Within easy accessibility, but not in the workroom, an adequately sized disinfecting chamber.

Formulas

Mold Nutrient

For exposure in petri dishes to test-room conditions (see Part I):

Maltose-agar: 5 grams (gm.) or 1½ teaspoons (t.)
Sodium chloride (*not* table salt): 25 gm. or 4¼ t.
Distilled or deionized water: 250 milliliters (ml.) or 8¾ fluid ounces (fl. oz.)

Mix ingredients and heat with constant stirring until the agar is dissolved. Pour into petri dishes that have been sterilized in boiling water. Fill dishes half full and cover immediately. Allow the medium to cool and harden and most of the moisture condensed on the covers to evaporate. After a fifteen- or twenty-minute exposure of the medium in the room being tested, recover and place dishes under a sterilized bell jar with a Vaseline seal between its rim and the sterilized surface on which it rests. The surface can be a sheet of glass. The sterilization of it and of the bell jar can be done by washing in hot water and wiping, just before use, with alcohol. For the necessary moisture, include in the jar a small container of water that has been boiled. Allow to stand for a week or two. The severity of the conditions in the room is indicated by the number of spots of innoculation and the variety of the mold growth.

Fungicide for Pastes

o-phenyl phenol or thynol: 2 or 3 t.
Ethyl alcohol: 50 ml. or 1¾ fl. oz.

Put several teaspoonfuls of the crystals in the alcohol. Stir until dissolved. Make in small amounts because not much is needed. Use a well-stopppered bottle and keep in a dark, cool place.

Caution: The materials are toxic; therefore, the container should be marked POISON.

Magnesium Bicarbonate Water

For introducing beneficial ions into deionized or distilled water used in treatments and making it slightly alkaline. And for neutralizing pastes and secondary papers and increasing the buffering property of backing papers.

1. For small quantities: yield about 200 ml.
 a. Made with seltzer water:

 > One bottle of seltzer water: 300 ml. or 10½ fl. oz.
 > Powdered magnesium carbonate: 15 gm. or 10 tablespoons (T)

Put the magnesium carbonate in an empty bottle of slightly greater capacity than the seltzer-water bottle and that has a tightly fitting cap or cork. Place both bottles in a refrigerator overnight or until thoroughly chilled. The reason for keeping the materials cold is to increase the quantity of the magnesium carbonate that will go into solution. As quickly as the operation can be done, open the seltzer-water bottle and put the charged water into the magnesium carbonate bottle. Cap firmly and agitate for a short period. Return to the refrigerator. Keep the magnesium carbonate from settling for the next half hour by repeating the periods of agitation and return to the refrigerator. Allow the excess magnesium to settle for several hours or overnight. Siphon off the clear liquid. Keep firmly capped and refrigerated.

 b. Made with a soda-water siphon:
 The most convenient way to make magnesium bicarbonate water is with a standard strong-walled soda-water siphon. It must be modified by cutting an inch off the siphon tube so that its end will be clear of the sediment of undissolved magnesium carbonate.

 > Distilled or deionized water: 400 ml. or 13½ fl. oz.
 > Powdered magnesium carbonate: 20 gm. or 6½ T.

Pour the water into the siphon bottle. Place it and the container with the magnesium carbonate in the refrigerator until chilled. Funnel the carbonate into the siphon bottle. Shake well. Discharge the carbon dioxide cartridge. Shake well. Keep the magnesium carbonate from settling for the next half hour by repeating the periods of agitation, and return to the refrigerator. Allow the excess magnesium to settle overnight. Siphon off the clear liquid. Keep firmly capped and refrigerated between uses.

2. For larger quantities:

Magnesium carbonate: 57 gm. or 2 oz.
Distilled or deionized water: 4 liters or 1 gallon

Stir the carbonate into the water until it is thoroughly immersed. Bubble carbon dioxide gas from a pressurized cylinder through the mixture for about two hours. Allow to settle overnight. Siphon off the clear solution. Keep in a well-stoppered container for use until magnesium carbonate begins to settle out. Discard the remainder.

Calcium Hydroxide Solution

Used for the same purposes as magnesium bicarbonate water.

Calcium hydroxide: 4 gm. or 2 t.
Distilled or deionized water: 1 liter or 1 quart

Stir the hydroxide into the water until it is thoroughly immersed. Close the container and shake it vigorously several times. Allow to settle overnight. Allow the undissolved hydroxide to remain in the bottom of the container. Use only the clear solution.

Note: To test the alkalinity of carbonated solutions, place a drop on a piece of paper and wait until it has dried, then test with an acid-base indicator. The pH of carbonated solutions cannot be judged until all the carbonation has gone off.

Adhesives

An ideal adhesive for use on valuable papers should:

1. Retain bonding properties sufficient for the particular use.
2. Remain acid free.
3. Be no more subject to discoloration than the paper itself.
4. Be no more subject to mold or insect attack than the paper.
5. Remain readily soluble in its original solvent (water-soluble adhesives being preferred far above all others).
6. Have a reasonably long shelf life.
7. Be easy to prepare.

Unfortunately, there is as yet no adhesive that meets all of these specifications. Proprietary materials fall especially short:

1. Many commercial pastes and synthetic emulsion glues are acid and become unstable with time.
2. Pressure-sensitive tapes should not be used in direct contact with papers of value. Some are not designed for archival purposes and can be actually destructive, communicating discoloration and causing brittleness. Even the solubilities of those that are meant to be long lasting change and become difficult to remove. Of the latter, the most reliable are the Archival Aids tapes. But they should not be used on works of art.
3. Gummed paper tapes, like the stamp-hinge variety, are not recommended. The adhesive is neither strong nor enduring, and the paper is usually acidic glassine, a material that becomes brittle and weak.
4. Mounters in frame shops are inclined to use gummed cloth tape for hinging. This tape seems to do little harm. But it is thick enough to make impressions on most papers, and the adhesive tends to yellow.

Formulas for a few adhesives are given in the following paragraphs. All of them have their drawbacks. Yet if the technician keeps on hand the materials with which to make them, and if he has the persistence to use them within the suggested limits, his principal needs should be successfully met.

Wheat-Starch Paste

This adhesive and its associate, rice-starch paste, are smooth, strong, and white and retain their tack even when diluted. They are safe to use for any purpose involving direct application to papers of value. Both are thoroughly time tested, having been used by generations of Oriental mounters and for many years having

been a favorite among paper conservators. Because they have withstood the test of actual time, they are suggested as the chief adhesives that should be used for most purposes, such as the mending of edge tears and the attachment of mounting tabs.

Their faults are that they require a little time and care to make and to prepare for use. Also, they have a fairly short shelf life and must be discarded the moment they show signs of spoiling.

Wheat starch: 30 gm. or 12½ t.
Distilled or deionized water: 200 ml. or 7 fl. oz.
o-phenyl phenol solution in ethyl alcohol: 5 or 6 drops (optional)

1. The double-boiler method:
 Put the water in the upper part of a double boiler and, before cooking, soak the starch in it for about a half an hour with occasional stirring until the starch is thoroughly saturated. Cook over slowly boiling water with constant stirring for thirty minutes. The material will become thick and opalescent. It will go through a very stiff stage, then, toward the end of the cook, will become less stiff and easier to stir. At the end of the cook, add the drops of the OPP solution; remove the lower part of the double boiler and cook with rapid stirring directly on the burner for about two minutes. Put in a storage jar that, together with its lid, has been wiped with a swab dipped in the OPP solution. Keep in a dark, cool place, but not in the refrigerator.

2. An improved method based on Japanese techniques:
 In a saucepan, mix the starch in the water until it is thoroughly saturated. Place the pan directly on moderate heat, keeping the paste just short of boiling throughout the cooking. Stir constantly for twenty-five or thirty minutes. As described above, the paste will become less stiff at the end of the cook. Then, if desired, drops of the OPP solution may be added as a mold deterrent. Spoon the paste into a disinfected jar. When it has cooled a little, fill the jar with cold water. After a few minutes, pour off the first water and refill with fresh. Whenever some paste is removed for use, pour off the water and replace.

Rice-Starch Paste

Rice starch: 10½ gm. or 6 t.
Cold distilled or deionized water: 475 ml. or 1 pint

Mix the starch and a little of the water to a thick cream. Bring the rest of the water to a boil. Add the mixture to the water and stir constantly over moderate heat until the paste becomes thick and glossy. To disinfect, swab the container with the OPP solution.

Note: Wheat- and rice-starch pastes serve the same purposes. Since there is no need to have both on hand, the preference of most conservators is for wheat starch. A few conservators use paste made from the flour of wheat or rice, but flour introduces unnecessary ingredients and is therefore not recommended.

To prepare for use, break down an amount of the storage paste sufficient for the need by pressing it with a spoon or spatula through a strainer. Repeat the straining once or twice. The strainer can be a circular Japanese sieve or, for a small quantity of paste, a piece of synthetic screening held over the paste dish. Dilute it with distilled or deionized water or, if a neutral paste is desired, with a mixture of water and magnesium bicarbonate water. The resulting paste should test by pH indicator to be slightly alkaline. The amount of dilution, best judged by experience, depends on the thickness of the paper and its reaction to the aqueous adhesive. For most uses, the paste, which could pucker the paper if used too thickly, should be diluted to a heavy creamlike consistency.

The Mix

Often a stronger adhesive than standard paste is needed in the forming of special mattings and enframements. The Mix could be excellent for such purposes. It is a mixture of Methyl Cellulose Paste powder and polyvinyl acetate emulsion, Jade no. 403, the synthetic white glue found to be most reliable. The Mix is more plastic, more maneuverable, and slower setting than the PVA emulsion itself. Its strength depends on the amount of PVA emulsion incorporated in the mixture. An astonishingly small amount is required for a strong adhesive. A recommended mixture is one-half part Jade no. 403 to ten parts Methyl Cellulose Paste Powder.

Methyl Cellulose Paste Powder: 7 gm. or 3 t.
Distilled or deionized water: 235 ml. or 8 fl. oz.

Stir the powder into the water. After twenty or thirty minutes, stir again very thoroughly. Put into a sterilized storage jar. When needed for use, add the Jade no. 403.

Caution: This adhesive should not be used in direct contact with a paper of

value because it is slightly acid and is not soluble in water alone. It swells and softens in water, but for complete removal toluene is also required.

Methylcellulose Adhesive

The synthetic bonding agents methylcellulose and sodium carboxymethylcellulose have become important in the paper conservation field. In different grades and viscosities, they have been used for a number of purposes—sizings, consolidents, adhesives. Basically they are cellulose ethers derived from cotton or wood cellulose that has been altered chemically. Cathleen Baker has written a valuable article on their compositions and uses, ''Methylcellulose and Sodium Carboxymethylcellulose: An Evaluation for Use in Paper Conservation Through Accelerated Aging.''

Their major advantages in paper conservation are their solubility in both water and organic solvents and their resistance to mold. For example, they have been kept for long periods in well-closed storage jars without showing signs of deterioration. Yet they have not withstood the test of actual time. They are good bonding agents, but as spot adhesives that are subject to stress; they do not have the strength of the starch pastes. Therefore, when they are used as hinge attachments for photographs, a frequent use, they are made up to high viscosities or in combination with starch paste. Following is one recipe for hinging purposes used by photograph conservators.

Methocel A4M (4000cps) 4 percent in distilled or deionized water

Methocel, like all methylcelluloses, is soluble in cold water, but it seems to go into solution more easily if it is first dispersed in about a third of the water, heated to around 194° F (90° C), then stirred vigorously in the rest of the water that has been made very cold in the refrigerator.

Heat-Set Adhesive

Rhoplex AC 236: 1 part
Rhoplex AC 73: 1½ parts
Distilled or deionized water: 1 part

Mix the ingredients. Heat until blended, but do not exceed 200° F (94° C). Paint the solution evenly on a sheet of Mylar (polyester film). Lay a sheet of strong tissue (Barcham Green's lens tissue) smoothly on it. Allow to dry. Peel off, beginning at one corner. In use, as for mending tears in secondary materials (documents or textbook pages), apply with a moderately hot tacking iron over a silicone release paper.

Suppliers

1. Artists' supply stores

2. Extermination and pest-control suppliers

3. Framing suppliers

4. Furniture stores or upholsterers

5. General department stores

6. Grocery stores

7. Hardware stores

8. Medical-supply houses

9. Photographic suppliers

10. Plastics and glass dealers

11. Scientific supply houses

12. Abbeon-Cal
 123 Gray Avenue
 Santa Barbara, Calif. 93101

13. Aiko's Art Materials Import
 714 North Wabash Avenue
 Chicago, Ill. 60611

14. Alnor Instrument Company
 7555 North Linden Street
 Skokie, Ill. 60077

15. American National Standards Institute
 1430 Broadway
 New York, N.Y. 10018

16. A/N/W (Andrew/Nelson/Whitehead)
 31-10 48th Avenue
 Long Island City, N.Y. 11101

17. A.P.F., Inc.
 315 East 91st Street
 New York, N.Y. 10128

18. Applied Science Laboratories
 2216 Hull Street
 Richmond, Va. 23224

19. Bacharach Instruments Company
 625 Alpha Drive
 Pittsburgh, Pa. 15238

20. Belfort Instrument Company
 727 South Wolfe Street
 Baltimore, Md. 21231

21. Berkey Marketing Companies, Inc.
 Gossen Division
 25-20 Brooklyn-Queens Expressway
 Woodside, N.Y. 11377

22. Bill Cole Enterprises
 P.O. Box 60
 Wollaston, Mass. 02170

23. Bookmakers
 2025 Eye Street, N.W.
 Washington, D.C. 20006

24. Brookstone Company
 127 Vose Farm Road
 Peterborough, N.H. 03458

25. Brainard Strapping
 Division of Sharon Steel
 P.O. Box 591
 Warren, Ohio 44482

26. Carl Zeiss, Inc.
 1 Zeiss Drive
 Thornwood, N.Y. 10594

27. Castle Company
 Division of Sybron
 1 Green Valley Parkway, Suite 22
 Green Valley Corporate Center
 Malvern, Pa. 19355

28. Charles T. Bainbridge Sons, Inc.
 Raritan Center
 50 Norfield Avenue
 Edison, N.J. 08817

29. Chicopee Manufacturing Company
 P.O. Box 2537
 Gainesville, Ga. 30503

30. Ciba-Geigy Corporation
 Additive Division
 3 Skyline Drive
 Hawthorne, N.Y. 10532

31. Cincinnati Gasket Company
 40 Illinois Avenue
 Reading
 Cincinnati, Ohio 45215

32. Conservation Materials Ltd.
 240 Freeport Boulevard
 Box 2884
 Sparks, Nev. 89431

33. Conservation Resources
 International, Inc.
 8000-H Forbes Place
 Springfield, Va. 22151

34. Continental Felt Company
 22 West 15th Street
 New York, N.Y. 10011

35. Corning Glass Works
 Corning, N.Y. 14830

36. Crestwood Paper Company, Inc.
 315 Hudson Street
 New York, N.Y. 10013

37. CYRO Industries
 25 Executive Boulevard
 P.O. Box 579
 Orange, Conn. 06477

38. Denton Vacuum, Inc.
 2 Pin Oak Avenue
 Cherry Hill Industrial Center
 Cherry Hill, N.J. 08003

39. DeVilbiss Company
 P.O. Box 913
 Toledo, Ohio 43692

40. Dick Blick Company
 P.O. Box 1267
 Galesburg, Ill. 61401

41. Duro-Test Company
 2321 Kennedy Boulevard
 North Bergen, N.J. 07044

42. E. I. du Pont de Nemours
 Company, Inc.
 1007 North Market Street
 Wilmington, Del. 19898

43. Eastman Kodak Company
 343 State Street
 Rochester, N.Y. 14650

44. Eaton-Dikeman
 Mt. Holly Springs, Pa. 17065

45. Ebco Manufacturing Company
 265 North Hamilton Road
 Columbus, Ohio 43213

46. Elkay Products Company
 35 Brown Avenue
 Springfield, N.J. 07081

47. Fisher Scientific Company
 711 Forbes Avenue
 Pittsburgh, Pa. 15219

48. Ford Glass
 Dept. HR-21
 P.O. Box 43343
 Detroit, Mich. 48243

49. Foxboro Company
 South Norwalk, Conn. 06856

50. Gallard-Schlesinger Chemical
 Manufacturing Corporation
 584 Mineola Avenue
 Carle Place, N.Y. 11514

51. General Electric Company
 Lamp Division
 King of Prussia, Pa. 19406

 Sheet Products Section
 Plastics Business Division
 Plastics Avenue
 Pittsfield, Mass. 01201

52. Globe-Amerada Glass Company
 2001 Greenleaf Avenue
 Elk Grove Village, Ill. 60007

53. Hollinger Corporation
 P.O. Box 6185
 3810 South Four Mile Run Drive
 Arlington, Va. 22206

54. Howard Paper Mill
 P.O. Box 982
 Dayton, Ohio 45401

55. Hurlock Brothers Company, Inc.
 1446 West Hunting Park Avenue
 Philadelphia, Pa. 19140

56. International Light Company
 Dexter Industrial Green
 Newburyport, Mass. 01950

57. J. S. Staedtler, Inc.
 1 Morris Court
 P.O. Box 68
 Montville, N.J. 07045

58. Lennox Industries, Inc.
 P.O. Box 1319
 Columbus, Ohio 43216

59. Light Impressions
 P.O. Box 940
 Rochester, N.Y. 14603

60. Littlemore Scientific Engineering
 Company
 Railway Lane
 Littlemore
 Oxford, England OX44PQ

61. M&C Specialty Company
 90 James Way
 Southampton, Pa. 18966

62. MacBeth Company
 Division of Kollmorgan Corporation
 Munsell Color
 2441 North Calvert Street
 Baltimore, Md. 21218

63. Martin Processing Company
 P.O. Box 8068
 Martinsville, Va. 24112

64. Micro Essential Laboratory
 4224 Avenue H
 Brooklyn, N.Y. 11210

65. Multiform Desiccant Products, Inc.
 1418 Niagara Street
 Buffalo, N.Y. 14213

66. National Draeger, Inc.
 Box 120, 101 Technology Drive
 Pittsburgh, Pa. 15230

67. New York Central Supply Company
 62 Third Avenue
 New York, N.Y. 10003

68. North American Philips Lighting
 Company
 1 Westinghouse Plaza
 Bloomfield, N.J. 07003

69. Pacific Transducer Corporation
 2301 Federal Avenue
 Los Angeles, Calif. 90064

70. Paper Nao
 1-29-12-201 Sengoke
 Bunkyo-ku
 Tokyo 112, Japan

71. Pastorelli and Rapkin
 287 Green Lanes
 Palmers Green
 London N13 4X5

72. Permacel
 U.S. Highway No. 1
 New Brunswick, N.J. 08903

73. Pittsburgh Plate Glass Industries,
 Inc.
 1 Gateway Center
 Pittsburgh, Pa. 15222

74. Pohlig Brothers, Inc.
 P.O. Box 8069
 2419 East Franklin Street
 Richmond, Va. 23223

75. Process Materials (Archivart
 Products)
 329 Veterans Boulevard
 Carlstadt, N.J. 07072

76. Protectoart, Inc.
 450 West End Avenue
 New York, N.Y. 10024

77. Rising Paper Company
 Housatonic, Mass. 01236

78. Rohm and Haas Company
 Independence Mall West
 Philadelphia, Pa. 19105

79. S and W Framing Supplies, Inc.
 120 Broadway
 Garden City Park
 Long Island, N.Y. 11040

80. Schleicher & Schnell, Inc.
 10 Optical Avenue
 Keene, N.H. 03431

81. Schwartz Chemical Company
 50-01 2nd Street
 Long Island City, N.Y. 11101

82. Science Associates
 230 Nassau Street
 Box 230-12
 Princeton, N.J. 08542

83. Seal Products, Inc.
 550 Spring Street
 Naugatuck, Conn. 06770

84. Sears Roebuck and Company
 (store in locality)

85. Shoten, Mizokawa Taizo
 Nakatachiuri-sagaru
 Omiya-dori, Kamikyo-ku
 Kyoto 602, Japan

86. Solar Screen Company
 53-11 105th Street
 Corona, N.Y. 11368

87. Spink & Gabore, Inc.
 11 Troast Court
 Clifton, N.J. 07011

88. Starrett Company
 121 Crescent Street
 Athol, Mass. 01331

89. Stockwell Rubber Company
 4749 Tolbut Street
 Philadelphia, Pa. 19136

90. Strathmore Paper Company
 Westfield, Mass. 01085

91. TALAS (Technical Library Service)
 213 West 35th Street
 New York, N.Y. 10001

92. Taylor Instrument Company
 Division of Sybron Corporation
 Glenn Bridge Road
 Arden, N.C. 28704

93. Tensor Corporation
 333 Stanley Avenue
 Brooklyn, N.Y. 11207

94. Thomas Scientific
 99 High Hill Road at I-295
 P.O. Box 99
 Swedesboro, N.J. 08085

95. 3M Company
 3M Center, Building 230
 St. Paul, Minn. 55101

96. United Manufacturers Supplies, Inc.
 3 Commercial Street
 Hicksville, N.Y. 11801

97. University Products, Inc.
 P.O. Box 101
 South Canal Street
 Holyoke, Mass. 01041

98. Vacudyne, Inc.
 375 East Joe Orr Road
 Chicago Heights, Ill. 60411

99. Velcro Corporation
 39 South Fullerton Avenue
 Montclair, N.J. 07402

100. Verd-A-Ray Corporation
 615 Front Street
 Toledo, Ohio 43605

101. Verilux, Inc.
 35 Mason Street
 P.O. Box 1512
 Greenwich, Conn. 06830

102. W. J. Barrow Restoration Shop
 State Library Building
 11th and Capitol Streets
 Richmond, Va. 23119

103. W. L. Gore & Associates, Inc.
 Attn. Laurie B. Gil, Product
 Specialist
 100 Airport Road
 P.O. Box 1550
 Elkton, Md. 21921

104. Walter Kidde & Corporation
 1394 South Third Street
 Mebane, N.C. 27302

105. Walton Laboratories
 Division of Melnor Industries
 1 Carol Place
 Moonachie, N.J. 07074

106. Washi-no-Mise
 Attn. Mrs. Sadako Orraca
 22 West 75th Street, 2B
 New York, N.Y. 10023

107. Watrous and Company, Inc.
 Drawer 40
 21750 Main Street, Unit 27
 Matteson, Ill. 60443

108. Wei T'o Associates, Inc.
 P.O. Drawer 40
 21750 Main Street
 Matteson, Ill. 60443

109. Westlake Plastics Company
 West Lenni Road
 Lenni Mills, Pa. 19052

110. Wild Heerbrugg Instruments, Inc.
 456 Smith Street
 Farmingdale, N.Y. 11735

111. William C. Lam Consultants
 101 Foster Street
 Cambridge, Mass. 02138

112. Zora's Artists' Materials
 11961 Santa Monica Boulevard
 P.O. Box 250036
 Los Angeles, Calif. 90025

Materials and Equipment for Environmental Control and for the Workshop

Note: Numbers in Appendix II refer to the suppliers listed in Appendix I.

Absorbers, ultraviolet, for natural and synthetic surface coating materials: Tinuvin P and Tinuvin 327 (Bonzotriagoles) by Ciba-Geigy, 30

Acid-base indicators, for testing papers
Archivists pen or similar instrument, 32, 33, 59, 91, 97
Indicator sticks, 32, 50, 91
Testing fluid (chlorophenol red), one of three solutions in the paper testing kit (Tri-test Kit) by the Applied Science Laboratory. See *Test kit*, 18, 97

Acid-base indicators, for testing liquids
Papers, 47, 50, 64, 65, 94
Solutions, 47, 50, 64
Sticks, 47, 50, 64, 65, 94

Adhesives
Dry mounting tissue. See *Photographers' equipment* and *Mounting materials*
Jade No. 403 or Promatco A-1023 (PVA emulsions), 75, 91
Laboratory purified gelatin, in sheets, like Silver Label (Fisher), 11, 47
Methyl cellulose, 11, 47, 59, 91
Methyl Cellulose Paste Powder, 75, 91
Rhoplex AC 73 and 236 by Hercules, for making heat-set tissue, 32
Rice starch, 13, 32, 59, 91
Solvent bonding solution, like Rez-n-Bond by Schwartz Chemical, for joining acrylic (Plexiglas) pieces, best applied from a polyester squeeze bottle with a needle-tube applicator, 10, 81
Wheat starch, 32, 59, 91, 97

Air conditioners
Window: Any reliable manufacturer. Of suitable shape and capacity, 5, 7, 84
Zone Master, 58

Air gun. See *Spraying equipment*

Air pollution detectors
Gas analyzer, 49
Gas detector kits, 11, 19, 66, 94

Air-velocity meters, 11, 14, 19

Alkaline tissue paper. See *Papers*

Ammonia (household). See *Cleaners*

Analytical filter pulp. See *Poulticing materials*

Anemometer. See *Air-velocity meters*

Antistatic polish, for synthetic glazing materials, 10, 38, 79, 81

Applicators. See *Swabs*

Aprons. See *Coats, laboratory*

Backing papers. See *Papers*

Balance, weighing; sensitive enough to weigh accurately less than a gram, like

Environmental monitoring. See *Air pollution detectors, Humidity indicators and meters,* and *Photometers*

Envelopes. See *Boxes, cases, envelopes, and folders*

Erasers

 Crumbled: Skum-X by Dietzen or Document Cleaning Powder (in small cans with spout), or Opaline Dry Cleaning Pads (in porous cloth bags), or Document Cleaning Pad, 1, 22, 32, 57, 67, 91

 Kneadable, like Artists Vita by FaberCastell or a good-quality wallpaper cleaner, for big jobs, 1, 59

 Pencil: Peel-off Magic Rub Pencil, Faber's Racekleen, or Mars Rasor by Staedtler, 1, 57, 91

 Vinyl: Magic Rub by FaberCastell or Mars Plastic Eraser by Staedtler, 1, 32, 57, 91

Fans

 Exhaust fan, mounted in window, strong enough to completely evacuate noxious vapors from the room, 5, 7

 Rotary fan, small, to blow fumes away from operator's face while doing local work with solvents, 5, 7, 47

Fiberglas sheeting, see *Photographers' Equipment*

Fiberglas window screening, heavy gauge, to form screened shelves, for fumigating cabinet; see Figure 1; 5, 7, 10

Filling material, for filling losses in surface of frames

 Gesso Hyplar (Grumbacher) or Liquitex (Permanent Pigments); or Molding plastic by U. S. Gypsum (mix with PVA emulsion adhesive), 1, 3, 7, 17, 79

Filter, tap water, 5, 7, 9

Filters, ultraviolet. See *Glazing material, radiation filters* and *Synthetic flexible sheeting, radiation filters*

Finger cots (surgical supplies): One on each finger will protect a valuable paper from hand contact during such operations as dry cleaning with erasers; eliminates the discomfort of plastic or rubber gloves, 8, 47

Fire extinguisher, CO_2 or Halon. Do not use extinguishers filled with water, wet chemicals, or sodium bicarbonate, 7, 22, 47, 104

Folder, instrument, bamboo or bone, 1, 13, 79, 91

Folders, acid-free. See *Boxes, cases, envelopes, and folders*

Forceps (tweezers)

 High quality, with fine points and accurate closure; one with straight nose and one with bent, 24, 32, 47, 91, 94, 97

 Large, for picking up large materials, metal or bamboo, 1, 13, 47

Frames

 Sectional frames, for enframement of pictures, especially for temporary shows, 1, 3, 79

 Silk-screen frames, for holding netting used in washing operations, different sizes to fit in trays, 1, 3, 79

Framing tools. See *Tools, framers'*

Fumehood, large enough to hold the optimum size of paper; may have to be specially made; or an effective exhaust fan, see *Fans*, 47, 94

Fumigation chambers

 Homemade chamber. See Figure 2. Fungicides. See *Pesticides* Furniture bumpers. See *Tools, framers'*

Mat cutter. See *Cutting tools*

Measuring devices: for volume measurement, see *Kitchen utensils* and *Glassware, laboratory*; for linear measurement, see *Caliper, Rulers,* and *Tools, carpenters'*

Microscopes. See *Optical Instruments*

Micrometer. See *Caliper*

Moistener, porcelain roller, for wetting adhesives on cloth and paper tapes, 1, 7, 59

Mounting material
Dry mounting tissue, 23
Transparent plastic corners, 32, 59, 79, 91, 97
Velcro and Velcoins, 32, 59, 79, 91, 97

Munsell Book of Color, Glossy Finish Collection, with removable samples, for a check on color stability after exhibition or treatment, 62

Netting. See *Synthetic flexible sheeting*

Optical instruments
Binocular head loupe, like Optivisor, working distance 9″ to 10″, 32, 79, 91
Operation microscope, like Olympus or Zeiss Operation Microscope, 26
Polarizing chemists' monocular microscope with magnification to 100X and better, if fiber and pigment study is needed, like the Wild Polarizing Microscope, 47, 94, 110

Oven, with thermostat that will maintain fairly stable temperatures, like the laboratory oven by Boekel, 40°–200°C, 47, 94

Pads
Neoprene or polyethylene, open meshed, for cushioning hard surfaces, 11, 47, 94

Padded oblong blocks and horses, for protection of frames during framing procedures (homemade), 4, 7

Pads of papermaker's felts, ¼″ thick, for flattening purposes in the drying sandwich, 34

Strips of carpeting or batt felt, for padding flooring of storage bins, 4, 5, 7

Synthetic sponge rubber, smooth surface and uniform thickness, ½″ thick, for flattening purposes in the drying sandwich; or, similarly sized pads of white gum rubber, ¼″ thick, 4

Pail, safety, for inflammable waste. See *Safety devices*

Paints
Acrylic polymer emulsion artists' colors, such as Liquitex by Permanent Pigments or Hyplar by Grumbacher, 1, 40, 67, 79, 112
Toners, wax, metallic and wood tones, for toning breaks in frames, like Rub 'n Buff, 79
Watercolors, Dr. Ph. Martin's Synchromatic Transparent, for toning windowmats, etc., 1, 91
Watercolors, translucent, cakes or tubes, such as those by Winsor & Newton or Grumbacher, 1, 40, 67, 79, 112

Pallettes, small-cupped, for touch-up procedures; large-cupped for washes used in decoration of windowmats, as above and 13

Pamphlet or print cases. See *Boxes, cases, envelopes, and folders*

Panels
Masonite, ¼″ thick, cut in rectangles of required sizes, can be used to

Notes

[1] For excellent information on this entire section given in careful detail, see Garry Thomson, *Museum Environment*.

[2] Paul Coremans, "Climate and Microclimate."

[3] Further information can be obtained from the air-monitoring agency of each state department for natural resources and environmental control. The state lung association can also be helpful.

[4] One such instrument is the Miran Gas Analyzer produced by Foxboro Company. It comes in two styles, one of which is portable. It is used by museums such as the Smithsonian Institution and costs around $10,000.

[5] The hand-held pump and detector tubes of Bacharach Instruments Company has calibrated tubes for six different polluting gases that can be purchased separately in packages of ten. The kits, complete with pump and packages of desired tubes, cost about $230 and are obtainable through local distributors. The Multi-gas Detector Pump Kit by National Draeger costs around $230. Tubes may be purchased separately in packages of twelve. It has tubes for two hundred different gases including an important one for ozone (CH 31301). Draeger also manufactures diffusion detector tubes that give parts-per-million times hours, and the Polymeter, with long-term tubes by which concentrations of contaminants can be determined over a period of several hours. Thomas Scientific offers the LaMotte Air Pollution Testing Outfit for about $275 with six kits and sampling pump. Each kit is sufficient for twenty-five tests; air is drawn through an absorbing solution that is then treated with the test-kit reagents, giving a color reaction that is matched against permanent color standards of known concentration.

[6] Activated charcoal filters are used to absorb ozone. Activated carbon is an excellent absorber of organic molecules and sulfur-bearing compounds. The filter can be reactivated by heating. It is usually used together with filters such as electronic precipitators, which remove particulated matter.

[7] Accurate and versatile, but expensive, is the thermal anemometer with probe, which can detect drafts in large or small spaces. A product of Alnor Instrument Company, it measures air currents accurately from ten to two thousand feet per minute and comes in a compact wooden carrying case. The cost is about $1,100. Less costly is a hand-size

172

device, the Floret Air Velocity Indicator, manufactured by Bacharach Instruments. It can accurately measure air speeds between 50 and 1,200 feet per minute and can act as an indicator of air drafts if the movement is below that speed. It is equipped with a probe and costs about $120.

[8]For a clear, concise description of the relationship between absolute humidity and relative humidity of the air, see Ann B. Craddock, ''Control of Temperature and Humidity in Small Institutions.''

[9]Sling psychrometers can be obtained at most reliable scientific supply houses. The important requirement is to be sure that the mechanism of the pivotal attachment of the handle to the body of the instrument is well designed for strength so that the thermometer element will not fly off during use. Some sturdy instruments are the Taylor Sling Psychrometer, obtainable at Thomas Scientific, and the Bacharach Sling Psychrometer. Both cost around fifty dollars.

[10]Good instruments are the Psychro-Dyne, sold by Thomas Scientific (cost is about $120), and the Psychron by Belfort Instrument Company. Each comes equipped with a psychrometer slide rule and has a psychrometric chart printed on the casing.

[11]The user should shop for this instrument to get one that suits the particular situation in size and design as well as in operation. Some hygrothermographs to consider are those of Belfort Instrument Company and of Watrous and Company, the Serdex of Bacharach Instruments, and the Dickson of Thomas Scientific. The charts are driven by quartz movements powered by small voltage batteries. The Dickson instrument records for seven days; the others can be adjusted to record for either twenty-four hours or seven days. All cost a little under seven hundred dollars.

[12]Some dial hygrometers are: the Durotherm Hygrometer of Watrous and Company, also obtainable from TALAS; the Airguide of Thomas Scientific; the German-made Abbeon, obtainable from Abbeon-Cal; and the English-made Edney Hygrometer of Pastorelli and Rapkin, also available from Conservation Materials. The costs run between forty dollars and seventy-five dollars.

[13]pHydrion Humidicator, impregnated paper one-half-inch wide, comes on a spool. A short section is torn off for exposure and then its color is matched to a calibrated color chart. It is produced by Micro Essential Laboratory and is obtainable from TALAS. Also, there is the conveniently readable and attractive Humidity Indicator Card composed of small squares graduated to indicate humidities 10% to 100%. It is produced by Multiform Desiccant Products.

[14]V. D. Daniels and S. E. Wilthew, ''An Investigation into the Use of Cobalt Salt Impregnated Papers for the Measurement of Relative Humidity.''

[15]In new constructions or in renovations where the aesthetic aspect of the building would not be injured, consideration could be given to the advantages of the insulating effects of double- or triple-glazed windows that might have one pane coated with a reflecting metallic oxide and might have another made of tinted glass. Not only heat transmission but also the quality of light can be controlled to a large degree by this type of window. Refer to the products of Pittsburgh Plate Glass Industries, of Globe-Amerada Glass Company, or of Ford Glass.

[16]George deW. Rogers, "The Ideal of the Ideal Environment."

[17]Richard D. Buck, "A Specification for Museum Airconditioning, Part I."

[18]Of the two kinds of dehumidifiers, the desiccant and the refrigerant, the first is preferred in cold climates because desiccant materials are more effective under cool conditions. A source of humidifiers and dehumidifiers are the Kenmore machines of Sears Roebuck and Company.

[19]Also might be considered a more expensive air-conditioning system such as the Zone Master of Lennox Industries. It is a system that allows controls of three or four different rooms (zones) by independent blower coils and thermostats from one condenser and refrigerant tank, which are usually placed out of doors.

[20]Nathan Stolow, "Fundamental Case Design for Humidity Sensitive Museum Collections" and "The Microclimate: A Localized Solution"; Tim Padfield, "The Control of Relative Humidity and Air Pollution in Show-Cases and Picture Frames."

[21]Buck, "Specification for Museum Airconditioning."

[22]Nathan Stolow, "Some Studies in Protection of Works of Art during Travel" and "The Ideal Container for Travel- or Humidity-Sensitive Collections"; Caroline K. Keck, *Safeguarding Your Collection in Travel*; Stephen A. Horne, *Way to Go! Crating Artwork for Travel*.

[23]Carl J. Wessel, "Environmental Factors Affecting the Permanence of Library Materials."

[24]Amdur, "Humidity Control."

[25]W. J. Barrow, *The Barrow Method of Restoring Deteriorated Documents*; W. J. Barrow Research Laboratory, "Spray Deacidification;" A. D. Baynes-Cope, "The Non-aqueous Deacidification of Documents"; R. D. Smith, "New Approaches to Preservation" and *Preserving Cellulosic Materials through Treatment with Alkylene Oxides* (Smith is the originator and president of Wei T'o Associates, makers of three deacidification formulations obtainable either in bottles or in fairly long lasting spray cans.); George B. Kelly, Jr., *Composition for Use in Deacidification of Paper*; G. B. Kelly, Jr., Lucia C. Tang, and Marta K. Krasner, "Methyl Magnesium Carbonate"; W. H. Langwell, "The Vapour Phase Deacidification of Books and Documents"; J. C. Williams and G. B. Kelly, Jr., "Research on Mass Treatment in Conservation."

[26]R. D. Smith, "Mass Deacidification at the Public Archives of Canada."

[27]G. B. Kelly, Jr., and J. C. Williams, "Mass Deacidification with Diethyl Zinc: Large-Scale Trials."

[28]For help in this discussion as well as other scientific matters, my thanks are due to a number of scientists who lent kindly ears and did their best to answer questions both written and oral. Some of them are: Donald K. Sebera and Peter Sparks, both now of the Library of Congress; Edgar E. Dickey and T. Alfred Howells, formerly of the Institute of Paper Chemistry; Robert L. Feller, of the Carnegie-Mellon Institute of Research; Robert M. Organ, formerly of the Smithsonian Institution; and George J. Reilly, of Winterthur Museum.

[29]The darkening is sometimes noticed after treatment with the formulas containing

magnesium methoxide and magnesium methyl or ethyl carbonate. The discoloration occasionally shows up when the paper has been dampened with water after deacidification.

[30]If future acidity should cause eventual discoloration, areas that did not receive full treatment may darken, forming a mottled pattern. Aqueous methods may compensate for uneven spraying if the paper is immediately covered within a closed plastic sheeting to keep the paper damp with the agent for three or four hours ("marinate," as W. J. Barrow termed the procedure), thus permitting the dissolved alkali to travel along and between the fibers. Nonaqueous methods introduce more deacidification agents into the paper and therefore could cause greater disparity of color if unevenly sprayed.

[31]pHydrion acid-base indicators are manufactured by Micro Essential Laboratory. From Micro Essential may be readily obtained many pH ranges, full range and short ranges of any desired span. Thomas Scientific also carries these tapes. Gallard-Schlesinger Chemical Manufacturing Corp. is responsible for the MN products, which include MN Universal Indicator Paper (pH 1–11), Duotest and Tritest tapes, and the Tri-box Kit of three spools. The Alkacid tapes obtained from Fisher Scientific include the Wide-range Test Ribbon (pH 2–10) and Full-range pH Kit of seven spools. Also, there are indicator solutions that cover a broad range. A drop of the indicator into a test tube of the solution being tested will give a color reading. Micro Essential Laboratory makes pHydrion One Drop Indicator Solution (pH 1–11), and Fisher Scientific has the Universal Indicator Solution.

[32]Gallard-Schlesinger Chemical Manufacturing Corporation makes the MN pH-Fix Universal Sticks (pH 0–14), composed of four indicator squares adhered to one stick. Many of the conservation supply houses carry the plastic-stick indicator: TALAS has the Non-bleeding pH Indicators; Conservation Materials and University Products carry Color-fast pH Indicator Strips. These indicators can be used to test unbuffered and colored solutions because they can be left in the solutions until their colors stop changing.

[33]The Archivists Pen is carried by TALAS and by Light Impressions. University Products has a set of pencils that includes a wide-range pencil and three short-range, as well as a vial of distilled water used in conjunction with the pencils.

[34]The kit (which will be discussed later in the text), called the Tri-test Kit, is produced by Applied Science Laboratories. It is also obtainable from Light Impressions, from Pohlig Brothers, and from United Manufacturers Supplies.

[35]The original product, whose initial fabrication was supervised by W. J. Barrow, is called "Permalife." Formerly made by Standard Paper Company of Richmond, it is now, in all its forms and including its name, the property of the present maker, Howard Paper Mill in Dayton, Ohio. Hollinger Corporation of Richmond is a distributor of "Permalife" papers, such as 20-pound Bond and 80-pound Cover.

[36]Companies that provide acid-free materials:
A. 100% rag, buffered mounting board, two and four ply, whites and off whites, sometimes grays, browns, and blacks, usually 32″ × 40″ or 40″ × 60″.
A/N/W
Charles T. Bainbridge Sons
Conservation Materials

Crestwood Paper Company
Hollinger Corporation
Hurlock Brothers Company
Light Impressions
Process Materials
Rising Paper Company (materials obtained from distributors)
Strathmore Paper Company (materials obtained from distributors)
TALAS
University Products

B. 100% rag, unbuffered mounting board, neutral, two and four ply, whites and off whites, usually 32″ × 40″ and 40″ × 60″.
Conservation Materials
Crestwood Paper Company
Process Materials
TALAS
University Products

C. Purified wood fibered, buffered mounting board, two and four ply, whites and sometimes in many colors.
Charles T. Bainbridge Sons
Conservation Materials
Conservation Resources International
Crestwood Paper Company
Hollinger Corporation
Howard Paper Mill
Hurlock Brothers Company
Light Impressions
Process Materials
University Products

D. Almost all of these companies carry acid-free papers of different weights, including bristol board, glassine, and blotting paper. See especially Conservation Materials Ltd., Conservation Resources International, Process Materials, and University Products.

E. Boxes, cases, envelopes, and box-making boards can be obtained especially from the four companies mentioned in D above, also from Light Impressions, Hollinger Corporation, and Pohlig Brothers.

[37]Good tapes for this particular purpose because they have the same gloss as glass or rigid plastic are: J-Lar, made by Permacel and obtained through the distributor, M&C Specialty Company; or 3M Scotch Brand Tape no. 600 obtained from any hardware store.

[38]Roy Perkinson, "On Conservation: Lighting Works of Art on Paper."

[39]Feller, "Control of the Deteriorating Effects of Light." Nathan Stolow, "The Action of Environment on Museum Objects: Part II, Light."

[40]A footcandle is a unit for measuring illumination. The illumination level (or illu-

minance) of light falling on a surface is measured in footcandles or lumens (the measure of the flow of light) per square foot. Footcandles are the units that have been generally used in the United States. One unit is equal to ten lux, the unit used in Great Britain. A lux is lumens per square meter.

[41]These polymethyl methacrylate plastics are produced by Rohm and Haas Company. Plexiglas G, the standard material, comes in many thicknesses, from ⅛″ to 2″. Plexiglas UF3 can be obtained from local glass and plastics dealers, from TALAS, from Light Impressions, and from Conservation Resources International. CYRO Industries makes similar materials; Acrylite OP 2 is the sheeting comparable to Plexiglas UF3. Some other trade names for polymethyl methacrylate treated to absorb ultraviolet radiation are Perspex VE and Oroglas UF 3.

[42]Weatherable Mylar is produced by Martin Processing Company and is obtainable through local distributors. It comes in two forms: without adhesive for shades, and with adhesive for bonding to glass. Comparable materials are made by Solar Screen Company: the first form is called Solar Shade and the second is called E-Z Bond Clear UV Glass Film.

[43]Raymond H. LaFontaine, ''Comparison of the Efficiency of Ultraviolet Absorbing Compounds.''

[44]Solargray is one example of many by Pittsburgh Plate Glass Industries.

[45]Donald C. Hegnes, ''What's New in Glass.'' See also Pittsburgh Plate Glass pamphlet *The Right Glass 1986*, 8.26a.

[46]Pittsburgh Plate Glass Industries makes a series of double-paned windows, such as the Solarban Twindow, the Solar Cool Twindow, and the LHR Twindow units. For other sources of these glasses, see note 15.

[47]Scotchtint Solar Control Film by 3M Company.

[48]The Warm White fluorescent lamp is said to emit the least UV radiation of all the standard lamps.

[49]Ray Shield 403 by Westlake Plastics Company. The Solar-Screen Fluorescent Bulb Jacket by Solar-Screen Company. The conservation supply houses that have UV absorbing sleeves are TALAS, Conservation Resources International, and Light Impressions.

[50]Ultralume by North American Philips Lighting Company, high in the Color Rendering Index (CRI), at 5,000° Kelvin (K), the Ultralume gives excellent daylight rendering (lengths 18″ to 96″). Verilux has the Verilux VLX, CRI 96 for general illumination; and the Verilux F40T12VLX/M that emits virtually no UV because it is coated with a UV absorber on the inside of the glass, used for closer, more particular lighting (48″). Duro-Test Company has Optima 50 that at 5,000° K has excellent daylight rendering, CRI 91 (48″ and 96″); and Color Gard 50 that blocks 99% of UV because of its coating of titanium silica on the inside of the glass. General Electric Lamp Division produces the Chroma 50, 5,000° K, of excellent daylight rendering; and for general illumination the tube SP 35, which gives off light between the tubes SP30 (warm) and SP41 (cool or equivalent to northern light).

[51]Corning Glass Works of Corning, N.Y., makes Pyrex glass with an electrically

conducting coating that reflects infrared rays. It comes in thicknesses of ⅛″, ¼″, and ³⁄₁₆″, obtainable through Cincinnati Gasket Company, which cuts the sheet to required sizes.

[52]All dichroic reflecting bulbs should be held in special well-ventilated fixtures because of the heat they throw to the back. Cool Beam dichroic PAR bulbs by North American Philips Lighting Company and by General Electric come in spots, floods, and wide floods of 75W and 150W. 75W is recommended for museum use because the 150W throws back considerable heat. General Electric also has dichroic Precise Bulbs of 12W for close, emphasis lighting.

[53]Fiberglass screening comes in rolls about 54″ by 18′, obtainable from dealers of photographic supplies.

[54]Suggestions for competent lighting engineering and consulting firms can be sought from museums that have undergone recent gallery renovations or the erection of new wings. One firm that has been well recommended is William C. Lam Consultants. For temporary lighting arrangements, consideration may be given to the suggestions made in Lothar P. Wittenborg, "Illumination," in *Good Show: A Practical Guide for Temporary Exhibitions*.

[55]UV-Visible Photometer IL 1351, made by International Light, can be equipped with two sensors, one to measure the visible light in footcandles, the other to measure radiation in the ultraviolet range in microwatts/square centimeter. It is battery operated and has digital displays. It costs about $900. A recommended, easy to use instrument for the detection of UV only is the portable battery-operated unit, Crawford UV Monitor Type 760, made by Littlemore Scientific Engineering Company and obtainable from Science Associates. It costs about $430. The Panlux Electronic Footcandle Meter is obtainable from the Berkey Marketing Companies, Inc. It costs about $390. All Gossen meters can be obtained from dealers in photographic supplies.

[56]Electrical dimmers tend to make the color of the light more yellow. The lighting designers at the Metropolitan Museum of Art have found that the intensity of the light can be reduced without changing its color by interposing a grid between the bulb and the diffuser. The grid can be made of aluminum window screening painted with a black heat-resistant paint. Its effectiveness can be adjusted by using more than one piece of screening, or even sections of a piece.

[57]Glossy Finish Collection, Removable Samples in two Binders, MacBeth Company.

[58]R. L. Feller and R. M. Johnston-Feller, "Use of International Standards Organization's Blue-Wool Standards for Exposure to Light, I and II," *AIC Preprints* of the Sixth and Seventh Annual Meetings at Fort Worth, 1978, and Toronto, Ontario, 1979. The cards of British Blue-Wool Standards are obtainable from TALAS, or information can be requested from American National Standards Institute.

[59]The information in this section is derived from *Pest Control in Museums: A Status Report (1980)*; from a conversation with entomologist Thomas Parker, who is most generous with his knowledge; and from Thomas Parker, "Integrated Pest Management for Libraries."

[60]F. Flieder, *La Conservation des documents graphiques: recherches experimentals.*

[61]T. M. Ilaims and T. D. Beckwith, "Notes on the Causes and Preservation of Foxing in Books"; and R. E. Press, "Observations on Foxing of Paper."

[62]Instances have been reported in which, after severe fungal attacks, molds continued to flourish in the infected books for several years even though the RH had been kept well below 60%. See William Chamberlain, "Fungus in the Library." A possible explanation could be that molds, especially in the interior of books, are not always rendered inactive by lowered RH once they have established a deep-seated foothold; or, perhaps more likely, that local pockets of dampness, even within the thickness of the paper, continued to exist.

[63]For actions to be taken during abnormal conditions—the aftermaths of disastrous floods, tempests, and fires—reference is made to Peter Waters, *Salvaging Fire and Water Damaged Archival Materials*, who developed the techniques after such experiences as the 1967 Florence flood; and to Willman Spawn, "After the Water Comes."

[64]Deborah Nagin and Michael McCann, *Thymol and o-Phenyl Phenol: Safe Work Practices*.

[65]Vacudyne has redesigned its fumigation chambers to meet health requirements with an automatic flow-through ventilation system. The chambers are made for the use of ethylene oxide but can be modified to accommodate methyl bromide or Vikane. They come in a number of sizes, the smallest, at 18 cub. ft., costs about $16,000.

[66]Perri Peltz and Monona Rossol, *Safe Pest Control Procedures for Museum Collections*.

[67]Kenneth Nesheim, "The Yale Non-toxic Method of Eradicating Book-eating Insects by Deep Freezing."

[68]Richard D. Smith, "The Use of Redesigned and Mechanically Modified Commercial Freezers to Dry Water-wetted Books and Exterminate Insects." The Instrument is obtainable from Wei T'o Associates. Its cost is about $16,000.

[69]All the chemicals mentioned under Insect Control are best obtained from Extermination Pest Control Equipment and Supplies companies listed in local telephone directory Yellow Pages.

[70]NIOSH publications, such as "How to Get along with Your Solvents" (76–108) and "NIOSH Certified Personal Protective Equipment" (76–145), are available from the Division of Technical Services, Publications Dissemination.

[71]Many of the protective devices and clothing are obtainable from scientific houses, as the Fisher Scientific Company. Bill Cole Enterprises carries a complete supply: safety cabinets and cans for solvents, laboratory aprons, coats, gloves, goggles and face shields, respirators with special filters, such as one for organic vapors, eye-wash fountains, fire and smoke detectors, and so on.

[72]To find sources for the materials mentioned in this section, please refer to the proper headings under Materials and Equipment in Appendix II.

[73]American National Standards Institute, *Standard ANSI-PH-1.41* (1981), "Specifications for Photographic Film for Archival Records: Silver Gelatin Type on Polyester Base." Henry Wilhelm, *Procedures for Processing and Storing Black and White Photographs for Maximum Possible Permanence*.

[74]Merrily A. Smith et al., "Pressure-Sensitive Tape and Techniques for Its Removal."

[75]Robert Futernick, "Removal of Pressure-Sensitive Tapes and Adhesives."

[76]Carolyn Horton, *Cleaning and Preserving Bindings and Related Materials.*

[77]E. J. Pearlstein et al., "Effects of Eraser Treatment on Paper."

[78]Lucia C. Tang and N. M. M. Jones, "The Effects of Wash Water Quality on the Aging Characteristics of Paper."

[79]J. Nelson, et al., "Effects of Wash Water Quality on the Physical Properties of Three Papers."

[80]J. C. Williams et al., "Metallic Catalysts in the Oxidative Degradation of Paper"; S. Banik, H. Stachelberger, and O. Wächter, "Investigation of the Destructive Action of Copper Pigments on Paper and Consequences for Conservation."

[81]W. J. Barrow Research Laboratory, "Spray Deacidification."

[82]Japanese names for papers may not always be meaningful, so the choice of a paper for a specific purpose may have to depend on the judgment of the user, a judgment that can be made by fingering and flexing the paper, assessing its thickness and fiber length, and testing it for acidity.

[83]For a discussion of various and ingenious ways of matting paper, see Merrily A. Smith, *Matting and Hinging of Works of Art on Paper.*

[84]Diluted household ammonia or Windex makes a good glass cleaner if allowed to evaporate completely before the matted picture is put into the frame.

[85]Nathan Stolow, "The Microclimate: A Localized Solution."

[86]"Polyester Film Encapsulation," Library of Congress Publications on Conservation of Library Materials, Conservation Workshop Notes on Evolving Procedures, Series 300, No. 5.

[87]W. J. Barrow, *The Barrow Method of Restoring Deteriorated Documents.*

[88]Procedure for encapsulation can be found in Mary E. Greenfield, "Mylar Envelopes." Encapsulation kits with instructions are obtainable from some of the suppliers like Hollinger Corporation and Conservation Materials.

[89]The conservation staff of the Library of Congress has developed ways of forming a so-called polyester book whose pages are separately encapsulated. See Barbara Meier-James, "Modification of the Basic Polyester Post Binding."

[90]William Minter, "Mylar Encapsulation Using Ultrasonic Welding"; Louis Pomerantz, "Polyester Welding Machines."

[91]Weintraub, Steven, "A New Silica Gel and Recommendation," AIC *Preprints* 1982.

Bibliography

Amdur, E. J. "Humidity Control—An Isolated Area Plan." *Museum News*, Part II, Technical Supplement 6, vol. 43, no. 4 (December 1964): 58–61.

American Institute for Conservation of Historic and Artistic Works (AIC). *Directory, 1984–85*. Washington, D.C.: AIC, 1985.

American National Standards Institute (ANSI). "Specifications for Photographic Film for Archival Records, Silver Gelatin Type on Polyester Base," Standard ANSI-PH-1.41. New York: ANSI, 1981.

Baker, Cathleen A. "Seven Helpful Hints for Use in Paper Conservation." In *The Book and Paper Group Annual*, vol. 3, 1–7. Washington, D.C.: AIC, 1984.

Banik, Gerhard, H. Stachelburger, and Otto Wachter. "Investigation of the Destructive Action of Copper Pigments on Paper." In *Preprints of IIC* (1982): 75–78.

Barrow, W. J. *The Barrow Method of Restoring Deteriorated Documents*. Richmond, Va.: Dietz Press, 1965.

Baynes-Cope, A. D. "The Nonaqueous Deacidification of Documents." *Restaurator* (Copenhagen) 1, no. 1 (1969): 2–9.

Buck, Richard D. "A Specification for Museum Airconditioning." *Museum News*, Part I, Technical Supplement no. 6, vol. 43, no. 4 (December 1964): 53–57.

Brown, Margaret R., Don Etherington, and Linda K. Ogden. *Boxes for the Protection of Rare Books: Their Design and Construction*. Washington, D.C.: Library of Congress, 1982.

Browning, B. L. *Analysis of Paper*. rev. ed. New York: Marcel Dekker, 1977.

Chamberlain, William. "Fungus in the Library." *Library and Archival Security* 4, no. 4 (1982): 35–55.

Clark-Morrow, Carolyn. *Conservation Treatment Procedures*. Littleton, Colo.: Unlimited, 1982.

Coremans, Paul. "Climate and Microclimate." *Conservation of Cultural Properties with Special Reference to Tropical Conditions*. Museums and Monuments Series XI. Paris: UNESCO, 1968.

Craddock, Ann B. "Control of Temperature and Humidity in Small Institutions." In

Bulletin No. 7. Cooper-Hewitt Museum, New York State Conservation Conservancy, edited by Konstanze Backmann. New York: 1985.

Daniels, V. D., and S. E. Wilthew. "An Investigation into the Use of Cobalt Salt Impregnated Papers for the Measurement of Relative Humidity." *Studies in Conservation* 28, no. 2 (May 1983): 80–84.

Edwards, Stephen R., Bruce M. Bell, and Mary Elizabeth King, eds. *Pest Control in Museums: A Status Report (1983).* Albany, N.Y.: Association of Systematics Collections, 1980.

Feller, Robert L. "Control of the Deteriorating Effects of Light upon Museum Objects." *Museum* 17, no. 2 (1964): 70–98.

———. "The Heating Effects of Illumination by Incandescent Lamps." *Museum News,* Technical Supplement, vol. 46, no. 9 (May 1968): 39–46.

Feller, Robert L., and Ruth M. Johnston-Feller. "Use of International Standards Organization's Blue Wool Standards for Exposure to Light: I and II." In *Preprints of AIC.* Sixth and Seventh Annual Meetings at Fort Worth, 73–80, and Toronto, 30–36. Washington, D.C.: AIC, 1978 and 1979.

Flieder, Francoise. *La Conservation des documents graphiques: recherches experimentals.* Paris: ICOM Edition Eyrolles, 1969.

Futernick, Robert. "Methods and Makeshift." In *The Book and Paper Group Annual,* vol. 3. Washington, D.C.: AIC, 1984.

———. "Removal of Pressure-Sensitive Tapes and Adhesives." In *The Book and Paper Group Annual,* vol. 3. Washington, D.C.: AIC, 1984.

Greenfield, Mary E. "Mylar Envelopes." *Guild of Book Workers Journal* 11, no. 3 (Spring 1973): 23–27.

Hegnes, Donald C. "What's New in Glass," *Museum News* 51, no. 1 (September 1982): 23–25.

Horne, Stephen A. *Way to Go! Crating Artwork for Travel.* Hamilton: Gallery Association of New York State, 1985.

Horton, Carolyn. *Cleaning and Preserving Bindings and Related Materials.* Conservation of Library Materials series, Pamphlet 1. Chicago: American Library Association, 1967.

Iliams, T. M., and T. D. Beckwith. "Notes on the Causes and Prevention of Foxing in Books." *Library Quarterly* 45, no. 4 (1935): 407–18.

Keck, Caroline K. *Safeguarding Your Collection in Travel.* Nashville, Tenn.: American Association for State and Local History, 1970.

Keck, Caroline K., H. T. Block, J. Chapman, J. G. Lawton, and N. Stolow. *A Primer on Museum Security.* Cooperstown: New York State Historical Association, 1966.

Kelly, George B., Jr. *Composition for Use in Deacidification of Paper.* U.S. Patent no. 3,939,091. February 17, 1976.

Kelly, George B., Jr., Lucia C. Tang, and Marta K. Krasner. "Methyl Magnesium Carbonate: An Improved Nonaqueous Deacidification Agent." In *Preservation of Paper and Textiles of Historic and Artistic Value.* Advances in Chemistry Series no. 164, edited by J. C. Williams, 62–71. Washington, D.C.: American Chemical Society, 1977.

Kelly, George B., Jr., and J. C. Williams. "Mass Deacidification with Diethyl Zinc: Large-scale Trials." In *Preprints of AIC*. Annual meeting, Fort Worth, 81–92. Washington, D.C.: AIC, 1978.

Keyes, Keiko Misushima. "The Use of Friction Mounting as an Aid in Pressing Works on Paper." In *The Book and Paper Group Annual*, vol. 3, 101–4. Washington, D.C.: AIC, 1984.

Koyano, Masako. *Japanese Scroll Paintings: A Handbook of Mounting Techniques*. Washington, D.C.: Foundation of the American Institute for Conservation (FAIC), 1979.

La Fontaine, Raymond H. "Comparison of the Efficiency of Ultraviolet Absorbing Compounds." *Bulletin of AIC* 16, no. 1 (Winter 1975/76): 74–94.

Langwell, W. H. "The Vapour Phase Deacidification of Books and Documents." *Journal of the Society of Archivists* (London) 3, no. 3 (1966): 137ff.

Library of Congress. *Polyester Film Encapsulation*. Washington, D.C., 1980. (Obtainable from the U.S. Government Printing Office, Stock Number 030-000-00114-1) Washington, D.C.

McCann, Michael. *Artists Beware: The Hazards and Precautions in Working with Art and Craft Materials*. New York: Watson-Guptill Publications, 1979.

————. *Health Hazards Manual for Artists*. rev. and enl. New York: Nick Lyons Books, 1985.

McCann, Michael, and Gail Barazani. *Proceedings: Health Hazards in Arts and Crafts Conference*. Washington, D.C.: Society of E. Health, 1980.

Matthai, Robert A. *Energy Management for Museums and Historical Societies*. New York: New York Hall of Science, 1982. (Available from American Association of Museums, P. O. Box 33399, Washington, D.C. 20033.)

Meier-James, Barbara. "Modification of the Basic Polyester Post Binding." In *The Book and Paper Group Annual*, vol. 2, 62–65. Washington, D.C.: AIC, 1983.

Merck and Company. *The Merck Chemical Index of Chemicals and Drugs*. 10th ed. Rahway, N.J.: Merck and Co., 1983.

Michalski, Stefan. "Suction Table: History and Behavior." In *Preprints of AIC*. 9th annual meeting, Philadelphia, 129–36. Washington, D.C.: AIC, 1981.

Minter, William. "Mylar Encapsulation Using Ultrasonic Welding." *Abbey Newsletter* 4, no. 2 (April 1980): 24.

Munsell Book of Colors. Glossy Finish Collection with Removable Samples. Baltimore: MacBeth Co., 1966.

Myers, James N., and Denise N. Bedford, eds. *Disaster Prevention and Coping*. Stanford: Stanford University Libraries, 1981.

Nagin, Deborah, and Michael McCann. *Thymol and o-Phenyl Phenol: Safe Work Practices*. New York: Center for Occupational Hazards, 1982.

National Institute of Occupational Safety and Health (NIOSH). *How to Get along with Your Solvents*. 76–108. Cincinnati: NIOSH, 1976.

————. *NIOSH Certified Personal Protective Equipment*. 76–145. Cincinnati: NIOSH, 1976.

————. *Working with Solvents*. 77–139. Cincinnati: NIOSH, 1977. (Publications available from the Division of Technical Services, Publication Dissemination, 4676 Columbia Parkway, Cincinnati, Ohio 45226.)

Nelson, J., A. King, N. Indictor, and D. Cabelli, "Effects of Wash Water Quality on the Physical Properties of Three Papers." *Journal of AIC* 21, no. 2 (Spring 1982): 59–76.

Nesheim, Kenneth. "The Yale Non-toxic Method of Eradicating Book-eating Insects by Deep Freezing." *Restaurator* (Copenhagen) 6, nos. 3, 4 (1984): 147–64.

Padfield, Tim. "The Control of Relative Humidity and Air Pollution in Show-cases and Picture Frames." *Studies in Conservation* 11, no. 1 (February 1966): 8–27.

Parker, Thomas. "Integrated Pest Management for Libraries." Paper delivered at the International Conference on Preservation, Vienna, Austria, April 1986. Sponsored by UNESCO, International Federation of Library Associations, and Directors of National Libraries. (Available for $5.00 from Dr. Thomas Parker, 44 Essex Avenue, Lansdowne, Pa. 19050.)

Pearlstein, E. J., D. Cabelli, A. King, and N. Indictor. "Effects of Eraser Treatment on Paper." *Journal of AIC* 22, no. 1 (Fall 1982): 1–2.

Peltz, Perri, and Menona Rossol. *Safe Pest Control Procedures for Museum Collections*. New York: Center for Occupational Hazards, 1983.

Perkinson, Roy. *Conserving Works of Art on Paper*. 1975. Reprint. (Available from American Association of Museums, P. O. Box 33399, Washington, D.C. 20033.)

————. "On Conservation: Lighting Works of Art on Paper." *Museum News* 53, no. 3 (November 1974): 5–7.

Petherbridge, Guy, and J. Malcolm Harrington, eds. *Safety and Health in the Paper Conservation Laboratory*. Vols. 5 and 6, *Paper Conservator*. London: 1980/81.

Pittsburgh Plate Glass Industries. *The Right Glass*. 8.26a. Pittsburgh: Pittsburgh Plate Glass Industries, 1986.

Pomerantz, Louis. "Polyester Welding Machines." *AIC Newsletter* 7, no. 3 (May 1982): 10–11.

Press, R. E. "Observations on Foxing of Paper." *International Biodeterioration Bulletin* (Birmingham, England) 2, no. 1 (1976): 27–30.

Rogers, George deW. "The Ideal of the Ideal Environment." *Journal of the ICC—Canadian Group* 2, no. 1 (Autumn 1976): 34–39.

Smith, Merrily A. *Matting and Hinging of Works of Art on Paper*. Washington, D.C.: Library of Congress, 1981.

Smith, Merrily A., Norvell M. M. Jones II, Susan L. Page, and Marian P. Dirda. "Pressure-sensitive Tape and Techniques for Its Removal." In *The Book and Paper Group Annual*, vol. 2, 95–113. Washington, D.C.: AIC, 1984.

Smith, Richard D. "Mass Deacidification of the Public Archives of Canada." In *The Conservation of Library and Archival Materials and the Graphic Arts*, Cambridge Conference, 131. London: Institute of Paper Conservation and the Society of Archivists, 1980.

————. "New Approaches to Preservation." In *Deterioration and Preservation of Li-*

brary Materials. Edited by W. Winger and R. D. Smith, 139–75. Chicago: University of Chicago Press, 1970.

———. *Preserving Cellulosic Materials through Treatment with Alkylene Oxides.* U.S. Patent no. 3,676,055. 1970.

———. "The Use of Redesigned and Mechanically Modified Commercial Freezers to Dry Water-wetted Books and Exterminate Insects." *Restaurator* (Copenhagen) 6, nos. 3–4 (1984): 165–90.

Spawn, Willman. "After the Water Comes." *Pennsylvania Library Bulletin* 28, no. 6 (November 1973): 143–251.

Stolow, Nathan. "The Action of Environment on Museum Objects. Part II: Light." *Curator* 9, no. 4 (December 1966): 302ff.

———. "Fundamental Case Design for Humidity-Sensitive Museum Collections." *Museum News,* Technical Supplement no. 11, vol. 44, no. 6 (February 1966): 45–62.

———. "The Ideal Container for Travel- or Humidity-Sensitive Collections." In *Museum Registration Methods,* 389–394. Washington, D.C.: American Association of Museums and Smithsonian Institution, 1979.

———. "The Microclimate: A Localized Solution." *Museum News* 56, no. 2 (November/December 1977): 52–63.

———. "Some Studies in Protection of Works of Art during Travel." In *Recent Advances in Conservation,* ICC Rome Conference. London: Butterworths, 1963.

Tang, Lucia C., and N. M. M. Jones II. "The Effects of Wash Water Quality on the Aging Characteristics of Paper." *Journal of AIC* 21, no. 2 (Spring 1979): 61–81.

Thomson, Garry. *The Museum Environment.* Reprint. London and Boston: Butterworths, 1981.

———. "A New Look at Colour Rendering, Level of Illumination, and Protection from UV Radiation in Museum Lighting. *Studies in Conservation* 6, nos. 2, 3 (August 1961): 49–82.

Tillotson, Robert. *Museum Security / La Sécurité dans les musées.* Paris: ICOM, 1977.

Toishi, Kenzo. "Humidity Control in a Closed Package." *Studies in Conservation* 4, no. 3 (August 1959): 81–87.

W. J. Barrow Research Laboratory. "Spray Deacidification." In *Permanence/Durability of the Book 3.* Richmond, Va.: Dietz Press, 1969.

Waters, Peter. *Procedures for Salvage of Water Damaged Library Materials.* Washington, D.C.: Library of Congress, 1975.

Weidner, Marilyn K. "Damage and Deterioration of Art on Paper due to Ignorance and the Use of Faulty Materials." *Studies in Conservation* 12, no. 1 (1967): 5–25.

———. "A Vacuum Table of Use in Paper Conservation." *AIC Bulletin* 14, no. 2 (1974): 115–20.

Weintraub, Steven. "A New Silica Gel and Recommendations." *Preprints of AIC,* 10th annual meeting, Milwaukee, 169–173. Washington, D.C.: AIC, 1982.

Wessel, Carl J. "Environmental Factors Affecting the Permanence of Library Materials." In *Deterioration and Preservation of Library Materials.* Edited by H. W. Winger and R. D. Smith, 39–84. Chicago: University of Chicago Press, 1970.

Williams, J. C. "Chemistry of the Deacidification of Paper." *Bulletin of the IIC-AG* 12, no. 1 (1971): 16–32.

Williams, J. C., C. S. Fowler, M. S. Lyon, and T. L. Merrill. "Metallic Catalysts in the Oxidative Degradation of Paper." In *Preservation of Paper and Textiles of Historic and Artistic Value*. Advances in Chemistry Series 164, edited by J. C. Williams, 37–61. Washington, D.C.: American Chemical Society, 1977.

Williams, J. C., and G. B. Kelly, Jr. "Research on Mass Treatment in Conservation." *Bulletin of AIC* 14, no. 2 (1974): 69–77.

Wittenberg, Lothar P. *Good Show!: A Practical Guide for Temporary Exhibitions*, Washington, D.C.: Smithsonian Institution, 1981. Chap. 4, "Illumination," pp. 76–82.

Index